THOMAS EAKINS

Philadelphia Museum of Art

May 29 to August 1, 1982

Museum of Fine Arts, Boston

September 22 to November 28, 1982

The exhibition and catalogue are supported by grants from the IBM Corporation and The Pew Memorial Trust

THOMAS EAKINS

ARTIST OF PHILADELPHIA

Darrel Sewell

Philadelphia
Museum of Art

1982

Cover:
William Rush Carving His
Allegorical Figure of the Schuylkill
River (detail), 1876-77

Design: Laurence Channing
Printing: Lebanon Valley Offset

**Library of Congress Cataloging in Publication
Data**

Sewell, Darrel, 1939-
Thomas Eakins: artist of Philadelphia.
Catalogue of an exhibition.
1. Eakins, Thomas, 1844-1916—Exhibitions.
2. Painters—Pennsylvania-Biography.
3. Philadelphia (Pa.)—Biography. I. Eakins,
Thomas, 1844-1916. II. Philadelphia Museum of
Art. III. Title.
ND237.E15A4 1982 759.13 82-7509
ISBN 0-87633-047-2 AACR2

Contents

It was not difficult for the Philadelphia Museum of Art to find an exhibition to celebrate three hundred years of the history of this city. The painter Thomas Eakins is so quintessentially Philadelphian that an exhibition devoted to his work seemed a natural and even inevitable choice. Neither the Irish immigrant family of his father nor that of his Quaker mother had lived in Philadelphia in its early years. Nevertheless, Eakins, who was born here, worked here his entire life (except for four years of study in Europe), and died here, is very much part of the fabric of the city.

Naturally, Thomas Eakins is a legendary figure at the Pennsylvania Academy of the Fine Arts, where he studied, and then taught intermittently for ten years, and from which he was dismissed in 1886. The Academy was not to buy its first painting by him until 1897. Eakins knew Walt Whitman, a resident of Camden, the New Jersey city that faces Philadelphia across the Delaware River, and Henry O. Tanner, the black painter who had studied with him at the Academy; they were among the many friends he painted. The Schuylkill River, the medical schools at the Jefferson Medical College and the University of Pennsylvania, and the Seminary of Saint Charles Borromeo, among many other places, provided Eakins with local subjects and became part of his Philadelphia legend.

But another, lamentable part of this legend was the public indifference to his work, particularly in his native city. The Philadelphia Museum of Art was no exception; it too showed no interest in the artist during his lifetime. Before he died, only three of his works had changed hands in a manner that had destined them for this Museum. One was a watercolor, *Drawing the Seine,* which he painted in 1882 and gave to the lawyer and collector John G. Johnson in 1887; Johnson did express his appreciation ("It is admirably drawn and composed, full of movement, air and sunlight and charming in color"[1]), but he never bought a work by Eakins for his enormous collection, which came to be housed in the Philadelphia Museum of Art in the 1930s. Eakins's 1892 plaster quarter-scale study in relief of the horse Clinker for the Brooklyn Memorial Arch ended up in the collection of the Samuel S. Fleisher Art Memorial, which is administered by the Philadelphia Museum of Art. About 1895, Eakins painted a portrait of Mrs. Elizabeth Duane Gillespie, who in 1883 had founded the Associate Committee of Women (now the Women's Committee) of the Pennsylvania Museum (now the Philadelphia Museum of Art); in 1901 Eakins gave the painting to the Committee on Instruction of the Museum.

By the time of his death in 1916, the Museum had not yet bought a single work by Thomas Eakins (although it might be exonerated for failing to do so because it was then still primarily a collection of decorative and industrial arts). When a new director, Fiske Kimball, prepared to come to Philadelphia in 1925 he asked the curator of prints at the Metropolitan Museum of Art in New

York for advice and was told, "Go to see the widow Eakins."[2] He did, and bought for himself at the Sesquicentennial exhibition in 1926 *Wrestlers,* which he bequeathed to the Museum. Whether this act was the only reason or not, when Mrs. Eakins was later asked why she and the family friend Mary Adeline Williams decided to give their works to the Museum, she replied, "Other museum directors came and admired the pictures, Mr. Kimball came and bought one."[3] In any case, their gifts in 1929 and 1930 meant that this Museum has the largest single group of Eakins's work.

The generosity of Mrs. Eakins and Miss Williams gave the Museum the core of this exhibition. To that have been added other works, many of them given to the Museum by or through an Eakins and Philadelphia enthusiast, Seymour Adelman. Mr. Adelman also engineered the gift to the City of Eakins's house, which the Museum administers as an art center.

Since so much of the Eakins material that the Museum owns is preparatory or investigatory, Darrel Sewell, the Museum's Curator of American Art, who has organized this exhibition, decided that the emphasis should be on the themes that Eakins explored in paint, on paper, in sculpture, and in photography. In order to explore fully the themes of the exhibition, it was necessary to borrow—sometimes the supreme masterpieces

for which the Museum has only studies, such as *The Gross Clinic,* from the Thomas Jefferson University, sometimes studies for finished works in our own collections, such as the sketches for *Between Rounds* and *An Actress* from the Hirshhorn Museum. The lenders have been extraordinarily generous, for which the Museum and, indeed, the City of Philadelphia are deeply thankful.

Most of the lenders are also sending their works to the Museum of Fine Arts in Boston. The exhibition is going to Boston in return for the 1980 loan to Philadelphia of their paintings by the eighteenth-century Bostonian John Singleton Copley. Philadelphians savored that exhibition of Copley's work, and we hope that Bostonians will similarly admire the art of Thomas Eakins. The arrangements for the exhibition have been made with Jan Fontein, Director of the Museum of Fine Arts, and Theodore Stebbins, its Curator of American Art. Because of the fragility of some of the works, not all can be shown at both institutions. In the same way, other commitments restrict the exhibition of certain paintings: at the request of the Museum of Fine Arts itself, *The Gross Clinic* will not be shown in Boston at this time, but will be included in the exhibition "A New World: American Paintings 1760–1900," which that Museum is organizing in collaboration with the Louvre in Paris.

The IBM Corporation volunteered its support of "Thomas Eakins: Artist of Philadelphia" in Philadelphia and Boston, for which both museums are most grateful. This exhibition takes its place

proudly as one of a series of the most distinguished exhibitions that this corporation has sponsored. In addition, the exhibition's organization and installation in Philadelphia have had the support of The Pew Memorial Trust as part of the continuing contribution it has made to the exhibition program of the Philadelphia Museum of Art. We can never thank the corporation on the one hand, and the foundation on the other, enough for their generosity. They have made our celebration of the work of Thomas Eakins secure.

Behind "Thomas Eakins: Artist of Philadelphia" is the indispensable contribution of Darrel Sewell, who has made the selection and written the catalogue. On the catalogue he has had the indefatigable collaboration of George Marcus, Head of Publications at the Philadelphia Museum of Art. So many others at the Museum of Fine Arts and the Philadelphia Museum of Art have worked on this exhibition that they cannot realistically be mentioned here. It was the ghost of that Philadelphian Thomas Eakins that brought about their joyful collaboration with each other, with the exhibition's sponsors, and with its lenders. We thank them.

Jean Sutherland Boggs
The George D. Widener Director

viii

One measure of Thomas Eakins's popularity today is the frequency with which his works are requested for loan. That museums and private individuals were willing to lend their works—which are much in demand, and which they no doubt feel rest all too seldom upon their own walls—is generous indeed, and we are most grateful to our lenders for making this exhibition possible.

Museum colleagues and scholars have kindly provided information of all kinds relating to Eakins's life and work. I am indebted to Lloyd Goodrich, whose 1933 biography and catalogue remain a touchstone for Eakins scholarship, and to Julie Berkowitz, Helen Cooper, William Innes Homer, John K. Howat, Elizabeth Johns, Dale Johnson, Margaretta K. Lovell, Mary L. Meyers, Milo M. Naeve, Phyllis D. Rosenzweig, Nicki Thiras, Carol Troyen, and Evan H. Turner for their interest and help.

Seymour Adelman and Mr. and Mrs. Daniel W. Dietrich II deserve particular thanks. Not only have they been completely generous in sharing their knowledge and making their collections available for study, their enthusiasm for Thomas Eakins as a man and an artist has been a constant source of inspiration and support. Peggy Macdowell

Thomas and Mr. and Mrs. John R. Garrett could not have been more hospitable and informative while allowing me to study the fascinating group of works by Thomas Eakins, Susan Macdowell Eakins, and Elizabeth Macdowell Kenton that remain in the Macdowell family.

Many members of the Museum staff have been at work to realize this exhibition, and I appreciate the time, skill, and knowledge that they have devoted to it. Since a large proportion of the exhibition has been drawn from the Museum's own collection, great demands have been made upon the Conservation Department. Marigene H. Butler, Head Conservator, and Andrew Lins, Decorative Arts Conservator, assisted by Albert Albano, Susan Schussler, Mark Tucker, Laurence A. Pace, Mervin J. Richard, and Denise Thomas examined each of the paintings, sculptures, and works on paper that were considered for exhibition and have carried out at least minor treatment of each of the sixty-nine objects selected. In addition, Mrs. Butler and Messrs. Pace, Richard, Tucker, and Robert G. Lodge have carried out major treatments on five paintings to make it possible for them to travel. Joseph Mikuliak has attended to all the details of framing adjustments, and Robert W. Anderson has strengthened many frames and built new ones for travel.

In the Registrar's Office, Judith Brodie has resourcefully coordinated innumerable details of

transportation and insurance. Timothy Farley and Hal Jones, with their usual ingenuity, have devised economical new ways to pack Eakins's works.

In the Department of American Art, Constance Kimmerle did useful research of all kinds for the exhibition, and Wendy Christie handled all the correspondence and cheerfully carried out the many administrative details related to it. To prepare this catalogue, Susanna D. Roberts performed heroic feats of typing, with assistance from Kimberly Parsons.

Finally, I must express my great debt to the late Theodor Siegl, who had a rare understanding of Thomas Eakins's intelligence, his sensibility, and his methods. Fortunately, the manuscript for Mr. Siegl's handbook to the Thomas Eakins Collection was completed before his untimely death in 1976. His work, and the memory of my conversations with him, have formed this exhibition.

D.S.

Lenders to the Exhibition

Addison Gallery of American Art, Phillips Academy, Andover, Massachusetts

Seymour Adelman

The Art Institute of Chicago

The Art Museum, Princeton University

The Brooklyn Museum, New York

The Butler Institute of American Art, Youngstown, Ohio

Cincinnati Art Museum

The Cleveland Museum of Art

Mrs. Rodolphe Meyer de Schauensee

Mr. and Mrs. Daniel W. Dietrich II

The Fine Arts Museums of San Francisco

The Fort Worth Art Museum

Mrs. John Randolph Garrett, Sr.

Hirshhorn Museum and Sculpture Garden, Smithsonian Institution, Washington, D.C.

Honolulu Academy of Arts

The Hyde Collection, Glens Falls, New York

Jefferson Medical College, Thomas Jefferson University, Philadelphia

John G. Johnson Collection, Philadelphia

John Medveckis

Douglas W. Mellor

Memorial Art Gallery of the University of Rochester

The Metropolitan Museum of Art, New York

Misericordia Hospital, Philadelphia

Museum of Art, Rhode Island School of Design, Providence

Museum of Fine Arts, Boston

National Academy of Design, New York

Nelson Gallery–Atkins Museum, Kansas City, Missouri

Olympia Galleries Limited, Philadelphia

The Pennsylvania Academy of the Fine Arts, Philadelphia

Philadelphia Museum of Art

Randolph-Macon Woman's College Art Gallery, Lynchburg, Virginia

Reynolda House Inc., Winston-Salem, North Carolina

San Diego Museum of Art

Smith College Museum of Art, Northampton, Massachusetts

Peggy Macdowell Thomas

University of Pennsylvania, Philadelphia

Mrs. John Hay Whitney

Worcester Art Museum

Mr. and Mrs. Harrison M. Wright

Andrew Wyeth

Yale University Art Gallery, New Haven

Thomas Eakins was born in Philadelphia July 25, 1844, and with the exception of four years of study in Paris, he made the city his home for the rest of his life. At Central High School, which he entered in 1857, Eakins was generally a good student, achieving high marks in mathematics, science, and languages, especially French, which would serve him well during his years in Paris. The drawing curriculum at the school continued the direction of the early instruction he received from his father Benjamin, a writing master. His grades in drawing were perfect for each of his four years at the school, and his mastery of the subject was such that a year after his graduation in 1861, he competed for the position of professor of drawing, writing, and bookkeeping there, although he lost to Joseph Boggs Beale.

The few drawings that remain from Eakins's grade-school and high-school years show his command of drawing skills as they were then taught, but it is remarkable that none shows any spontaneous artistic expression. Eakins's father, and Eakins himself, had friends who were artists, and certainly examples of other kinds of art were available in Philadelphia to a young man interested in being an artist. The diary of Joseph Boggs Beale,[1] who was Eakins's exact contemporary and also a student at Central High School, reveals an enterprising, aspiring artist making use of every opportunity that the city offered—visits to the studios of established artists, exhibitions at the Pennsylvania Academy of the Fine Arts, self-instruction through the study of books on drawing and painting, excursions with friends to sketch and paint in the countryside around Philadelphia—and receiving the public recognition given to a talented young student.

In October 1862 Eakins registered at the Pennsylvania Academy of the Fine Arts for the first time, entering the antique class to draw from casts of ancient Greek and Roman sculpture, and attending anatomy lectures. He continued to work at the Academy during the next four years, and registered to observe demonstrations in anatomy and surgery at Jefferson Medical College as well. In the studios of the Academy, Eakins found an atmosphere quite different from that of Central High School. Instead of systematic instruction in drawing according to a prescribed set of rules, the Academy offered only casts of sculpture and space for the students to work, with no instruction beyond what could be learned from more experienced students. Eakins was confronted with the figure to be drawn, without any intervening system for observing

or rendering it. The two contrasting disciplines—the supervised and prescribed courses at Central High School and the unsupervised, self-motivated requirements of work at the Academy—were both formative in establishing Eakins's work habits in the years to come. Having come to the Academy as a sophisticated draftsman of one kind, Eakins was forced to begin again in his studies of the figure.

Eakins was determined to become a professional artist, and in September 1866 he sailed for Paris, where he was accepted as a student at the Ecole des Beaux-Arts. Eakins elected to work in the studio of Jean-Léon Gérôme, at that time an established artist twenty years Eakins's senior, who three years earlier had been elected as a professor of painting at the Ecole. In contrast to the scarcity of information about Eakins's youth in Philadelphia, a series of candid and articulate letters that he wrote from Paris to members of his family documents his life and his struggles as he was learning to be an artist. From these letters, Eakins emerges as the independent and serious character that is associated with his later life. His letters to his father also show the intimacy and frankness that existed between the two men until the end of Benjamin Eakins's life.

In Paris, Eakins remained almost aggressively himself, ostentatiously unimpressed by the sophistication and stylishness of the city, although he enjoyed his life in Paris. Two anecdotes describe Eakins as he appeared then, one written by his sister Frances, who with their father, visited Paris in 1868:

Yesterday morning we went to his studio. He had not yet finished any of his paintings (that is lady's work, he says) and of course they are rough looking, but they are very strong and all the positions are fine and the drawing good. He thinks he understands something of color now, but says it was very discouraging at first, it was so hard to grasp.

He has changed very little, he's just the same old Tom he used to be, and just as careless looking. His best hat (I don't know what his common one can be) is a great big gray felt steeple, look's like an ashman's; his best coat is a brown sack, and his best pantaloons are light, with the

biggest grease spot on them you ever saw. And then he most always wears a colored shirt. But he's the finest looking fellow I've seen since I left Philadelphia. We told him he was a little careless looking and he evinced the greatest surprise. "Good gracious," he said, "why I fixed up on purpose to see you, you ought to see me other days." You ought to see him bow; imagine Tom making a French bow. But I tell you he does it like a native.[2]

Years later his friend William Sartain recalled a day with Eakins in Paris:

I should have mentioned another companion of Tom's—Germain Bonheur. From this acquaintance we were invited to his parent's home. His sister Rosa Bonheur was there on a visit from her home in Fontainebleau and as she sat at the table she strikingly resembled Henry C. Carey the political economist of Philadelphia. Below she wore skirts but her upper attire resembled that of a man. She was very bossy and dictatorial, with the family, and when Germain differed from her on any point she would tell him to go to bed! Tom was speaking of our national mechanical skill and to illustrate his point he pulled out from his pocket his Smith & Wesson revolver. (I know of no other person in Paris who carried one!) Rosa put her hand into her pocket and pulled out one of the same make. She acquired the habit of carrying it during her sketching at Fontainebleau.[3]

Eakins took his work and life as a student very seriously and devoted his time to what he would later call learning the tools of his art. He was unusual among the young Americans who went to Paris during these years in that he did not rush to complete a picture or sculpture to exhibit in the Salons, as, for example, did his Philadelphia contemporaries Howard Roberts and Mary Cassatt. He devoted himself to painting academic studies of the nude figure in the studios of the Ecole, studied anatomy in a nearby medical school, and worked in his own room on composition studies. At some time during his years in Paris, he also studied briefly in the studio of the sculptor Augustin-Alexandre Dumont, and shortly before his departure from Paris, he worked under the painter Léon Bonnat in August and September of 1869.

Eakins's assessment of his progress as an art student was based upon personal standards and not upon comparison with the work of the other artists he saw around him. A few years later, Gérôme indicated that while he had considered Eakins a promising student, he was by no means a tractable or fully accomplished artist when he left Paris.[4] In November 1869, considering that he had learned all he could at the Ecole, Eakins left for Spain.

He traveled to Madrid and then on to Seville, where he started to work, describing in his letters home the problems he encountered in making his first painting, *A Street Scene in Seville*.[5] In June he returned briefly to Paris and then sailed for the United States, arriving in Philadelphia by July 4, 1870.

When Eakins returned to the United States to begin his artistic career after four years of study in Paris, he did not strike out on his own and move to New York—by then the center of American artistic activity and especially of the newer trends in art—nor did he establish a separate studio for his work. Instead of continuing the mildly Bohemian life he had led in Paris and conforming to the fashionable conceptions about an artist's life, he seems to have resumed the course of his daily activities much as it had been before he left Philadelphia. This may have been in deference to his mother's wishes during her long illness, but it also indicates that

Eakins considered art as one of the professions. He behaved like a young professional man—a doctor or a lawyer, for example—who while building his career, lived at home until he could set up his own household. That his family was willing to accommodate a working artist in that sober household is perhaps an indication that they found Eakins unchanged by his experience in Paris and agreed with his assumption that being an artist did not mean being a different kind of person. They must have shared his goals and respected his ideas. For Eakins, the intrusion of his sitters and friends into the quiet life of his family was less jarring than it would have been for an artist who painted different kinds of pictures. The subjects of Eakins's art, especially during the early years of his career, were family members and friends already familiar to the household.

In the years between 1870 and the Centennial celebration of 1876, Eakins established himself as an artist, working on a growing variety of subject pictures, and frequently in the newly popular medium of watercolor. He exhibited widely in the United States,

and in 1874 and 1875 sent works for exhibition in Paris. In the same years he began to gain a reputation as a teacher. He and Howard Roberts advised on the design of the classrooms in the Pennsylvania Academy of the Fine Arts building then being constructed, and in 1874 members of the Philadelphia Sketch Club invited him to conduct an evening life class, where, as his friend Earl Shinn recalled,[6] he quickly earned a reputation as an inspiring teacher.

The Centennial exhibition of 1876 provided an opportunity for Eakins to survey for the public his paintings of the past five years, in the five works that he exhibited in the art galleries and in the controversial painting of Dr. Gross [33], which was rejected by the painting jury of the Centennial but shown in an elaborate installation in the United States Army Post Hospital exhibit.

When the new building of the Pennsylvania Academy of the Fine Arts opened and classes resumed in 1876, Eakins worked as an unpaid assistant to Christian Schussele and as chief demonstrator of anatomy in the lectures and demonstrations of Dr. William Williams Keen. After Schussele's death in August 1879, Eakins was named professor of drawing and painting at the Academy. Eakins's plans for the curriculum in the Academy's schools are well documented in his own manuscript in the Academy archives, and in three, varied contemporary sources: a description of the program written by Fairman Rogers, chairman of the Committee on Instruction of the Academy, which appeared in the *Penn Monthly* in 1881; an article in *Scribner's Monthly* by William C. Brownell, which was published in September 1879 before Eakins actually assumed control at the Academy; and a short history of the Academy school written some years later by Earl Shinn.[7]

Even before Eakins had assumed his duties at the Academy, Brownell had noticed his influence upon the schools, and had described his approach to teaching as "radical," opposed to the conservative approach of Schussele. In fact, Eakins's innovations in the curriculum did not consist of entirely new approaches but rather the modification of the existing academic program in accord with his own experiences as a student. He de-emphasized extended study of drawing from antique sculpture and emphasized immediate painting from the nude model, an intensive study of dissection, and the use of sculpture as an aid to understanding form.

The philosophy of teaching that Eakins instituted was based on the atelier system he had known in Paris. As Fairman Rogers explained, the Academy did not intend to provide systematic instruction in art but to make facilities available so that the student would have the opportunity to have training in such areas as the living model, dissection, and sculpture. Rogers reiterated Eakins's point that classes were to be informal, with occasional criticism given by the instructor, and that the facilities of and program at the Academy were intended for the serious professional artist. His emphasis on the fact that this period of a student's work was "steady grinding" labor[8] was clearly intended to illustrate the seriousness of purpose and the dedication required of students in the school.

Although, from the beginning, Eakins was recognized as a dedicated and inspiring teacher, his methods were controversial. In the 1879 article, Brownell wrote admiringly of the Academy program, but raised questions about the appropriateness of the form of study required by Eakins and pointed out flaws he saw in the

course at the Academy. He especially questioned the study of dissection in the rigorous form that Eakins required, and was skeptical of the aesthetic benefits of what was clearly a grisly and unpleasant occupation; he also raised the issue of aesthetic philosophy.

While Eakins's emphasis on the study of the nude figure was not an unusual part of an academic curriculum, the presence of both male and female students at the Academy as well as Eakins's insistence that the women follow a course of study identical to that of the men—including life-study classes from both nude male and female models—was a constant source of tension, as a letter from an irate but articulate mother in 1882 made clear. Writing to James Claghorn, the Academy president, she defined her objections quite clearly:

Would you be willing to take a young daughter of your own, into the Academy Life Class, to the study of the nude figure of a woman, whom you would shudder to have sit in your parlor clothed & converse with your daughter? Would you be willing to sit there with your daughter, or know she was sitting there with a dozen others, studying a nude figure, while the Professor walked around criticising that nudity, as to her roundness in this part, & swell of

the muscles in another? That daughter at home had been shielded from every thought that might lead her young mind from the most rigid chastity. Her mother had never allowed her to see her young naked brothers, hardly her sisters after their babyhood & yet at the age of eighteen, or nineteen, for the culture of high Art, she had entered a class where both male & female figures stood before her in their horrid nakedness. . . .

. . . Why then is often so much looseness of morals among the young men? To them anything so effective in awakening licentiousness as this daily & nightly study of woman's nudity! . . .

Now Mr. Claghorn, does this pay? Does it pay, for a young lady of a refined, godly household to be urged as the only way of obtaining a knowledge of true art, to enter a class where every feeling of maidenly delicacy is violated, where she becomes so hardened to indelicate sights & words, so familiar with the persons of degraded women & the

sight of nude males, that no possible art can restore her lost treasure of chaste & delicate thoughts? There is no use in saying that she must look upon the study as she would that of a wooden figure! That is an utter impossibility. Living moving flesh & blood, is not, & cannot be studied thus. The stifling heat of the room, adds to the excitement, & what might be a cool unimpassioned study in a room at 35°, at 85° or even higher is dreadful.

Then with all this dreadful exposure of body & mind not one in a dozen could make a respectable draped figure. Spending two years in life study of flesh color, that a decent artist would never need, & then have to begin over again for the draped figure. Where is the elevating enobling influence of the beautiful art of painting in these studies? The study of the beautiful in landscape & draped figures, & the exquisitely beautiful in the flowers that the Heavenly Father has decked & beautified the world with, is ignored, sneered at, & that only made the grand object of the Ambition of the student of Art, that carries unholy thought with it, that the Heavenly Father himself covers from the sight of his fallen children.[9]

An example of Eakins's disregard for the conventional morality of the day—the removal of the loincloth from a male model in a women's life class—is traditionally cited as the reason for his dismissal from the Academy in 1886. Concern

for the morality of the students was undoubtedly a factor, but the mother's question, "Does this pay?," was surely of more than rhetorical significance to the Board of Directors. In 1882 the Directors had adopted a policy of charging tuition fees for study at the Academy, and in their concern to make the Academy classes self-supporting, they were, without a doubt, interested in making the program as generally appealing as possible.

The mother's additional question, "Where is the elevating enobling influence of the beautiful art of painting in these studies?," echoes the objections that Brownell had made three years earlier. Although Fairman Rogers in his 1881 article had emphasized that the program at the Academy was deliberately restricted in order to focus the students' attention upon the essentials of study, as well as pointing out the limited means of the Academy, and that picture making and the history of art were best learned outside the program, disagreements over questions of teaching method and of aesthetics by both the board and the older students were further causes for dissatisfaction with Eakins as

head of the school. A confusion of morality and aesthetics, which can be seen in the vicious attack that some of Eakins's students, members of the Sketch Club, mounted upon his personal reputation, was probably the final provocation for the Board of Directors to demand Eakins's resignation in February 1886.

Eakins's firing received considerable coverage and discussion in the local press and attention in national art publications. A group of his students signed a petition to protest his forced resignation, and by the end of February some forty of them had formed the Art Students' League in Philadelphia, where Eakins taught without pay until 1892. Dismissal from the Academy came as a great blow to Eakins, and he virtually stopped painting for more than a year afterward—until he was restored from a bout of depression by a trip to the Bad Lands of the Dakotas in the summer of 1887.

During his years at the Academy, Eakins had also begun to teach outside of the city, making weekly trips to New York beginning in 1882 to teach at the Students' Guild of the Brooklyn Art Association, and beginning in 1885, at the Art Students' League. He lectured on anatomy at the National Academy of Design from 1888 to 1895 and at the Cooper Union from 1890 to 1897.

He began a series of anatomy lectures at Drexel Institute in Philadelphia in February 1895, but again the use of the nude model in a class of male and female students caused his dismissal the next month.

Eakins's career as an artist had continued to grow during his years at the Academy; he exhibited widely, and by 1886 was a figure of considerable prominence in American art. His paintings were often singled out for discussion, but his work was never popular with collectors or critics. Although he had some admirers and received some favorable reviews, the realistic but harsh appraisal in 1881 of his old acquaintance and early supporter Earl Shinn is typical enough of public opinion:

"Starting out after Rail" [26] is a pale blue picture, the water in front patterned with reflections so as to make it a most illusory piece of crystal. Without any labor-saving ideas of brush-work or texture, without felicity of touch, but rather

xvi

by a kind of brutal exactitude which holds in a vise-grip the scientific facts of wave-shape and wave-mirroring, Eakins has arrived at a representation of flat water reflecting boat and sky which borders on the miraculous; the figures are sincere and professional, of course—an old boatman stooping to look under the boom, and an experienced, close-shaven, simpleminded sportsman, the reverse of all that is amateurish, theatrical, or rigged out in costume for effect. "Biglin Brothers Practising" [17] is an oil painting with a strong effect of late golden light playing around the knotted muscles of the oarsmen. "Base-ball Playing" [28] contains two perfectly-studied attitudes, so workmanlike as to be an authority in the game, and so crisply modelled in their envelope of close white suits as to suggest silver statuettes. The exact uncompromising, hard, analytic style of Eakins is shown in all these contributions: the spectator's approval is not solicited, but extorted; one thinks of a scientific mind that has made the mistake of taking up art, and wonders whether any better career could have offered itself than the present one of successful instruction. After all, though Eakins is a character of whom one

sees most conspicuously the shortcomings and the want of charm, we must do him the justice to say that he is the only one of all the French pupils who has come home and improved on himself instead of retrograding.[10]

In the 1880s, grudging respect for Eakins's work was gradually eroded, and although he continued to exhibit, his work was generally ignored. His bitterness about his rejection as a teacher and an artist is apparent in his statement from a letter of 1894:

My honors are misunderstanding, persecution & neglect, enhanced because unsought.[11]

During these years, Eakins received support and encouragement from his wife, Susan Macdowell, whom he had married in 1884. The daughter of William H. Macdowell, a well-known Philadelphia engraver and a liberalist of independent and progressive views who had encouraged his daughter's interest in art, she had been a student at the Academy from 1876 to 1882, and had won recognition for her talent as a painter. Eakins also was fortunate in the friendship of the sculptor Samuel Murray, who came to the Art Students' League as a student in 1887 and who was a friend and companion of Eakins until the end of his life.

After 1886 Eakins abandoned subject pictures almost completely, and concentrated his attention upon a series of portraits that would occupy him for the rest of his

career. In the 1890s he began to win some of the public recognition that previously had eluded him. He sent ten paintings to the art exhibitions of the World's Columbian Exposition in Chicago in 1893, where he was awarded a bronze medal, and the following years brought a modest but steady series of prizes and invitations to serve on exhibition juries. In the portraits, Eakins's contemporaries found an acceptable expression of his independence of thought and talent as an artist, which they had not seen in his subject pictures, and artists of a younger generation, such as Robert Henri, found in them an honesty and directness of vision that were in accord with their own interests.

Eakins's career as an artist was effectively ended in 1910 with advancing ill health, but the sense of his importance as a figure in American art continued to grow, and the memorial exhibitions of his work held at the Metropolitan Museum of Art in New York and the Pennsylvania Academy of the Fine Arts in 1917, the year after his death, consolidated his reputation as one of America's greatest artists.

Catalogue of the Exhibition

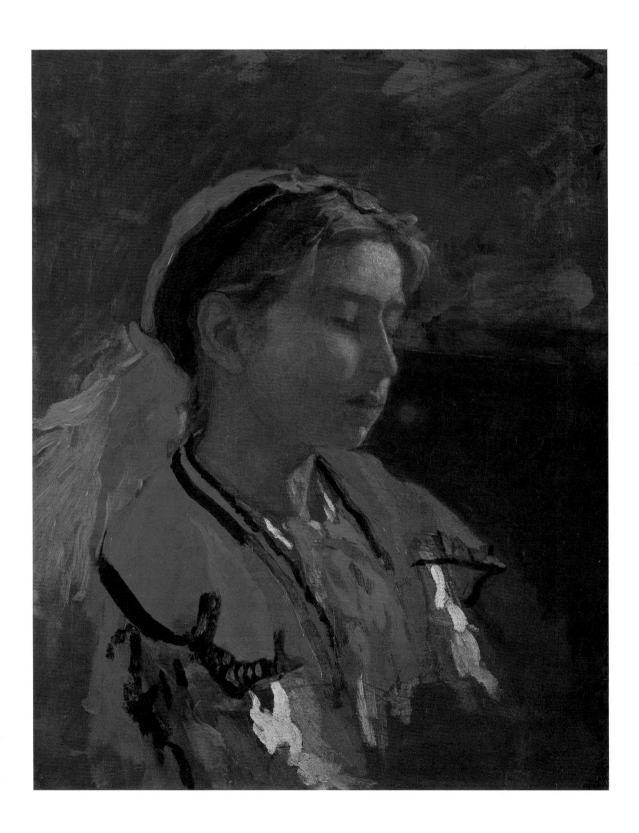

I. Student Work

1. Carmelita Requena
Goodrich 32
1869–70
Oil on canvas
21 1/16 x 17 1/8″ (53.5 x 43.5 cm)
The Metropolitan Museum of Art, New York.
Bequest of Mary C. Fosburgh

Thomas Eakins's first lessons in art were directed to drawing as a useful discipline. Even before he attended grammar school, his father Benjamin Eakins, a writing master, taught him the elements of the fine penmanship and ornamental calligraphy that he used in his own profession. His early ability to draw neatly and accurately, to letter in a variety of ornamental styles, and to embellish his work with the calligrapher's ornamental scrolls is revealed in two maps that he drew while a student at the Zane Street Grammar School.[1] At Central High School, drawing was an integral part of the rigorous curriculum, following Horace Mann's principle:

There is no department of business or condition in life, where the accomplishment [of drawing] would not be of utility. Every man should be able to plot a field, to sketch a road or a river, to draw the outlines of a simple machine, a piece of household furniture, or a farming utensil, and to delineate the internal arrangement or construction of a house.[2]

For three to four hours a week during each school year, students devoted themselves to a systematic program of increasingly difficult drawing exercises presented in texts such as Rembrandt Peale's *Graphics* (first published 1834), intended to teach them to write a fine hand, to represent objects by analyzing them as composites of geometric shapes, and to make mechanical and perspective drawings.

A drawing of a lathe belonging to his father [2], made when Eakins was in his last year at Central High School, indicates why he received perfect marks in his drawing classes. Undoubtedly a class exercise, it shows Eakins's mastery of the complicated problem of setting a three-dimensional object in perspective. In the lower left-hand corner, Eakins noted measurements for the perspective framework of the drawing, which would allow anyone who understood the perspective system to verify its accuracy by measuring the drawing and testing the results as one would verify a scientific experiment. The circles and compound curves of the machinery present a difficult problem in perspective, and the sureness with which the lathe is drawn reveals Eakins's sophistication as a draftsman. In addition to the precise reproduction of the measured shape, Eakins was probably assigned the additional problem of drawing the complex shadows cast by a light coming from above the lathe and to the left, shown by the strong highlights reflected off the drive wheel. Eakins carried the illusionistic effect even further by carefully imitating the wood grain of the top of the lathe and treadle, and by differentiating the kinds of metals within the mechanism. He completed the drawing as a presentation piece by adding a caption in accomplished lettering at top.

This drawing is to be judged by its precision, accuracy, and meticulous attention to detail. It embodies the exercise of mental and manual skill and the earnest pursuit of excellence that was the goal of the course. The perfection of Eakins's drawing within the accepted standards of Central High School suggests why he had the self-confidence to apply there for the position of professor of drawing and writing one year after his graduation in 1861.

When Eakins entered the antique class at the Pennsylvania Academy of the Fine Arts in October 1862 and especially when he was admitted to the life class in February 1863, it must have become apparent to him that the problems of drawing and rendering form that confronted the professional artist required techniques of drawing different from those he had learned from his father and in high school. The initial stage in an artist's education at the Academy was the repetitive practice of drawing, first from casts of antique sculpture and then from nude models in life classes. Eakins had little interest in this phase of his training, and very few of his academic drawings remain. Because of their scarcity, it is difficult to establish the course of his development as an artist during these early years. The drawings of a seated nude man [4] and a nude woman wearing a mask [5] are the sort that would have been required of Eakins in these classes. The image of the masked woman is Eakins's most famous drawing, often cited as an example of his approach to the study of the nude as an objectively observed,

unidealized form—and also as evidence of the prudery at the Academy, where until the early 1880s models often posed in masks to conceal their identities. If the drawing had been made at the Academy before Eakins went to Europe in the fall of 1866, as had been assumed,[3] it would indicate that Eakins progressed rapidly. The technique is remarkably mature for a young student, and quite independent of the more traditional method of defining form, first with outlines and then with a series of hatchings, that was practiced by such established artists as Christian Schussele, who was put in charge of the classes at the Academy in 1868.[4] With a sureness that suggests practiced observation, and with remarkable selectivity for a young artist, Eakins concentrated upon the model's torso, studying the large masses and anatomical balance of the figure but indicating the less essential parts only summarily. The drawing technique, too, is fully developed and expert; the figure is modeled in strong contrasts of light and dark created by rubbing in, and erasing, areas of charcoal with a drawing stump, and then by rendering the skin of the figure with delicate strokes. In all, the drawing shows a command of what Eakins later called the "grand construction" of the figure, and the ironic

emphasis upon the contrast between the explicitly rendered body and the anonymity of the face goes beyond mere observation.

It had also been suggested that the masked nude was drawn by Eakins at the Ecole des Beaux-Arts in Paris.[5] If so, it would be further evidence of Eakins's insistence on working in his own direction, for in comparison with the sophisticated figure studies produced by advanced students in the life classes at the Ecole, in which technique was itself refined as part of the drawing, the masked figure appears crude in spite of its forcefulness. The drawing of the seated man is a less dramatic treatment of the subject, but the economy with which his hands are modeled shows the same disregard for technique for its own sake characteristic of Eakins only some years after his return to America. For this reason, Theodor Siegl dated these drawings 1874–76, from the period after the artist's return from Europe.[6] Although he did not continue figure drawing on his own in Philadelphia, Eakins was asked by members of the Philadelphia Sketch Club to conduct a life class in 1874, and Siegl proposed that Eakins made these drawings in the class while the students were working.

As a student in Paris, Eakins avoided the drawing classes as much as he could, and felt that he began to study art seriously only when he could paint his studies in oil instead of drawing them in charcoal. After five months of drawing in the studios of the Ecole des Beaux-Arts, Eakins was allowed to paint sketches of the figure in the atelier of Jean-Léon Gérôme. His letters to his father

speak of his struggles with the new medium and his difficulties in defining form with color instead of black and white:

Sometimes in my spasmodic efforts to get my tones of color, the paint got thick, and he [Gérôme] would tell me that it was the thickness of the paint that was hindering me from delicate modelling or delicate changes. How I suffered in my doubtings, and I would change again, make a fine drawing and rub weak sickly color on it, and if my comrades or my teacher told me it was better, it almost drove me crazy, and again I would go back to my old instinct and make frightful work again.[7]

Of the many such painted studies that Eakins must have made during his years in Paris, few remain. The painting of a male model leaning on a staff, called *The Strong Man* [3], is the most accomplished of them; the model, seen from the side with his head turned away, presents a challenging view of the foreshortened figure. It is confidently painted with individual strokes surely placed to render form, without additions or reworking. Its rough paint texture adds to the illusion of volume and solidity, and its rich variety of colors in the tone of the flesh indicates experience both in observing the effect of light on the model and in translating these observations into color. The assurance with which the study is painted suggests that it was executed toward the end of Eakins's work in France, when he told his father:

I know perfectly what I am doing and can run my modelling, without polishing or hiding or sneaking it away to the end.[8]

In November 1869, after Eakins wrote to his father that he had learned what he had hoped to learn about being an artist by coming to France, he went to Spain. He stopped first in Madrid, where he studied the paintings by Velázquez in the Prado, and then moved on to settle in Seville, where he began his "regular work,"[9] considering the distinction between the life and work of a student and that of a professional artist as the execution of full compositions. Eakins set up his easel on the roof of his hotel in Seville and began what he called "the most difficult kind of a picture"—a composition in full sunlight.[10] He hired as his models a family of itinerant street performers. Perhaps as a pre-liminary study for the painting, called *A Street Scene in Seville*,[11] he sketched the young daughter of the family, Carmelita Requena [1]. At Christmas 1869, Eakins de-scribed his model to his little sister Caroline, who was about the same age:

Some candy given me, I ate a little and then gave the rest to a dear little girl, Carmalita, whom I am painting.... She is only seven years old and has to dance in the street every day. But she likes better to stand still and be painted. She looks down at a little card on the floor so as to keep her head still and in the right place, and when we give her the goodies she eats some and puts the nicest ones down on the card so she would be looking at them all the time while she poses.[12]

The technique of the sketch is similar to that of *The Strong Man* but its greater freedom perhaps reflects Eakins's study with Léon Bonnat the previous summer. It takes advantage of the contrast of bright highlights and strong shadows of the figure seen in full sun, as opposed to the delicately modulated flesh tones of a model studied in the filtered light of a Parisian atelier. Even more, Eakins seems to have relished the vibrant colors of Carmelita's costume, which he rendered in bold areas of pure color, reflecting his exhilaration with the brilliant hues and bright sunshine of Spain. The completion of the finished painting, on which the artist worked for more than three months, presented Eakins with many more difficulties than he had expected, as he related to his father:

Picture-making is new to me; there is the sun and gay colors and a hundred things you never see in a studio light, and ever so many botherations that no one out of the trade could ever guess at.[13]

2. Drawing of a Lathe
1860
Pen, ink, and watercolor on paper
16⁵⁄₁₆ x 22″ (41.4 x 55.9 cm)
Hirshhorn Museum and Sculpture Garden,
Smithsonian Institution, Washington, D.C.

3. Study of a Nude Man (The Strong Man)
Goodrich 26
c. 1869
Oil on canvas
21½ x 17⅝″ (54.6 x 44.8 cm)
Philadelphia Museum of Art. Gift of Mrs.
Thomas Eakins and Miss Mary Adeline Williams

4. Study of a Seated Nude Man
Goodrich 4
1874–76
Charcoal on paper
24⁵⁄₁₆ x 18½″ (61.8 x 47 cm)
Philadelphia Museum of Art. Gift of Mrs.
Thomas Eakins and Miss Mary Adeline Williams

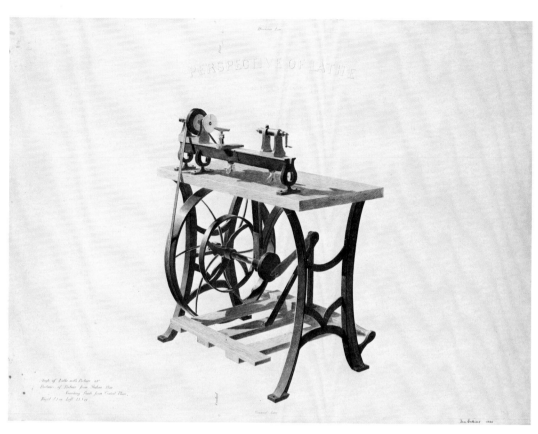

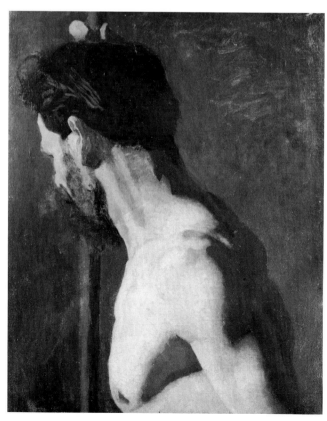

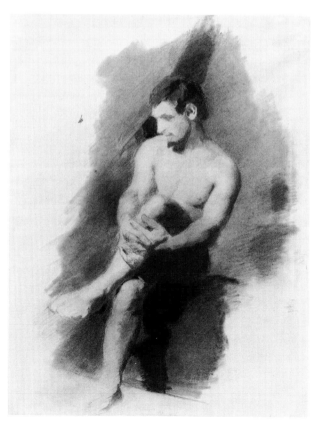

5. Study of a Seated Nude Woman Wearing a Mask
Goodrich 1
1874–76
Charcoal on paper
24¼ x 18⅝″ (61.6 x 47.3 cm)
Philadelphia Museum of Art. Gift of Mrs.
Thomas Eakins and Miss Mary Adeline Williams

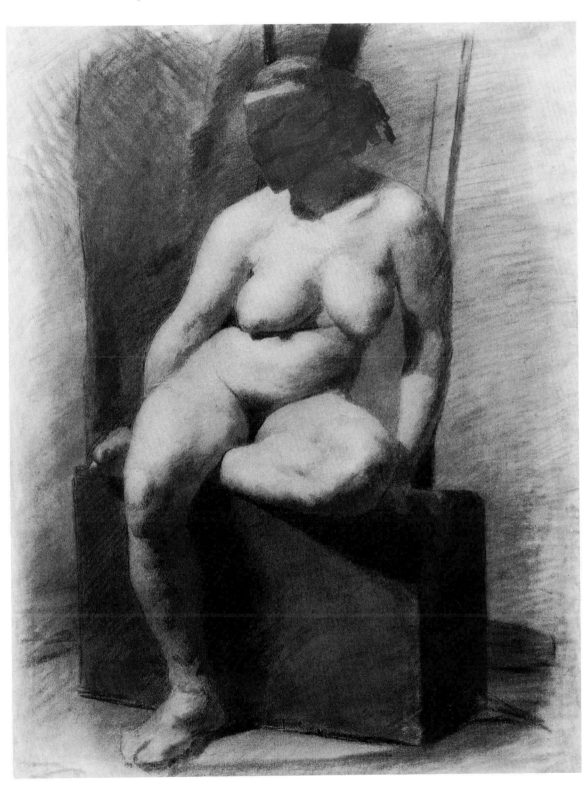

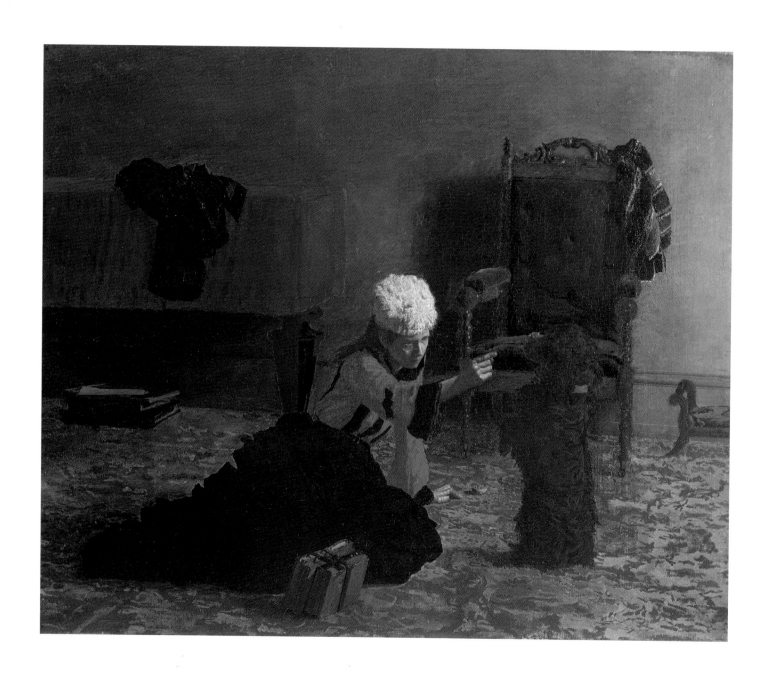

II. Early Portraits at Home

6. Elizabeth Crowell with a Dog
Goodrich 46
1874
Oil on canvas
14 x 17¼" (35.6 x 43.8 cm)
San Diego Museum of Art. Purchased by the
Fine Arts Society

When Eakins returned home from Europe in July 1870, he chose as his models his family and his friends. His sisters and those of William Crowell, who would marry Eakins's older sister Frances in 1872, were ready models for his painting. Perhaps Eakins made these early portraits of women in the Eakins house merely as studies—learning exercises not at first intended for exhibition—but in them may be found the sympathy and interest in character that would appear throughout his work. Eakins's paintings of these young women are remarkable for their avoidance of conventional sentiment and the absence of standard ideas of female beauty. Their voluminous clothing is studied as complex arrangements of often colorful form, not to create a stylish personality. In the shadowy interiors of the Eakins parlor, the bright clothing and richly patterned carpet stand out as notes of pure color.

Considered simply as studies, these paintings show Eakins's growth as an artist during the six years after his return to America. Comparison of the small, very simple painting of his sister Frances at the piano, done soon after his sojourn in Europe [9], with the large painting of Elizabeth Crowell at the piano, painted in 1875 [11], shows the growth in compositional ability and the control of color and technique that Eakins had achieved. The profile view of Frances is plainly conceived, with light falling on the figure from behind and the background unadorned. Some damage to the painting over the years makes it impossible to judge the technical finish of the completed work, but the folds of Frances's white summer dress and the bow of her scarlet sash show the artist's careful study. In the portrait of Elizabeth painted about five years later, the study of light and the tonality of the painting are more subtle, the composition assured and complex, resulting in one of Eakins's most romantic works. This was one of the artist's favorite paintings; he exhibited it at the Centennial and it always hung over the fireplace in his parlor.[1]

In the painting of his sister Margaret and their youngest sister Caroline entitled *Home Scene* [10], from about 1871, a certain amount of contrivance underlies the composition. The orange seems to have been placed on the piano simply to show double reflections, while Margaret's pose seems forced as she leans on the back of her hand, rests her elbow on the music rack, and reaches to play with the kitten crawling over her shoulder. The contrast between the studied artificiality of Margaret's pose and the unselfconscious angularity of her little sister, however, characterizes the psychological contrast between a young girl and a mature woman—the contrast further emphasized by differences in their dress and by Margaret's inscrutable expression as she contemplates her sister.

In the portrait called *Elizabeth Crowell with a Dog* [6], painted about three years later than *Home Scene*, Eakins again used the pose of a young girl seated on the floor, this time, however, to convey the effect of an instantaneous view. He captured the intensity and spontaneity of an adolescent girl in the angularity of her figure as she makes her pet dog balance a biscuit on his nose. It is as though throughout the day she had been preoccupied with the moment when she would fling aside her schoolbooks and play with her pet. The painting is affectionate and perceptive without being sentimental. Although it contains the elements of a charming genre scene, the care with which each aspect is studied gives it an intensity of specific emotion and character that is quite different from the stock emotions usual in genre paintings.

In the portrait of Margaret in skating costume, painted about 1871 [8], these same qualities can be seen. The early date of the painting is obvious in the labor that Eakins devoted to the technical problems of representing the figure in the oil medium, apparent in the thick, uneven painted surface but not in its presentation or conception of personality, which is like his later portraits. The figure, seen against a plain background, is brought close up to the picture plane, and the subject looks away from the viewer, staring into space, the individuality of her features suggesting prolonged, careful observation. The soft, thick folds of Margaret's corduroy jacket are studied with the same care, and the profound abstraction of her expression contrasts with her casual attire in a way that empha-

sizes her mood. Instead of bringing clothing and expression together into one coherent effect, Eakins opposed them, using the disparity to emphasize the introspection and isolation of his sitter.

In the final painting of this series, *Baby at Play* [7], Ella Crowell, the first child of Eakins's sister Frances and William Crowell (who were living at the Eakins house on Mount Vernon Street when this painting was made), is shown playing in the sunlit backyard. The most striking aspect of this work is its scale, for Eakins painted the child at full length, giving her the physical presence of an adult sitter. Like the paintings of young women, this is not a generalized depiction of childhood nor does it have the sentimentality of children's portraits of the period. Instead, the pyramidal arrangement of the figure gives the child a monumental solidity and emphasizes her sobriety and concentration as she builds with blocks, having discarded for the moment her bright toys. Ella Crowell is studied with affection as a child who has begun to think and learn, and her obliviousness to the artist reveals her in a moment of self-contained, independent being.

7. Baby at Play
Goodrich 99
1876
Oil on canvas
32¼ x 48″ (81.9 x 121.9 cm)
Collection of Mrs. John Hay Whitney

8. Margaret Eakins in Skating Costume
Goodrich 39
c. 1871
Oil on canvas
24⅛ x 20⅛″ (61.3 x 51.1 cm)
Philadelphia Museum of Art. Gift of Mrs.
Thomas Eakins and Miss Mary Adeline Williams

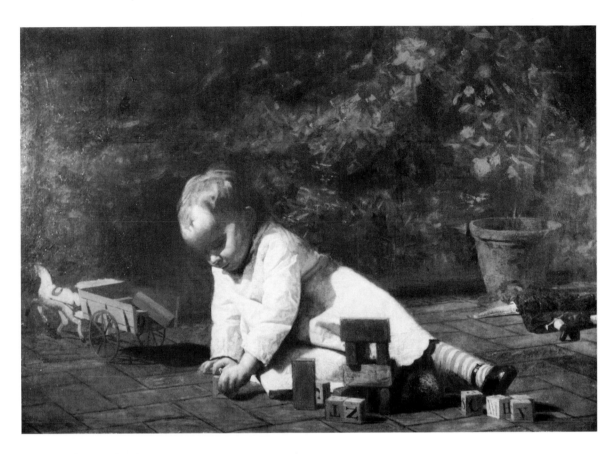

9. Frances Eakins
Goodrich 35
1870?
Oil on canvas
24 x 20″ (61 x 51 cm)
Nelson Gallery—Atkins Museum, Kansas City,
Missouri. Nelson Fund

10. Home Scene
Goodrich 37
c. 1871
Oil on canvas
21¹¹⁄₁₆ x 18¹⁄₁₆″ (55.1 x 45.9 cm)
The Brooklyn Museum, New York. Gift of
George A. Hearn, Frederick Loeser Art Fund,
Dick S. Ramsay Fund, Gift of Charles A.
Schieren

12

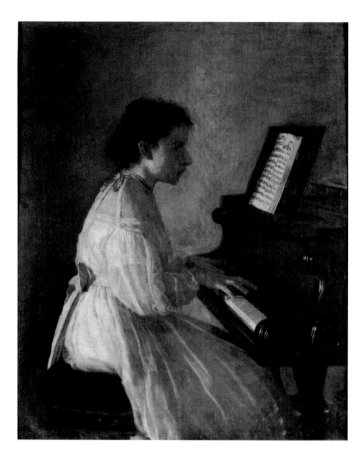

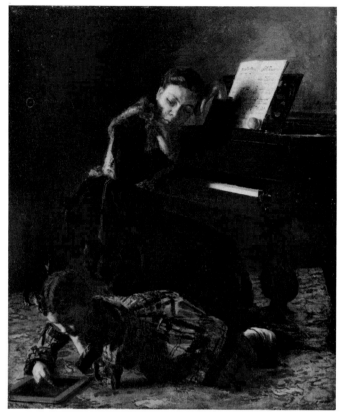

11. Elizabeth Crowell at the Piano
Goodrich 87
1875
Oil on canvas
72 x 48″ (182.9 x 121.9 cm)
Addison Gallery of American Art, Phillips
Academy, Andover, Massachusetts. Gift of
anonymous donor

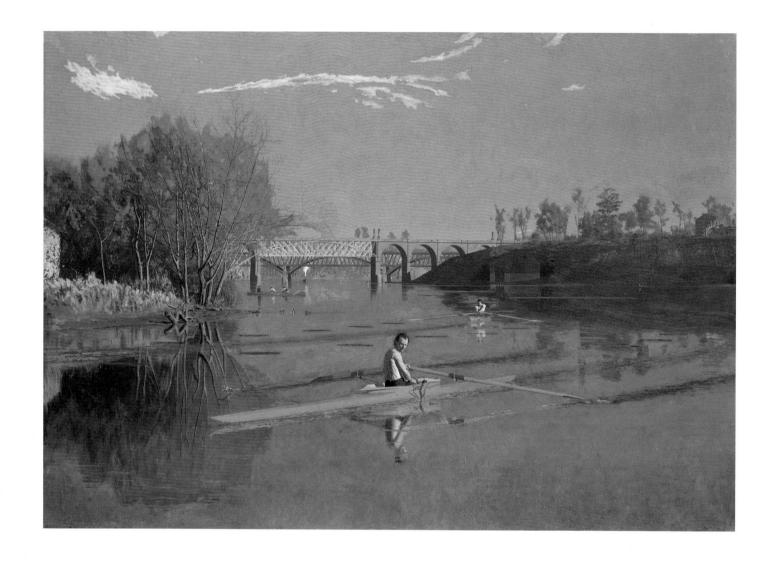

III. Rowing

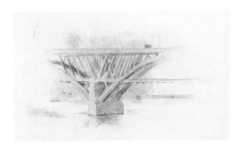

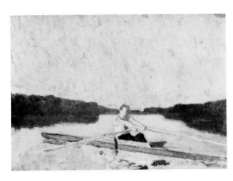

12. Max Schmitt in a Single Scull
Goodrich 44
1871
Oil on canvas
32¼ x 46¼″ (81.9 x 117.5 cm)
The Metropolitan Museum of Art, New York.
Alfred N. Punnett Fund and Gift of George D.
Pratt.

13. Drawing of the Girard Avenue Bridge
c. 1871
Pencil on paper
4⅛ x 6⅞″ (10.4 x 17.3 cm)
Hirshhorn Museum and Sculpture Garden,
Smithsonian Institution, Washington, D.C.

14. Sketch of Max Schmitt in a Single Scull
Goodrich 64
c. 1870–71
Oil on canvas
10 x 14¼″ (25.4 x 36.2 cm)
Philadelphia Museum of Art. Gift of Mrs.
Thomas Eakins and Miss Mary Adeline Williams

While in Paris, Eakins formulated a theory of art that influenced his choice of subject and approach to his work throughout his career. As he explained to his father:

In a big picture you can see what o'clock it is, afternoon or morning, if it's hot or cold, winter or summer, and what kind of people are there, and what they are doing and why they are doing it. The sentiments run beyond words. If a man makes a hot day he makes it like a hot day he once saw or is seeing; if a sweet face, a face he once saw or which he imagines from old memories or parts of memories and his knowledge, and he combines and combines, never creates—but at the very first combination no man, and least of all himself, could ever disentangle the feelings that animated him just then, and refer each one to its right place.[1]

The most frequently quoted sentence in this passage is the one in which Eakins describes the goal of the finished work. His stress on the necessity for clarity of time and place, on character, activity, and motivation of the people in the painting, is often cited as evidence for his preoccupation with fact in his work.[2] The following sentences, which make clear the importance of emotional content in a painting, and of the artist's feelings as its source, are often overlooked.

The combination of emotion and fact that Eakins sought is apparent in the scenes of his family and the Crowell sisters that he painted between 1870 and 1876 (*see* Chapter II). In the other paintings made during these same years—sporting scenes of rowing, sailing, and hunting—the sentiment, as Eakins

called it, is less immediately apparent, but no less important. Rowing, sailing, and hunting were sports that Eakins himself enjoyed, and they would seem natural subjects for him to paint. Yet, they complement the domestic scenes so exactly that they suggest Eakins deliberately selected them for the opportunities to expand his skills in a different direction. Instead of richly colored, shadowy interiors of a row-house parlor occupied by the still figures of women, the sporting pictures offered Eakins the full light of out of doors, the open spaces of landscapes, and the muscular figures of lightly clad men in motion. His concentration on rowing as a subject in the series of oils and watercolors he painted from 1870 to 1874 (and then never painted again) indicates that he used the subject to master a whole range of new artistic problems.

In terms of his stated philosophy, clearly Eakins did not depict oarsmen in their boats on the Schuylkill simply because they were readily available only a short walk from his house; he brought to the rowing subject the memories, knowledge, and sentiment that he thought imperative for an artist to have. His motivation for the paintings was his enjoyment of the familiar landscape, his friendship and admiration for his skilled companions, and his own personal enthusiasm for the sport. His models were friends who were also expert oarsmen and his own experience of rowing provided him with a

kinesthetic knowledge that could never have been gained through observation. In addition, the paintings appear to commemorate specific events, such as Max Schmitt's victories on the Schuylkill in the summer of 1870 or the Biglin brothers' appearance in the first pair-oared shell race in America in 1872. And there is something of a private joke in the way that Eakins rows rapidly into the distance in *Max Schmitt in a Single Scull* [12], while his friend turns to look out of the picture.

Writing to his father, Eakins had also described his conception of the artist's procedure in making a painting:

The big artist ... keeps a sharp eye on Nature and steals her tools. He learns what she does with light, the big tool, and then color, then form, and appropriates them to his own use. Then he's got a canoe of his own, smaller than Nature's, but big enough for every purpose.... With this canoe he can sail parallel to Nature's sailing. He will soon be sailing only where he wants to, ... but if ever he thinks he can sail another fashion from Nature or make a better-shaped boat, he'll capsize or stick in the mud, or nobody will buy his pictures or sail with him in his old tub.[3]

As the statement suggests, Eakins did not produce his rowing pictures by setting up his easel on the banks of the Schuylkill and painting what he saw. He re-created the scene, assembling it in his studio from various studies, which he made before he began the final painting—a process of "combination" in the literal sense.[4] This method is one that he would have learned

from Gérôme, who instructed his students: "Before you touch your canvas know what you are going to do."[5] Each of Eakins's paintings involved the preparation of many preliminary studies, which were usually discarded or painted over to provide a fresh surface for another study. For example, X-rays of the *Sketch for "The Gross Clinic"* [34] and of the portrait of J. Harry Lewis [112] show preparatory sketches of rowers underneath. Some of these survive, however, and their variety illustrates the painstaking thoroughness with which Eakins approached his subjects.

Quick oil sketches, such as the small *Sketch of Max Schmitt in a Single Scull* [14], loosely painted over pencil outlines, were probably made out of doors, as notations of general topography, large areas of color, specifics of light, and position of figures. Small drawings, such as the sketchbook page showing the Girard Avenue Bridge [13], which appears in the background of *Max Schmitt in a Single Scull* [12], serve to note specific details. Compositions were worked up employing studies of a posed model, such as the oil study of *John Biglin in a Single Scull* [19], or following a technique that Eakins later recommended to his students:

I made a little boat out of a cigar box and rag figures, with the red and white shirts, blue ribbons around the head, and I put them out into the sunlight on the roof and painted them....[6]

If the rowing paintings are considered in terms of the elements that Eakins thought most important for an artist to study—light, color, and form—it can be seen that his mastery steadily improved as he varied his treatment of these elements within each picture. In the earliest of the rowing paintings, *Max Schmitt in a Single Scull,* Eakins's large ambition for the work is obvious in the deep space of the view down the river and in the many carefully observed details. The heightened perception of motion in the absolute stillness of the landscape in mellow autumn sunlight is a brilliant concept. Yet the artist's difficulties with resolving his various studies into a pictorial whole are apparent. Every aspect of the scene seems to have been not only studied separately but also painted with an individual technique, so that men, water, trees, bridges each have their own material quality. When *Max Schmitt in a Single Scull* was shown in April 1871 at the Union League in Philadelphia, reviewers commented upon the "dull leaden sky," and the "somewhat scattered effect,"[7] at the same time recognizing Eakins's ability and promise for the future.

The conception of *The Pair-Oared Shell* [17] is so different from *Max Schmitt in a Single Scull,* painted a year before, that it must be seen as a deliberate reconsideration of the rowing theme. The elements of the painting are reduced to the shell and rowers, the massive pier of a bridge looming behind them, and the indistinct horizontal band of trees on the opposite bank. This format of a view directly across a river, which Eakins used in all the following rowing scenes, allowed him to have more control of space in the painting, limiting the surface of the river to a measurable plane.

To establish the composition exactly, Eakins made two perspective drawings for *The Pair-Oared Shell*; one to fix the position of the shell on the river [15], and the other to study the pattern of reflections in the water [16]. The use of perspective drawing, which Eakins had learned at Central High School, had no doubt been encouraged by Gérôme, who made elaborate perspective drawings for some of his own paintings, but Eakins was unusual in applying theories of perspective not just to foreshorten complex architectural settings but to set objects in the open landscape. Siegl's detailed analysis of the two drawings for *The Pair-Oared Shell* demonstrates that they are so precise that one can reconstruct exactly the distance of the boat from the spectator and the length of the boat, and establish the position of the sun and determine the date and time of day of the scene: 7:20 P.M. on either May 28 or July 27.[8] Unlike the river in *Max Schmitt in a Single Scull,* which was treated as a flat surface reflecting mirror images, in *The Pair-Oared Shell* it is in motion, and Eakins made the second perspective study to analyze reflections in its shimmering surface. He broke the water's surface into tilted planes containing fragments of color from the boat, the pier, and the clothing of the rowers, and

made notations on the drawing as to where a reflection might fall, for example, from the top of the head, shirt, or side of the shell, and painted the corresponding band of color on the ground plan. He noted other reflections that would appear in the finished painting, such as "340 ft reflection of trees on near side of a wave" or "Centre of cloud 36 [feet]," which he did not show on the drawing. The precise geometry of this study is rendered in a more painterly manner in the finished work, and there is no doubt that Eakins intended all such analytical studies to be subordinate to the whole effect. The perspective studies that Eakins made during these years later served as the basis for his teaching, and he noted in his lecture on the subject of reflections in water:

There is so much beauty in reflections that it is generally well worth while to try to get them right.[9]

In *The Pair-Oared Shell*, light is controlled as strictly as the perspective space. The blank light of *Max Schmitt in a Single Scull* has been exchanged for the haze and low-slanting sunlight of early evening, and the quality of light unifies the scene.

A review of *The Pair-Oared Shell* in the *New York Times*, written when it was shown for the first time in 1879, represented general opinion in denying the possibility of a "poetic impression" as the source of the painting:

It will be found remarkable for good drawing, natural and quiet composition, and a pleasant feeling in the color.... In a less technical sense, it is also an entrance into a

sphere of human activity where one might have expected artists would have sought for subjects long ago.... If it were possible to conceive that an artist who paints like Mr. Eakins had a poetic impression, we would like to think that in this composition he had tried to express the peculiar charm that everyone has experienced when rowing out of the sunlight into the shadow of a great bridge.[10]

In the most successful of the rowing canvases, *The Biglin Brothers Turning the Stake* [18], the effect of light is freer and more complex. Strong raking light creates a luminous landscape, emphasizing stands of trees and open fields, picking out the crowds of spectators on the far shore, and glancing off the rowers. In addition to establishing the space with a perspective drawing as he had in *The Pair-Oared Shell*, Eakins placed the two stake flags so that the distance between them can be assessed visually. The painting is as full of activity as *Max Schmitt in a Single Scull*, but here Eakins clarified the narrative of the scene by setting the other rowers and boats on the river well back into the distance and painting them less distinctly than the large, more completely realized figures of the Biglin brothers in the foreground.

Instead of an oil version of the theme, Eakins sent a watercolor of a rower to Gérôme in 1873—perhaps because it most completely achieved the integration of light, form, and color that had been his goal in the rowing paintings.

Gérôme praised the work in general but criticized the figure, which he found well painted but static, a fault he ascribed to the artist's having chosen to depict the middle of the stroke—similar, perhaps, to the position of the rear rower, John Biglin, in *The Biglin Brothers Turning the Stake*—instead of the pause at either extreme. Eakins painted a second version representing the rower at the end of a stroke, modifying the rower's position to that shown in the watercolor of *John Biglin in a Single Scull* [20], and sent it to Gérôme in 1874. He found it "entirely good."[11] For this watercolor, Eakins made an oil study [19] and a perspective drawing [21] that, while they are clearly studies, are remarkable works of art in themselves. In his perspective drawing Eakins combined the analytical procedures of the drawings for *The Pair-Oared Shell*. He established the receding plane of the water's surface, placed the boat on it at a slight angle to the horizontal, and studied the reflections of the shell, oars, and figure in the water. The figure of John Biglin is drawn in detail and modeled with wash to establish its volumes. The vertical center line and horizon line precisely control the placement of the figure so that the vertical line passes through the oarlock and Biglin's body and intersects the horizon just behind his head. To insure that the figure would be in exact proportion within the perspective space, Eakins made a small sketch of the figure at the top of the page.

Like any great preparatory drawing, this study for *John Biglin in a Single Scull* provides a clear insight into the artist's thought. The tension between observed reality and abstract composition that is apparent in the realistic figure of John Biglin fixed in the abstract linear scheme of the painting underlies all of Eakins's rowing subjects. In the oil study [19], Eakins explored color and light, working out the large color areas of the painting, the modeling of the figure, and the minute details, such as the folds of the red silk kerchief wrapped around his head. The pattern of colors reflected from the shell and the figure onto the water is also studied in detail. The slow-drying oil medium allowed corrections and changes not possible in watercolor. There is no anticipation of watercolor techniques, however, as background areas were laid in with a palette knife and the paint is opaque and thick overall. The tangibility of surface and effect of solid form that Eakins always associated with the oil medium are emphasized here and, with the bright saturated colors, create an effect of monumentality and mass so that the painting appears to have the limited space and strong volumes of a colored relief.

In the finished watercolor [20], Eakins retained the deliberateness of his perspective drawing and oil sketch, transcribing the exact composition and the precise details of the studies as he worked in a medium that demands speed and allows little correction. The relative freedom with which the sky is washed in indicates that Eakins was familiar with this aspect of watercolor technique, but most of the painting is carried out in small, parallel strokes, with the figure modeled in small areas of wash and stippling. The control with which Eakins was able to sustain this intricate technique throughout the painting is extraordinary. Perhaps it was the very insubstantiality of the watercolor effect that appealed to the artist; he used the brightness of the white sheet of paper and the transparency of the watercolors to achieve a luminosity and a silvery tone that seems equivalent to full light reflected on water. From the flickering brushstroke, the painting gains a pictorial coherence that is unique among the rowing subjects.

In spite of Gérôme's praise, Eakins criticized his paintings of the Biglin brothers as "clumsy & although pretty well drawn... wanting in distance & some other qualities."[12] And of another rowing picture, the last he was to do, he concluded: "Anyhow I am tired of it. I hope it will sell and I'll never see it again."[13] Some time in 1874, Eakins abandoned rowing subjects entirely, never to return to them.

15. Perspective Drawing for "The Pair-Oared Shell"
Goodrich 50
1872
Pencil, ink, and wash on paper
31 1/16 x 47 1/8" (78.9 x 119.7 cm)
Philadelphia Museum of Art. Purchased:
Thomas Skelton Harrison Fund

16. Perspective Drawing for "The Pair-Oared Shell"
Goodrich 51
1872
Pencil, ink, and watercolor on paper
31 13/16 x 47 9/16" (80.8 x 120.8 cm)
Philadelphia Museum of Art. Purchased:
Thomas Skelton Harrison Fund

20

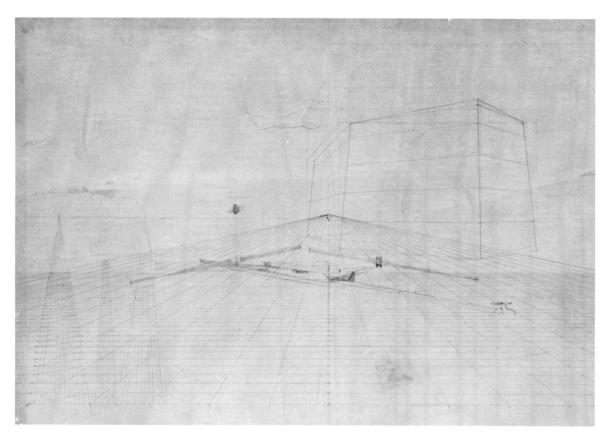

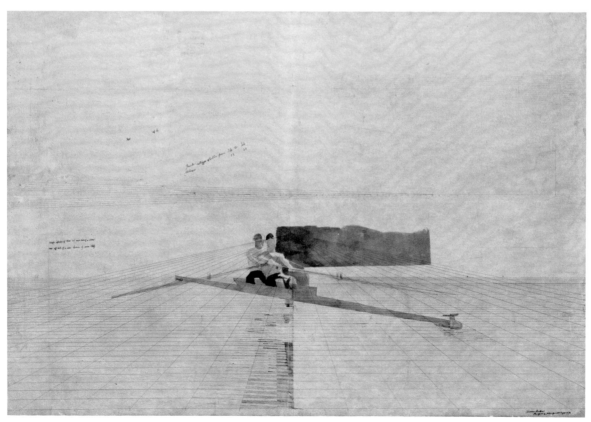

17. The Pair-Oared Shell
Goodrich 49
1872
Oil on canvas
24 x 36" (60.9 x 91.4 cm)
Philadelphia Museum of Art. Gift of Mrs.
Thomas Eakins and Miss Mary Adeline
Williams

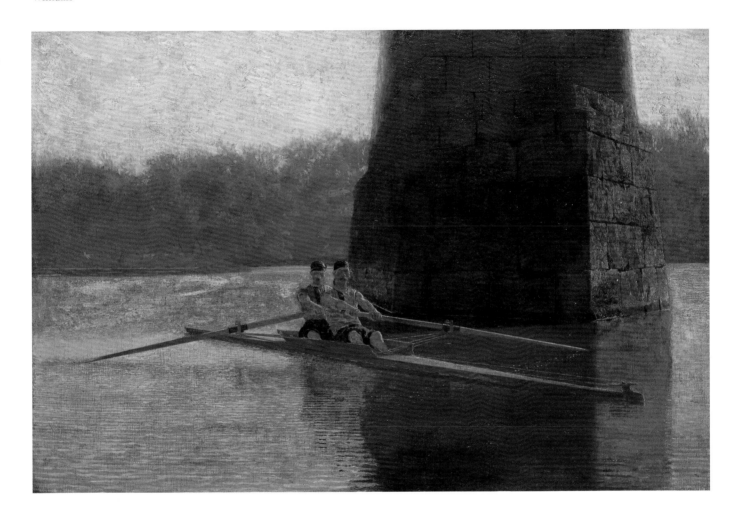

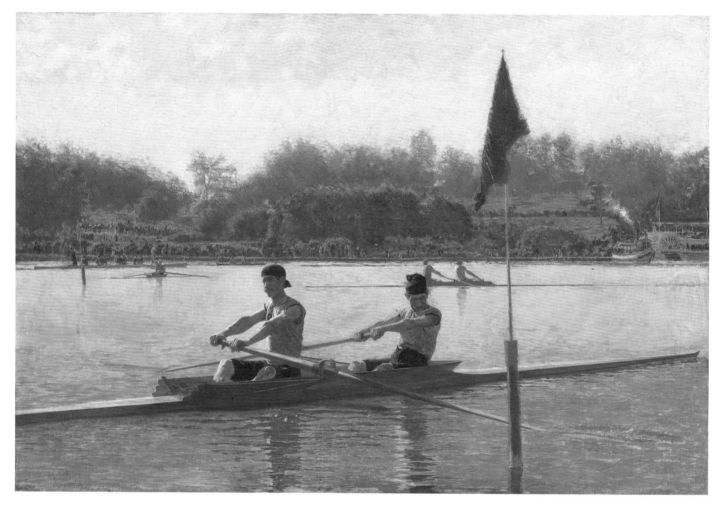

22

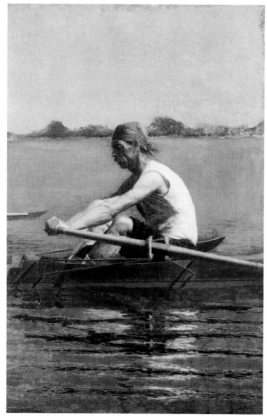

18. The Biglin Brothers Turning the Stake
Goodrich 52
1873
Oil on canvas
40¼ x 60¼" (102.2 x 153 cm)
The Cleveland Museum of Art. Hinman
B. Hurlbut Collection

19. John Biglin in a Single Scull
Goodrich 59
1873–74
Oil on canvas
24⁵⁄₁₆ x 16" (61.8 x 40.6 cm)
Yale University Art Gallery, New Haven.
Whitney Collections of Sporting Art,
given in memory of Harry Payne
Whitney, B.A. 1894, and Payne Whitney,
B.A. 1898, by Francis P. Garvan, B.A. 1897
Philadelphia only

20. John Biglin in a Single Scull
Goodrich 57
1873–74
Watercolor on paper
17⅛ x 23" (43.5 x 58.4 cm)
The Metropolitan Museum of Art, New
York. Fletcher Fund, 1924
Philadelphia only

21. Perspective Drawing for "John Biglin in a Single Scull"
Goodrich 58
1873–74
Pencil, ink, and wash on paper
27⅜ x 45³⁄₁₆" (69.5 x 114.8 cm)
Museum of Fine Arts, Boston. Gift of
Cornelius Whitney

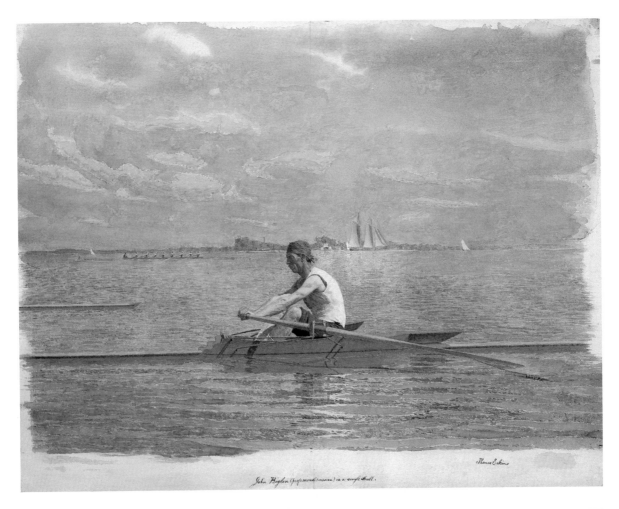

John Biglen (professional oarsman) in a single shull.

Thomas Eakins

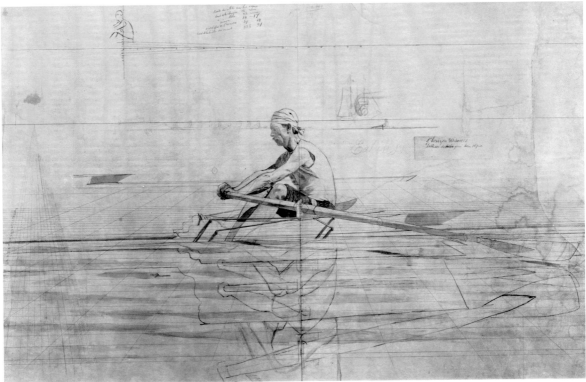

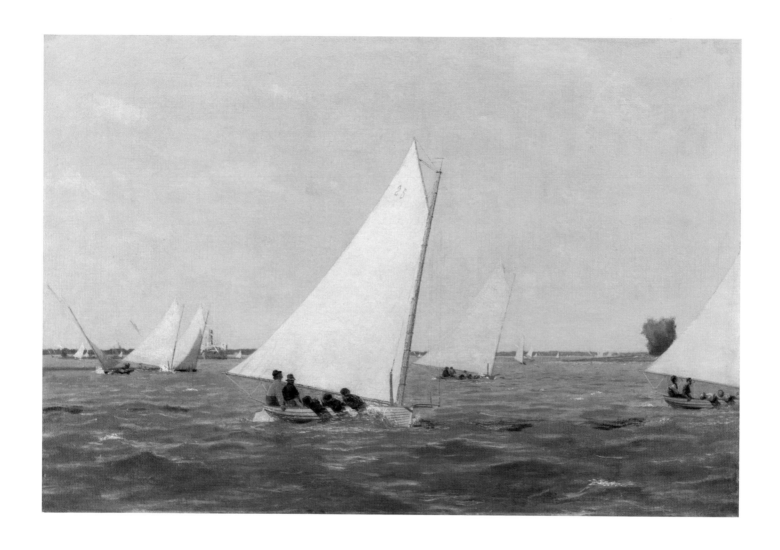

IV. Sporting Scenes

22. Sailboats Racing
Goodrich 76
1874
Oil on canvas
24 x 36″ (60.9 x 91.4 cm)
Philadelphia Museum of Art. Gift of Mrs.
Thomas Eakins and Miss Mary Adeline Williams

In 1874 Eakins began to exhibit his work actively, sending paintings to the exhibition of the American Society of Painters in Watercolor in New York, and to Paris for Gérôme to place for sale, as well as for his criticism. Most of the works sent for exhibition were of new subjects, hunting and sailing scenes, which Eakins may have considered to have more general appeal than rowing (see Chapter III). Gérôme's comment to Eakins, in a letter of 1874, "I do not know . . . if this kind of painting is salable,"[1] may be a reply to his student's questions about the commercial prospects of his works in addition to his concerns about the success of their technique and composition. The number of paintings of these subjects dated 1874 also suggests that Eakins was deliberately increasing the amount of work that he had to show.

Like rowing, sailing on the Delaware River and hunting reed birds in the New Jersey marshes across from Philadelphia were sports that Eakins enjoyed himself. As in the rowing pictures, he used his friends for models and drew upon his own experience to ensure that the paintings were exact in detail and effect. The small painting entitled *Hunting* [23] is one of the least elaborate of the hunting pictures, but the perspective drawing [24] shows that Eakins planned it as carefully as one of his rowing scenes. In the placement of the kneeling figure of the hunter on the perspective grid, Eakins's concern for the exact location of the figure both in the conceptual space and on the flat surface of the painting is evident. The austerity of the figure isolated in space is relieved by the droll humor of two birds stalking in the fore-ground. As the drawing indicates, Eakins may not have been able to place the figure of the reclining man to his satisfaction; in the painting it has been replaced by a dog which splashes away after game.

When two larger paintings of hunting subjects were shown at the Paris Salon in 1875, Eakins's friend William Sartain reported that they attracted "a good deal of attention."[2] The meticulous detail of the paintings was singled out by a reviewer for the *Revue des Deux Mondes*:

These two canvases [which M. Eakins has sent us from Philadelphia], each containing two hunters in a boat, resemble photographic prints covered with a light watercolor tint to such a degree that one asks oneself whether these are not specimens of a still secret industrial process, and that the inventor may have maliciously sent them to Paris to upset M. Detaille and frighten the école francaise.[3]

23. Hunting
Goodrich 73
c. 1874
Oil on canvas
9 x 11¾" (22.9 x 29.8 cm)
Collection of Andrew Wyeth

24. Perspective Drawing for "Hunting"
c. 1874
Pencil on paper
13¹³⁄₁₆ x 16¾" (35.1 x 42.5 cm)
Collection of Seymour Adelman

26

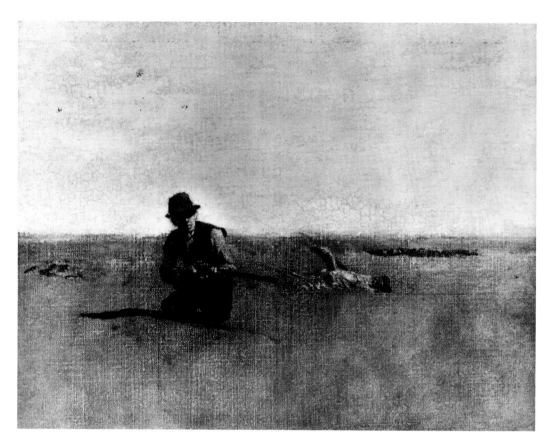

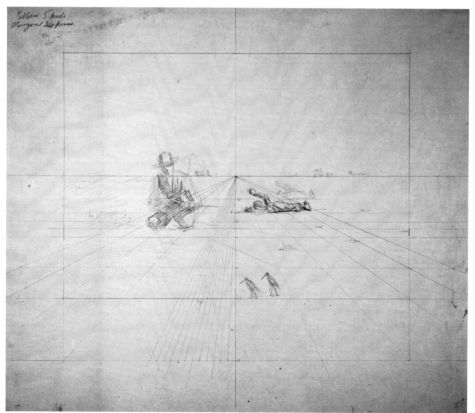

23. Hunting
Goodrich 73
c. 1874
Oil on canvas
9 x 11¾" (22.9 x 29.8 cm)
Collection of Andrew Wyeth

24. Perspective Drawing for "Hunting"
c. 1874
Pencil on paper
13¹³⁄₁₆ x 16¾" (35.1 x 42.5 cm)
Collection of Seymour Adelman

In 1875 Eakins sent four more paintings to Paris for Gérôme's opinion, and for submission to the annual Salon. Three of these were of boats sailing on the Delaware River, most likely *Starting Out After Rail* [26], *Ships and Sailboats on the Delaware* [27], and *Sailboats Racing* [22]. The paintings arrived late for admission to the Salon, so Gérôme sent them on to London for exhibition at Goupil's gallery, perhaps assuming that they would find a better market in England. Eakins recounted Gérôme's reaction in a letter to his friend Earl Shinn:

Gerome pitched into the water of the big one [possibly Sailboats Racing*] said it was painted like the wall, also he feared (just fear) that the rail shooting [possibly* Starting Out After Rail*] sky was painted with the palette knife. The composition of this one they all found too regular. They all said the figures of all were splendid. The drifting race [possibly* Ships and Sailboats on the Delaware*] seemed to be liked by all very much.*[4]

Possibly in response to Gérôme's criticism of the composition of *Starting Out After Rail*, Eakins made the version entitled *Sailing* [25] about 1875. The horizontal format of *Sailing* makes the placement of the boat more dynamic than in the vertical composition of *Starting Out After Rail*. The limited color scheme of brown, gray, and white, boldly painted with a palette knife and broad brushstrokes and then scraped or scratched with the pointed end of the brush, is clearly a contrast to the meticulous technique and illusionistic color of the earlier painting.

In spite of the faults that Gérôme found in the sailing paintings, they closely resemble his own style of painting and composition, especially in their relatively small size and the perfection of their technique. The tilting masts of the boats in *Sailboats Racing* create a balanced rhythmic play throughout the painting, and their diminution as they recede into the distance provides a precise gauge by which to judge the depth of the scene. Such careful study of the boats, the most complex of any of Eakins's treatments of boats on water, clearly reflects the methodical preparation that Gérôme recommended to his students. In a lecture prepared for his students years later, Eakins might have been thinking of the problem of representing the boat as it is seen in *Starting Out After Rail* when he wrote:

I know of no prettier problem in perspective than to draw a yacht sailing.... A vessel sailing will almost certainly have three different tilts. She will not likely be sailing in the direct plane of the picture. Then she will be tilted over sideways by the force of the wind, and she will most likely be riding up on a wave or pitching down into the next one.[5]

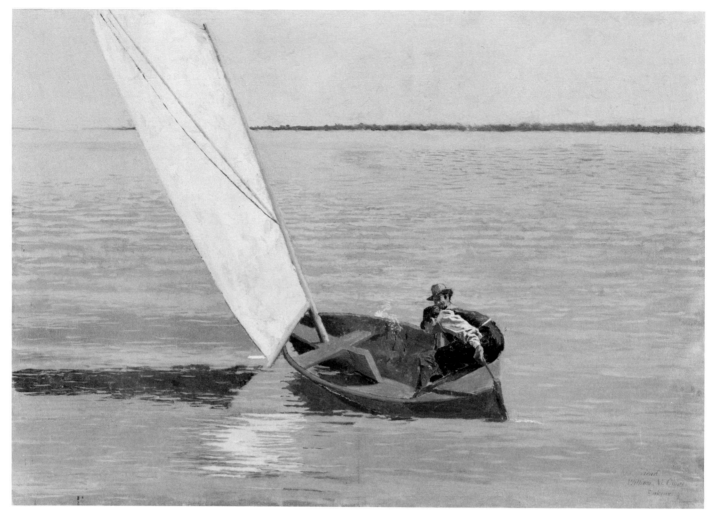

25. Sailing
Goodrich 77
c. 1875
Oil on canvas
31⅞ x 46¼″ (81 x 117.5 cm)
Philadelphia Museum of Art.
The Alex Simpson, Jr. Collection

26. Starting Out After Rail
Goodrich 78
1874
Oil on canvas
24 x 20″ (60.9 x 50.8 cm)
Museum of Fine Arts, Boston.
Charles Henry Hayden Fund

27. Ships and Sailboats on the Delaware
Goodrich 82
1874
Oil on canvas
10⅛ x 17⅛″ (25.7 x 43.5 cm)
Philadelphia Museum of Art. Gift of Mrs.
Thomas Eakins and Miss Mary Adeline Williams

28. Baseball Players Practicing
Goodrich 86
1875
Watercolor on paper
10⅞ x 12⅞″ (27.6 x 32.7 cm)
Museum of Art, Rhode Island School of
Design, Providence. Jesse Metcalf and Walter
H. Kimball Fund
Philadelphia only

30

Ships and Sailboats on the Delaware is one of the few paintings that Eakins ever made in which human beings are not the focal point. Instead, the subject is light and the appearance of boats on the water on a windless day. Even so, as Eakins described the scene to Shinn in 1875, the painting represents a specific event:

It is a still August morning 11 o'clock. The race has started down from Tony Brown's at Gloucester on the ebb tide.

What wind there is from time to time is astern & the big sails flop out some one side & some the other. You can see a least little breeze this side of the vessels at anchor. It turns up the water enough to reflect the blue sky of the zenith. The row boats and clumsy sail boats in the fore ground are not the racers but starters & lookers on.[6]

Ships and Sailboats on the Delaware is thinly and simply painted, the technique matching the limpid quality of the scene. The two ships are minutely detailed, their masts and rigging clearly defined. The only touches of strong color appear in the red shirts of two tiny figures in rowboats and in the limp burgee on the mast of the nearest large ship.

Eakins exhibited a watercolor version of *Ships and Sailboats on the Delaware*[7] at the American Society of Painters in Watercolor in 1875, which with the two other

watercolors that he showed—a hunting scene and *Baseball Players Practicing* [28]—indicates the range of his subjects at the time. Reviewing the exhibition, Shinn commented on these in terms Eakins himself might have agreed with:

The most admirable figure-studies, however, for pure natural force and virility, are those of Mr. Eakins, in which the method of Gérôme is applied to subjects the antipodes of those affected by the French realist. ... The selection of the themes in itself shows artistic insight, for American sporting-life is the most Olympian, beautiful and genuine side of its civilization from the plastic point of view The forms of the youthful ball-players, indeed, exceed most Greek work we know of in their particular aim of expressing alert strength in a moment of tension.[8]

At the end of the century, after his work had been devoted exclusively to portraiture for some time, Eakins returned briefly to sporting subjects in 1898 and 1899, painting athletes for the last time in three boxing scenes, *Taking the Count*,[9] *Salutat* [29], and *Between Rounds* [32], and in *Wrestlers*.[10] These were also sports that Eakins had enjoyed in his youth; in a letter from Paris, he had humorously pointed out that the wrestling students in Gérôme's studio provided an opportunity to study anatomy.[11] When he was making photographic studies for *The Swimming Hole* [98] in 1883, Eakins had taken other photographs of his students naked, boxing and wrestling out of doors, but he did not pursue the idea further. His interest in these

29. Salutat
Goodrich 310
1898
Oil on canvas
49½ x 39½″ (125.7 x 100.3 cm)
Addison Gallery of American Art, Phillips
Academy, Andover, Massachusetts. Gift of
anonymous donor

32

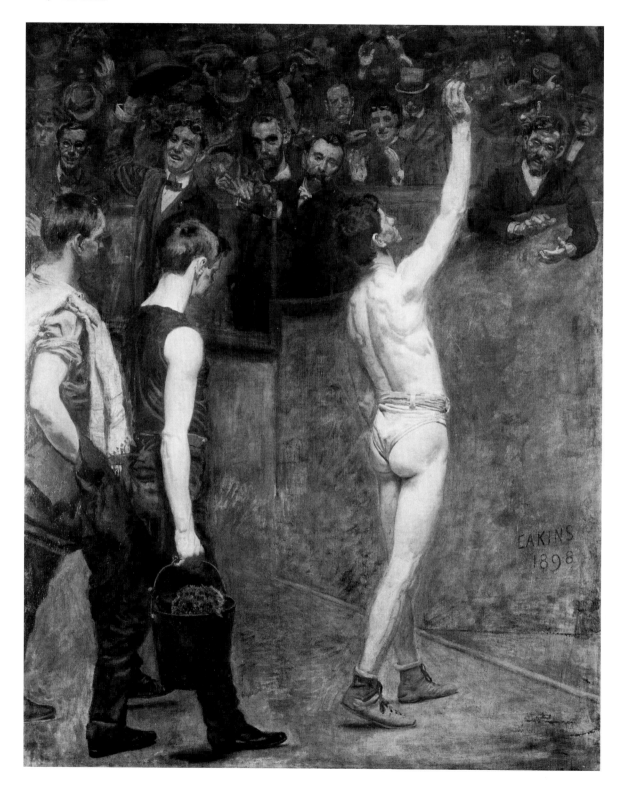

sports as pictorial subjects apparently revived during attendance at prizefights with Samuel Murray in 1897 or 1898. As with the early rowing, hunting, and sailing subjects, the inspiration for the boxing and wrestling pictures appears not to have been just the opportunity to paint the figure but Eakins's enthusiasm for all the particulars of the sport. Professional fighters posed for the boxers and attendants, and Eakins's friends were models for the spectators. The site was the Philadelphia Arena, located diagonally across Broad Street from the Pennsylvania Academy of the Fine Arts, and at least one of the paintings refers to a specific event: the poster at the left in *Between Rounds* announces the program for April 22, 1898, in which Billy Smith, who served as the model for the boxer in the painting, actually fought.

Eakins painted three different aspects of the scene in the Arena, showing fighters not in action but in poses that express specific moments in the psychology of the event. For example, victory and defeat are personified in the first of the series, *Taking the Count*, by the fighter kneeling before his opponent while the referee counts him out. Eakins's point of view in the boxing pictures was that of an observer, not a participant, and in watching the fights he perhaps recalled Gérôme's paintings of Roman gladiators in the arena,[12] such as *Ave! Caesar, Morituri Te Salutant* and *Pollice Verso*,[13] which he had seen in Paris. Like Gérôme, he gave a Latin title to the second painting of the series, *Salutat* [29]. In this work, Eakins emphasized the similarity of the modern professional boxer to the gladiator of old by the sculptural

treatment of the boxer's figure as he salutes the cheering crowd and by the inscription that he carved on the frame of the painting: "Dextra Victrice Conclamantes Salutat."

The longer view in *Between Rounds* [32] afforded Eakins the opportunity to paint one of his most completely developed genre scenes. Perhaps the small sketch for the painting [31] was made in the Arena itself to capture the essential narrative aspects of the scene just as he had done years before in his sketch for *The Gross Clinic* [34]. Eakins studied the figure of Billy Smith in a larger work made in his studio [30], and made studies of other major figures, such as that of the timer, who was his friend Clarence Cranmer, a sportswriter. Other details, such as the pattern of folds in the handler's blue shirt and the still life of the copper bucket with its sponge and bottles and the cut lemon in the corner of the ring, were studied equally carefully. In *Salutat* and *Between Rounds*, the particular quality of the light caused by the atmospheric haze of dust and smoke in the Arena seems to have interested Eakins; the figures of the boxers stand out not only because of their gleaming skin but because they are surrounded by an aura of light.

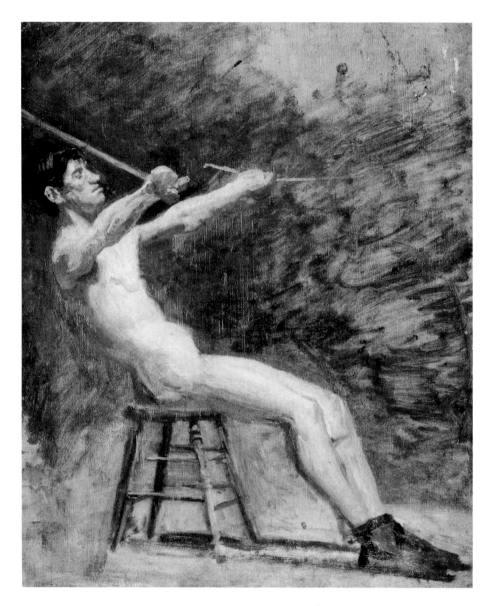

30. Billy Smith (Study for "Between Rounds")
Goodrich 314
c. 1898
Oil on canvas
20 x 16″ (50.8 x 40.6 cm)
Philadelphia Museum of Art. Gift of Mrs.
Thomas Eakins and Miss Mary Adeline Williams

31. Sketch for "Between Rounds"
Goodrich 313
c. 1898
Oil on paperboard
5⅞ x 4⅛″ (14.6 x 10.3 cm)
Hirshhorn Museum and Sculpture Garden,
Smithsonian Institution, Washington, D.C.

32. Between Rounds
Goodrich 312
1899
Oil on canvas
50⅛ x 39⅞″ (127.3 x 101.3 cm)
Philadelphia Museum of Art. Gift of Mrs.
Thomas Eakins and Miss Mary Adeline Williams

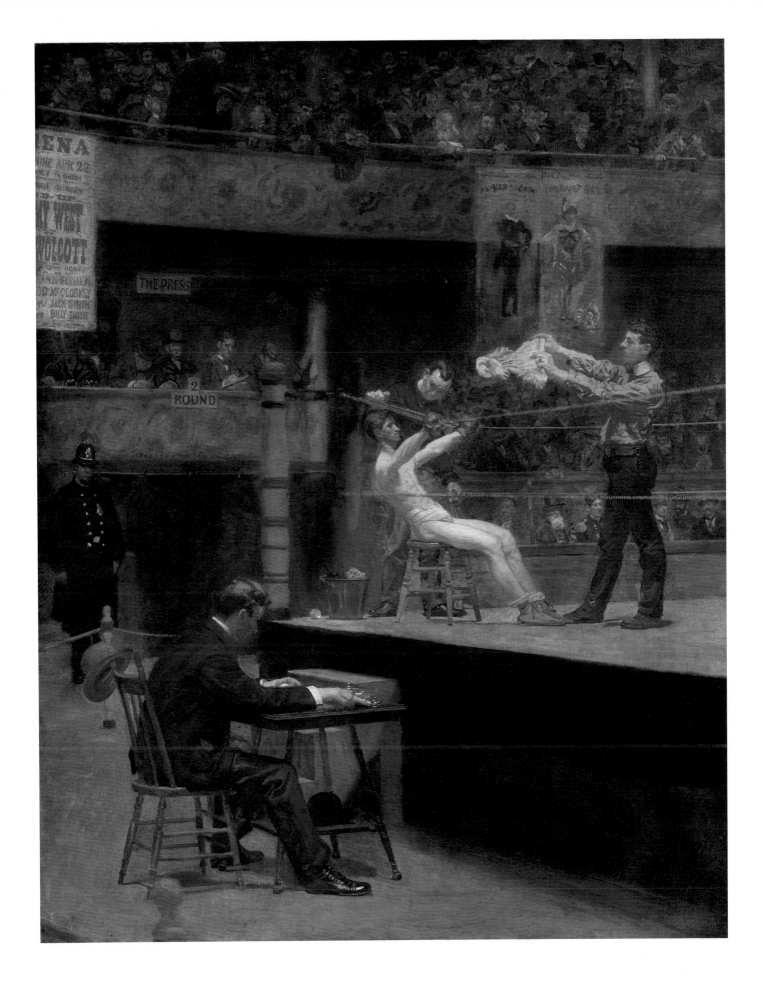

V. The Gross Clinic and The Agnew Clinic

33. The Gross Clinic
Goodrich 88
1875
Oil on canvas
96 x 78½″ (243.8 x 199.4 cm)
Jefferson Medical College, Thomas Jefferson
University, Philadelphia
Philadelphia only

For Eakins, as for other young American artists newly returned from study in Munich or Paris, the 1876 Centennial exhibition in Philadelphia offered an opportunity to show his works to a wide audience in competition with his American and European contemporaries. Thirty years old in the spring of 1875 and secure in his sense of his growth as an artist over the previous five years, Eakins must have felt it was time to paint a "masterpiece"—a complete statement of his abilities. For the Centennial, Eakins may have considered a more conventional subject from history, such as *Columbus in Prison* or the *Surrender of General Lee*,[1] but as for his earlier works he chose a subject from his own experience, an operation and demonstration by the famous surgeon Dr. Samuel David Gross in the surgical amphitheater at Jefferson Medical College [33]. In 1875 Gross was at the height of his career, famous in the United States and abroad for his teaching and his innovations in surgical technique. Eakins had attended anatomy lessons and observed operations at Jefferson before he went to France, and he registered again for courses in surgery and anatomy in 1873. This great man at work must have impressed him as a subject of heroic significance, dramatic in appearance and uniquely modern.

Although *The Gross Clinic* was not a commissioned portrait, Eakins may have seen in it the potential for winning commissions for portraits of other doctors at Jefferson Medical College. Founded in 1824, Jefferson had rapidly become one of the largest medical schools in the United States, and in 1870 it had formed an alumni association with Dr. Gross as its president. In his first presidential address to the association in March 1871, Gross had made an appeal for portraits of distinguished professors and alumni: "I trust that the Alumni Association will make it a part of their duty to adorn the College with memorials of this kind as a bare act of justice alike to themselves and to the honored dead who devoted their lives to the service of the school."[2] As one of a series of portraits of famous professors at Jefferson, the alumni had commissioned Samuel Bell Waugh to paint a portrait of Dr. Gross—a conventional portrait bust—which was presented to the college in 1875.[3] Eakins's portrait of Gross in *The Gross Clinic* may thus have been a direct, competitive comment on this portrait. In choosing his subject, Eakins may have drawn upon historical precedents of such earlier paintings as Rembrandt's *Anatomy Lesson of Dr. Tulp* (Mauritshuis, The Hague) or upon a more modern source such as Feyen-Perrin's *Anatomy Lesson of Dr. Velpeau*.[4] It is significant, however, that Eakins chose to paint not an anatomy lesson, a demonstration upon a dead subject, but an operation upon a living patient such as he had observed. As has been pointed out, the difference is very great: the knowledge that the patient is alive invites a much more immediate identification with the

38

subject and a much stronger emotional response to the painting.[5] For the composition, which emphasizes both the emotional intensity of the scene and the triumph of medicine, embodied in the figure of Gross, Eakins may have been indebted to the historical and religious subjects of Léon Bonnat or Théodule Ribot.[6]

On April 13, 1875, Eakins wrote his friend Earl Shinn that he was elated by his progress on a new work and that he had the composition blocked in.[7] By that time he had probably completed the sketch [34], which captures the salient elements of the finished painting: the figures in dark clothes, strongly lit from the skylight above and set against the shadowy tiers of students, the assisting physicians huddled over the patient while Dr. Gross turns away to make a point to the students, and the dramatic red strokes of blood on the patient's thigh and the surgeon's hand. Years later, one of Eakins's students recalled that this sketch was among the dozen of his own works that Eakins liked best.[8] Quickly and surely painted with palette knife and brush, this sketch may very well have been painted in the operating amphitheater at Jefferson, on a canvas that had already been used for studies of rowers.[9] The skill in painting that Eakins had developed in the previous years is evident in the economy with which he represented the foreshortened heads of the assisting doctors and defined other details by simply drawing them in quickly with a stroke of color; in the same way, he captured the strong masses of Gross's head in light and dark.

After he had completed the sketch, Eakins drew a frame around the picture to establish the general proportions of the finished canvas. The only significant changes in the final painting were the substitution of a table of instruments in the foreground for the barrier that separated the first tier of seats from the floor of the amphitheater, giving the scene an even greater immediacy,[10] and the addition of the figure of a woman— possibly the patient's mother— who, in contrast to the impassive figures deeply absorbed in the duties of their profession, recoils in horror from the operation.

Eakins developed the composition through individual studies of each of the figures. The large size proposed for the painting and the particular light of the scene presented the artist with new problems of representation. Two of the studies for the painting, one for Dr. Gross [35], the second, for one of the background figures [36], demonstrate the method that he followed. The study of Dr. Gross is painted entirely with a palette knife, which allowed Eakins to concentrate upon the large volumes of the doctor's head, and because of the nature of the technique, to avoid the temptation to be distracted by fine details. Paint is laid on thickly, without shaping the strokes to follow the contours of the face. As a result, the head appears to gain volume from thick masses of color, which seem to model it in the literal sense of a sculptor building up forms out of clay. The result is a remarkably dramatic, convincing image that resolves into a coherent image of solid form when seen from a distance. In the finished painting, the head is painted with a brush

instead of a palette knife, but the same large effect is retained. Eakins must have painted the finished version directly from the sketch, which is incised with two intersecting lines to establish the position of the head exactly in its place in the full composition. Eakins worked slowly and deliberately. For a subject as busy as Gross, he may have referred to a photograph during his work on the painting,[11] but undoubtedly the surgeon devoted considerable time to posing. Mrs. Eakins recalled her husband telling her that " while he was posing for his portrait, Gross remarked: ' Eakins, I wish you were dead ! ' "[12]

During this period, surgical demonstrations at Jefferson were open not only to doctors and medical students but also to interested spectators, such as Eakins, who showed himself at the far right of the finished painting. Each of the shadowy figures in the amphitheater has a distinct cast of countenance and posture, and we can assume that Eakins made studies for each of them, although most are no longer extant. With these, and the portrait studies for Gross and the other figures in the foreground, Eakins must have made at least twenty-seven oil sketches for the painting. The small sketch of his friend the writer and poet Robert C.V. Meyers [36] was painted as a study for the third figure from the right in the top row of students observing the operation. The sketch is summarily painted to record the essentials of the figure, but in addition, it remains a portrait of a distinct, introspective personality. It is squared for transfer, and the head is squared in greater detail to insure accuracy.

Eakins's pride in *The Gross Clinic* is indicated by the fact that he ordered a photographic reproduction of it [39], making a small black-and-white version [38] to be used for the reproduction, since photographic film at the time could not accurately capture the values of each of the colors in the painting. As a study, he made preparatory drawings of the heads of Dr. Gross and the assisting surgeon Dr. Barton [37], using a different technique for each head, one in pen resembling wood engraving, and one in brush, imitating the technique of the painting, which he then decided to adopt for the black-and-white version. Certain aspects of the composition are shown in more detail in this small version than they appear in the painting itself. Eakins, for example, can be seen much more clearly at the right of the amphitheater, his brow furrowed in concentration as he sketches the scene.

The Gross Clinic made its first public appearance in the form of the reproduction at the Penn Art Club on March 7, 1876, and a month later in the annual exhibition of the Pennsylvania Academy of the Fine Arts. When the photograph was first shown, William Clark, a friend of Eakins and a member of the Philadelphia Sketch Club, commented on its exhibition, in the *Philadelphia Evening Telegraph*, and used the occasion to compliment Eakins as " a young artist who is rapidly coming into notice as the

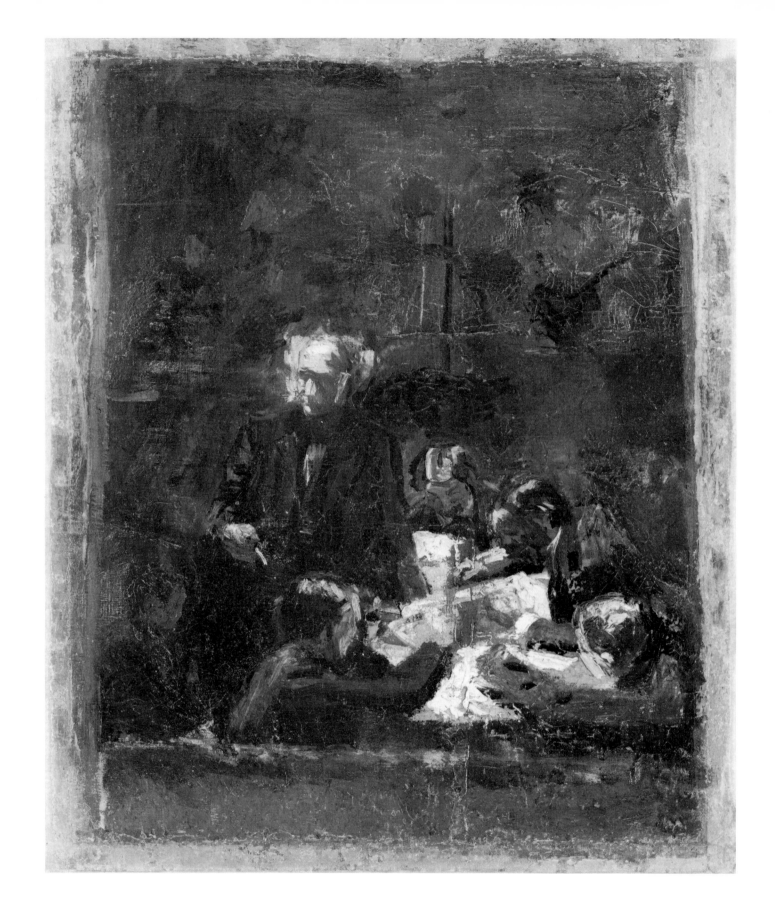

34. Sketch for "The Gross Clinic"
Goodrich 89
1875
Oil on canvas
26 x 22" (66 x 55.9 cm)
Philadelphia Museum of Art. Gift of Mrs.
Thomas Eakins and Miss Mary Adeline Williams

35. Study of Dr. Samuel David Gross
Goodrich 90
1875
Oil on canvas
24 1/16 x 18 13/16" (61.1 x 47.8 cm)
Worcester Art Museum

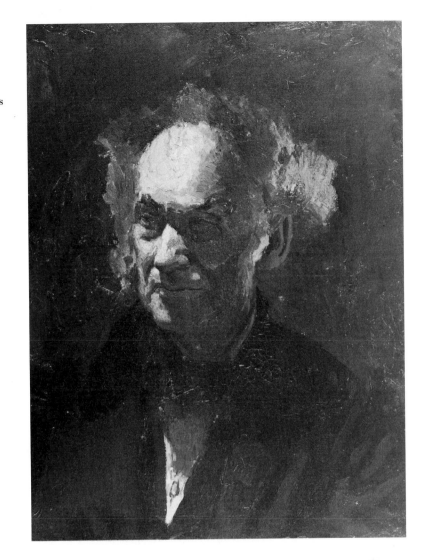

36. Study of Robert C. V. Meyers
Goodrich 93
1875
Oil on paper
9 x 8½" (22.9 x 21.6 cm)
Collection of Mr. and Mrs. Daniel W. Dietrich II

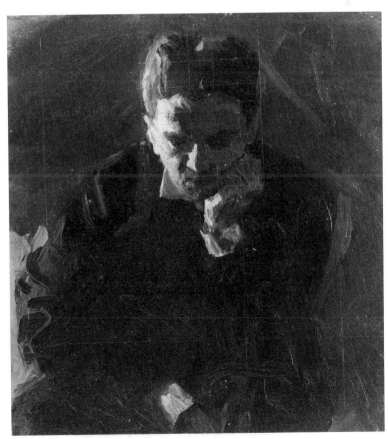

37. Heads of Dr. Gross and Dr. Barton (Study for Black-and-White Version of "The Gross Clinic")
Goodrich 92
c. 1875
Ink, wash, and pencil on paper
12¹¹⁄₁₆ x 15⅛" (30.6 x 38.4 cm)
Philadelphia Museum of Art. Gift of Mrs. Thomas Eakins and Miss Mary Adeline Williams

38. Black-and-White Version of "The Gross Clinic"
Goodrich 91
1875
India ink wash on cardboard
23⅝ x 19⅛" (60 x 48.6 cm)
The Metropolitan Museum of Art, New York. Rogers Fund, 1923
Boston only

39. Collotype of "The Gross Clinic"
1876
Collotype
13⅞ x 11⁷⁄₁₆" (35.2 x 29.1 cm)
Philadelphia Museum of Art. Gift of Mrs. Adrian Siegel

42

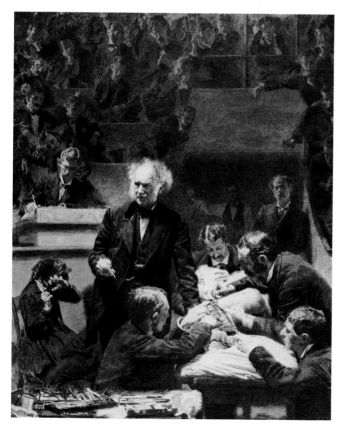

possessor of unusual gifts" and to praise the picture as a "work of great learning and great dramatic power."[13] When the painting itself was exhibited at the Haseltine Galleries in late April, at about the time that the selection committee for the Centennial exhibition was making its choices, Clark reviewed it in detail in the *Telegraph*, praising it and explaining it in enthusiastic terms. He noted, however, what might be anticipated as an objection to the work:

It is intensely dramatic, and is such a vivid representation of such a scene as must frequently be witnessed in the amphitheatre of a medical school, as to be fairly open to the objection of being decidedly unpleasant to those who are not accustomed to such things.

But he concluded:

This portrait of Dr. Gross is a great work—we know of nothing greater that has ever been executed in America."[14]

Clark's fear that the subject might be controversial was realized when the judges rejected *The Gross Clinic* for exhibition in the Centennial's art galleries, although they selected five other paintings by Eakins. In an article published in defense of the painting after the Centennial exhibition had opened, Clark scornfully commented upon the judges' decision:

It is rumored that the blood on Dr. Gross' fingers made some of the committee sick, but, judging from the quality of the works selected by them we fear that it was not the blood alone that made them sick.

Artists have before now been known to sicken at the sight of pictures by younger men which they in their souls were compelled to acknowledge was beyond their emulation.[15]

Although the painting was not shown in the art galleries, it was handsomely installed in the United States Army Post Hospital exhibit, lent by Dr. Gross himself.[16]

The Gross Clinic, like most other American paintings at the Centennial, received no notice in the press. After the close of the exposition, Eakins apparently took it back to his studio, where it remained until the alumni association of Jefferson Medical College purchased it in 1878. The following year, Eakins sent the painting to the second annual exhibition of the Society of American Artists in New York, where it received extensive coverage in the press. The critic for the *New York Tribune* summed up the general press reaction in his review of March 22, 1879:

This is ... a picture of heroic size that has occupied the time of an artist it has often been our pleasure warmly to praise and that a society of young artists thinks it proper to hang in a room where ladies, young and old, young girls and boys and little children, are expected to be visitors. It is a picture that even strong men find it difficult to look at long, if they can look at it at all; and as for people with nerves and stomachs, the scene is so real that they might as well go to a dissecting room and have done with it.

It is impossible to conceive, for ourselves, we mean, what good can be accomplished for art or for anything else by painting or exhibiting such a picture as this. . . . Here we have a horrible story—horrible to the layman, at least—told in all its details for the mere sake of telling it and telling it to those who have no need of hearing it. No purpose is gained by this morbid exhibition, no lesson taught—the painter shows his skill—and the spectator's gorge rises at it—that is all.[17]

When the Society of American Artists exhibition closed in New York, the works were sent to Philadelphia to be shown as a group in the Pennsylvania Academy's fiftieth annual exhibition. However, *The Gross Clinic* was listed in the catalogue separately from the other works of the Society of American Artists, and hung obscurely in a corridor. After the close of the exhibition at the Academy, Eakins exhibited the painting only twice again in his lifetime, at the World's Columbian Exposition in Chicago in 1893 and at the Universal Exposition in St. Louis in 1904.

Ironically, considering Eakins's later difficulties with sitters who did not like their portraits, Gross apparently approved of his. And although many critics and members of the general public found his subject offensive, Eakins must have been gratified by the approval of doctors and scientists who could judge its accuracy and appreciate its greatness as a portrait and its meaning as a celebration of modern medicine. When Dr. Gross's autobiography was published in 1887,[18] an engraving of *The Gross Clinic* was included as one of the two illustrations.

The Agnew Clinic [40], painted fourteen years after *The Gross Clinic*, is further evidence of the admiration for Eakins's work among the medical profession. It was commissioned by members of the undergraduate medical classes at the University of Pennsylvania to honor the distinguished surgeon and teacher Dr. David Hayes Agnew, who was retiring as professor of surgery after twenty-six years at the university. Instead of the traditional single-figure commemorative portrait, Eakins chose to show him, as he had shown Dr. Gross, in the middle of a surgical demonstration surrounded by his students.[19] As in *The Gross Clinic*, each of the assistants in the operation is an identifiable portrait, and Eakins painted students of the graduating class seated in the amphitheater. The painting was completed within three months and presented to the university at commencement, May 1, 1889.

To accommodate all the onlookers, Eakins chose a horizontal composition on the largest canvas of his career. The greater emphasis on the students and the variety of their poses, the separation of the figure of Dr. Agnew from the operation in progress, and the clear disposition of the doctors, nurse, and patient make the painting more directly illustrative in character than the dramatic and monumental composition of *The Gross Clinic*. *The Agnew Clinic* also shows the thorough development of Eakins's painting technique in the interven

ing years; it is more smoothly painted with the shaped strokes of Eakins's later painting style. The white surgical gowns of the participants prevent the dramatic study of black in strong light, with the contrast of white and blood red that gave *The Gross Clinic* its particular intensity. Instead of the histrionic figure of the patient's relative, here Eakins painted the unflinching, professional figure of a nurse. As in *The Gross Clinic*, Eakins's portrait is included. This time, however, it was painted by his artist wife Susan Eakins.

With *The Agnew Clinic*, so clearly related to his earlier painting in subject and scale, Eakins may again have been trying to assert his mastery in a major public statement, after a period of relative inactivity following his dismissal from the Academy in 1886. Instead, the exhibition of the work was to repeat the disappointments of past years, not only in the public reaction but in the rejection of the painting by his fellow artists. Like *The Gross Clinic*, *The Agnew Clinic* was first shown in public at the Haseltine Galleries in Philadelphia; in 1891, when he was invited to exhibit at the Academy's annual for the first time since his dismissal, *The Agnew Clinic* was accepted for exhibition, but it was eliminated at the last moment on a technicality at the request of the director's exhibition committee, which apparently considered the painting "not cheerful for ladies to look at."[20] When in 1892 Eakins submitted this and other paintings to the Society of American Artists in New York, where he had shown *The Gross Clinic* in 1879, they were rejected, which prompted his resignation from the society.

40. The Agnew Clinic
Goodrich 235
1889
Oil on canvas
84⅜ x 118⅛" (214.3 x 300 cm)
University of Pennsylvania, Philadelphia

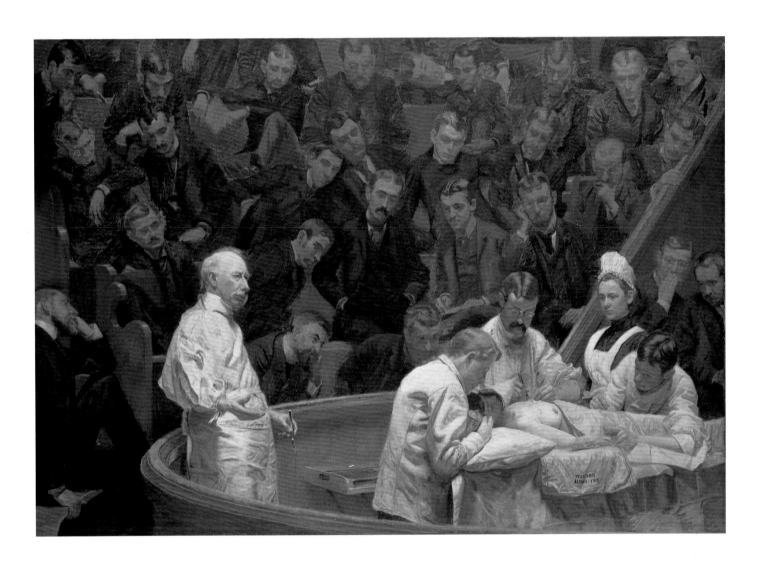

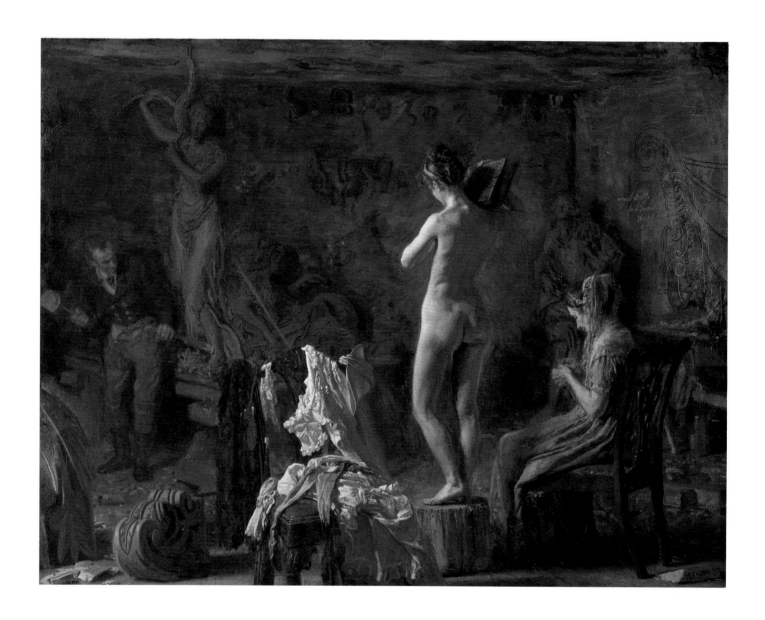

41. William Rush Carving His Allegorical Figure of the Schuylkill River
Goodrich 109
1876–77
Oil on canvas
20⅛ x 26⅛" (51.1 x 66.4 cm)
Philadelphia Museum of Art. Gift of Mrs. Thomas Eakins and Mary Adeline Williams.

In addition to *The Gross Clinic* [33], Eakins showed five other paintings in the art galleries at the Centennial, which represent the range of his work up to that time: *The Chess Players*,[1] a small and beautiful interior scene of his father and his friends playing chess; a portrait of Prof. Benjamin Howard Rand[2] in an elaborately studied interior; a "Lady's Portrait," probably *Elizabeth Crowell at the Piano* [11]; and two watercolors, *Baseball Players Practicing* [28] and a hunting scene.[3] These contemporary subjects, drawn from Eakins's own life, show his independence of traditional academic historical or exotic subject matter. Only in *William Rush Carving His Allegorical Figure of the Schuylkill River* [41] did Eakins turn to an historical genre subject similar to those done by Gérôme. As has been pointed out,[4] the subject of the artist at work in his studio was popular among nineteenth-century figure painters, and perhaps Eakins had such examples as Gérôme's *Bramante Showing Raphael the Sistine Ceiling* and *Rembrandt Etching*[5] in mind when he began his painting. Instead of portraying one of the illustrious figures in the history of European art, however, Eakins chose a scene from Philadelphia's own past. The subject, William Rush (1756–1833), an artist whom Eakins greatly admired, had been a famous American sculptor and a respected citizen of Philadelphia, whose work and life were closely associated with the city. Following a tradition for historical subjects, Eakins wrote a statement describing the composition for its exhibition:

When Philadelphia established its water-works to supply Schuylkill water to its inhabitants, William Rush, then a member of the Water Committee of Councils, was asked to carve a suitable statue to commemorate the inauguration of the system. He made a female figure of wood to adorn Centre Square at Broad Street and Market, the site of the water-works, the Schuylkill water coming to that place through wooden logs. The figure was afterwards removed to the forebay at Fairmount where it still stands. Some years ago a bronze copy was made and placed in old Fairmount near the Callowhill Street bridge. This copy enables the present generation to see the elegance and beauty of the statue, for the wooden original has been painted and sanded each year to preserve it. The bronze founders burned and removed the accumulation of paint before moulding. This done, and the bronze successfully poured, the original was again painted and restored to the forebay.

Rush chose for his model the daughter of his friend and colleague in the water committee, Mr. James Vanuxem, an esteemed merchant.

The statue is an allegorical representation of the Schuylkill River. The woman holds aloft a bittern, a bird loving and much frequenting the quiet dark wooded river of those days. A withe of willow encircles her head, and willow binds her waist, and the wavelets of the wind-sheltered stream are shown in the delicate thin drapery, much after

the manner of the French artists of that day whose influence was powerful in America. The idle and unobserving have called this statue Leda and the Swan, and it is now generally so miscalled.

The shop of William Rush was on Front Street just below Callowhill, and I found several very old people who still remembered it and described it. The scrolls and drawings on the wall are from sketches in an original sketch book of William Rush preserved by an apprentice and left to another ship carver.

The figure of Washington seen in the background is in Independence Hall. Rush was a personal friend of Washington and served in the Revolution. Another figure of Rush's in the background now adorns the wheel house at Fairmount. It also is allegorical. A female figure seated on a piece of machinery turns with her hand a water wheel, and a pipe behind her pours water into a Greek vase.[6]

Eakins may have chosen this subject not just because of his admiration for Rush but also because of the resistance that his emphasis on the study of the nude figure met when he began to teach at the Pennsylvania Academy of the Fine Arts in 1876. The example of a respectable young woman posing nude for an equally respected local sculptor supported his own ideas of the study of art, as Earl Shinn pointed out in a review of the painting in the *Nation* in 1878:

The painter of the fountain seemed to have a lesson to deliver—the moral, namely, that good sculpture, even decorative sculpture, can only be produced by the most uncompromising, unconventional study

and analysis from life, and to be pleased that he could prove his meaning by an American instance of the rococo age of 1820.[7]

Shinn also pointed out the evidence of Eakins's European training in *William Rush Carving His Allegorical Figure of the Schuylkill River* and its unusualness in American art:

The apparatus of hiring properties, arranging incidents, and employing models, by which conscientious works of art are elaborated, seemed to have been used only with two works produced in this country— Mr. Eakins's "Rush Carving the Fountain" and [Howard] Roberts's "Lot's Wife," a statue.[8]

The idea for the painting may have been in his mind as early as April 1875, since a letter to Shinn of that date shows a drawing of a stockinged leg and a buckled shoe, which may have been drawn after Rush's figure of George Washington in Independence Hall.[9] The subject was also inspired by John Lewis Krimmel's painting showing the allegorical figure in its original location, *Fourth of July in Centre Square*, of about 1810–12,[10] which Eakins studied in the galleries of the new Pennsylvania Academy after their opening in 1876.

While Eakins depicted Rush at work in his studio at the specific moment he was carving his figure of the Schuylkill (1809), the painting does not represent one moment in time, for in the background against the studio walls he showed sculptures by Rush—the figures of

George Washington (1814) and *The Schuylkill Freed* (c. 1828)—that were made at different times in Rush's career. To ensure the accuracy of his representation of these sculptures, Eakins visited them at their sites in Philadelphia and made drawings [42a–c] and later small wax models [43a–c,e] of them. He also made costume studies from contemporary prints, which he may have found in the Academy collections, as well as from Krimmel's painting, which provided Rush's costume, taken from the central figure of the group of two men and a woman [42d]. The three sketches of older women [42e–g] apparently contributed to the costume of the chaperone. The most completely studied figure is that of a young woman with a parasol [42h], taken most probably from a costume plate. Eakins seems to have enjoyed not only the dress itself, but its description, copying it at length down the left side of the drawing:

Walking dress A plain round robe of the finest French cambric A Capuchin cloak of muslin or coloured sarsnet, edged in Vandyke sitting close round the throat, with a falling collar, and confined in the centre with a ribband or brooch. A Village hat of straw or chip with a silk crown & ribband to correspond with the cloak. Shoes of brown kid; gloves York tan; & parasol of clouded sarsnet. August 1807.

This entire costume, including hat, parasol, and shoes, appears as if discarded by the model on a chair in the finished painting, presented with the accuracy of an arranged still life.

As he was later to encourage his own students to do in their work, Eakins made the small sculptural sketches of Rush's works as an aid to his understanding of their form and as references when composing his painting. The figures of *The Schuylkill Freed* [43e], the nymph and bittern [43a], and George Washington [43b] were studied to capture the essential positions of the figures and draperies. A detailed study of the head of the nymph [43c], which also originally included the bittern poised on her shoulder, may have been made to study the adjustment required of the model's head and neck to balance the bird. The head of William Rush [43d] is not a copy of any single known portrait, but a composite, possibly of Rush's sculptured self-portrait in the Academy and the painted portrait by Rembrandt Peale in Independence Hall.[11]

Eakins sought an authentic setting for his painting by visiting the waterfront neighborhood where Rush had worked in order to interview people who recalled his shop and could describe its appearance. He also visited a woodcarver's shop and painted a sketch of its interior [46]. The workmen in the foreground are summarily painted with a few broad strokes, but the casual arrangement of tools and shop products as they appeared in the shadows beyond obviously caught Eakins's attention. He painted these shadowy forms extensively, and similar indistinct shapes appear on the back wall of Rush's studio in the finished painting.

In an early overall sketch dated 1876 [44], many elements of the later painting are evident: the model posed on a section of tree trunk, the chaperone knitting,

Rush carving the nymph and bittern, the figure of George Washington, *The Schuylkill Freed,* and in the foreground, a few strokes of white that might indicate an arrangement of the model's clothing. Comparison with the finished painting shows how Eakins rearranged these elements to improve the composition—turning the chaperone to face into the picture, moving the figures of Rush and his sculpture farther to the left to create a deeper space, and adjusting the relative sizes of the figures and the two sculptures. In the sketch, Rush is wearing modern dress and the chair is also of a later date, showing none of the careful research into costume and furnishings that Eakins incorporated into his finished work.

Study of the nude figure of the model in the overall sketch, in a small figure study [45], and in the painting shows the process of evolution from a stolid figure into the more slender, more gracefully posed model. From the early stocky, huddled figure [44], he rearranged the pose in the small study [45] and examined the play of light across the delicate bone structure and musculature of the model's neck and back, which he emphasized even more in the final painting [41]. In the study, the model still keeps both feet flat on the floor, as she did in the earlier sketch, and appears to bend slightly forward. As a result there is an emphasis upon the division of the body at the waist, which breaks the long line of the figure and reinforces its static, heavy quality. In the finished painting the model's pose has been opened up even more, her weight balanced upon one foot to emphasize the long line of the body and to

find a graceful outline within her convincingly realistic pose. The changes Eakins made in the figure of his model show that he worked toward his own idea of beauty— graceful balance—the delicate, architecture of bone structure, and a long line developed not by forcing the figure to conform to a preconceived system of proportion or to an ideal of beautiful form but through sensitive, persistent study of the model.

Eakins sent *William Rush Carving His Allegorical Figure of the Schuylkill River* to the first exhibition of the Society of American Artists in New York in 1878. In this controversial exhibition, which showed the work of a new generation of American artists recently returned from study in Paris and Munich, the painting received considerable attention. Several critics complained about the lack of idealization in the figure, and the reporter for the *New York Times* carried the argument one step further :

What ruins the picture is much less the want of beauty in the nude model, (as has been suggested in the public prints,) than the presence in the foreground of the clothes of that young woman, cast carelessly over a chair. This gives the shock which makes one think about the nudity— and at once the picture becomes improper![12]

Only Eakins's friend William Clark, the critic of the *Philadelphia*

Evening Telegraph, gave the painting an unqualifiedly favorable review:

The substantial fact is that the drawing of the figure in this picture—using the word drawing in its broadest sense to indicate all that goes to the rendering of forms by means of pigments on a flat surface—is exquisitely refined and exquisitely truthful, and it is so admitted by all who do not permit their judgement to be clouded by prejudices and theories about what art might, could, would, and should be were it something else than, in its essence, an interpretation of nature, and of an order of ideas that must find expression through the agency of the facts of nature if they are to find any adequate expression. The best comment on this picture was that made by a leading landscape artist of the old school, and who, being of the old school, certainly had no prejudices in favor of works of this kind. This was that he had not believed there was a man outside of Paris, certainly not one in America, who could do a painting of the human figure like this.[13]

In 1908, at the age of sixty-four and near the end of his working life, Eakins returned to the William Rush theme that he had painted some thirty years earlier. He made a new composition sketch [48], reversing the original positions of Rush and the chaperone and placing the model in the foreground; he also painted separate studies of each of these figures [49].[14] On a canvas much larger than that of the earlier version, Eakins reduced the painting to its essentials, retaining only the necessary elements of the narrative and setting [47]. Instead of the boxlike space in the first painting created by showing the floor, ceiling, and two adjoining walls, the space of this version is reduced to the floor and back walls. The figures of *The Schuylkill Freed* and George Washington remain as allusions to Rush's career as a sculptor, as does the carved ornamental scroll, which has been moved to the center, but other historical details have been eliminated: the Negro chaperone appears in a nondescript black dress, while the Chippendale chairs and the model's costume have been removed. The figure of Rush has become much less of a portrait and his knee breeches, stockings, and buckled shoes casually echo a period style rather than faithfully reproduce it. The model stands firmly on her two feet, with none of the relaxed grace of the earlier pose, and her figure is painted as a sleek, solid volume in strong contrasts of light and dark—an exact rendering of the figure with none of the delicate sensuality of light on the infinitely varied surface of the human body that appears in the earlier painting. Eakins disregarded the extraneous details that were such an important part of the first picture and with the authority of a mature artist concentrated upon the central narrative.

At about the same time that he painted the 1908 version of the theme, Eakins developed a second, new treatment of the subject. Inspired perhaps by Gérôme's paintings of the 1890s of an artist and his model in a studio,[15] Eakins portrayed the model frontally, stepping down from the tree trunk in a pose that must have been studied from Eadweard Muybridge's photographs of the figure in motion made in the 1880s.[16] A preparatory sketch for this painting [52] shows that the original idea included a second figure on the left holding the model's robe, while another similar sketch also includes the nymph and bittern in the background [51]. This composition strays far from the careful historicism of the other Rush paintings. In the painting [50], which was left unfinished, only the ornamental scroll in the foreground recalls the historical references of the earlier versions.

The humor and self-mockery of Gérôme's portrayal of himself as the artist who appears with his model may have inspired Eakins to give the figure of Rush his own features. Instead of Gérôme's dapper figure and his nubile model, however, Eakins gave the humor of the painting his own twist; the figure of Rush has his own features and the body of an aging man, and his model is a middle-aged woman, with pendulous breasts and coarse hands. Far from the discreet eroticism of Gérôme's paintings are the dignity and propriety in this model's demure smile as she lowers her eyes to watch her footing and in the sculptor's courtly bow as he takes her hand to help her from the modeling stand. *William Rush and His Model* is Eakins's wry valedictory statement of the artistic principles to which he steadfastly held through a lifetime of controversy.

42. Studies for "William Rush Carving His Allegorical Figure of the Schuylkill River"
1875–76
Hirshhorn Museum and Sculpture Garden,
Smithsonian Institution, Washington, D.C.

52

a. George Washington
Pencil on paper
7¼ x 4¹¹⁄₁₆″ (18.3 x 11.8 cm)
b. The Schuylkill Freed
Pencil on paper
7¼ x 4¹¹⁄₁₆″ (18.3 x 11.8 cm)
c. Nymph
Pencil on paper
7¼ x 4¹¹⁄₁₆″ (18.3 x 11.8 cm)

d. Three Figures
Pencil on paper
7⁵⁄₁₆ x 4¹¹⁄₁₆″ (18.5 x 11.8 cm)
e. Two Women in Costume
Pencil on paper
7¼ x 4¹¹⁄₁₆″ (18.3 x 11.8 cm)
f. Laetitia Bonaparte
Pencil on paper
7⁵⁄₁₆ x 4¹¹⁄₁₆″ (18.5 x 11.8 cm)

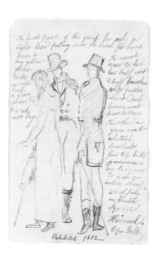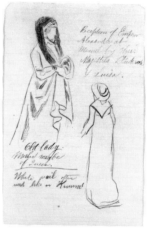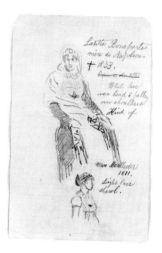

g. Mrs. Madison
Pencil on paper
7⁵⁄₁₆ x 4¹¹⁄₁₆″ (18.5 x 11.8 cm)
h. Woman with Parasol
Ink, pencil, and watercolor on paper
7¼ x 4¹¹⁄₁₆″ (18.3 x 11.8 cm)

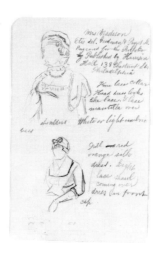

43. Models for "William Rush Carving His Allegorical Figure of the Schuylkill River"
Goodrich 498
1876–77
Philadelphia Museum of Art. Gift of Mrs. Thomas Eakins and Miss Mary Adeline Williams
Philadelphia only (plaster replicas [cast 1931] from the Philadelphia Museum of Art will be shown in Boston)

a. Water Nymph and Bittern
Pigmented wax, wood, muslin, wire, and nails
Height 9¾″ (24.8 cm)
b. George Washington
Pigmented wax, wood, wire, and nails
Height 8⅛″ (20.6 cm)

c. Head of Water Nymph
Pigmented wax, wood, and metal tubing
Height 7¼″ (18.4 cm)
d. Head of William Rush
Pigmented wax, wood, plaster, and nails
Height 7¼″ (18.4 cm)

e. The Schuylkill Freed
Pigmented wax, wood, wire, and nails
Height 4½″ (11.4 cm)

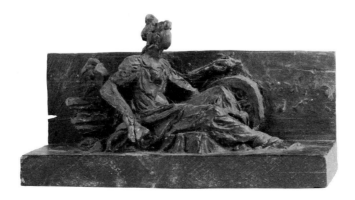

44. Study for "William Rush Carving His Allegorical Figure of the Schuylkill River"
Goodrich 111
1876
Oil on canvas
20³⁄₁₆ x 24″ (51.3 x 61 cm)
Yale University Art Gallery, New Haven.
Collection of Mary C. and James W. Fosburgh,
B.A. 1933, M.A. 1935

45. Study for "William Rush Carving His Allegorical Figure of the Schuylkill River"
Goodrich 113
1876–77
Oil on canvas
14⅛ x 11¼″ (35.9 x 28.6 cm)
The Art Institute of Chicago. Gift of
Dr. John J. Ireland

46. Interior of a Woodcarver's Shop (Sketch for "William Rush Carving His Allegorical Figure of the Schuylkill River")
Goodrich 112
1876–77
Oil on canvas
8⅝ x 13″ (21.9 x 33 cm)
Philadelphia Museum of Art. Gift of
Charles Bregler

54

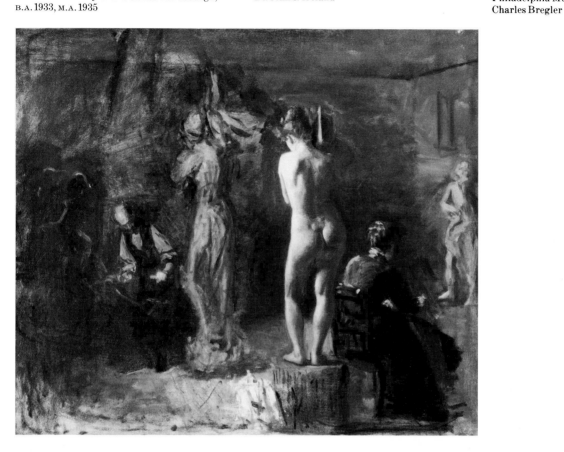

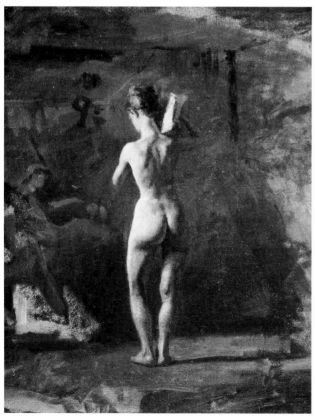

47. William Rush Carving His Allegorical Figure of the Schuylkill River
Goodrich 445
1908
Oil on canvas
36⁷⁄₁₆ x 48⁷⁄₁₆″ (92.5 x 123 cm)
The Brooklyn Museum, New York. Dick S. Ramsay Fund

48. Sketch for "William Rush Carving His Allegorical Figure of the Schuylkill River"
Goodrich 447
c. 1908
Oil on panel
6 x 8½″ (15.3 x 20.6 cm)
Hirshhorn Museum and Sculpture Garden, Smithsonian Institution, Washington, D.C.

49. Female Nude
Goodrich 203
c. 1908
Oil on canvas
24⅛ x 14⅛″ (61.3 x 35.9 cm)
Hirshhorn Museum and Sculpture Garden, Smithsonian Institution, Washington, D.C.

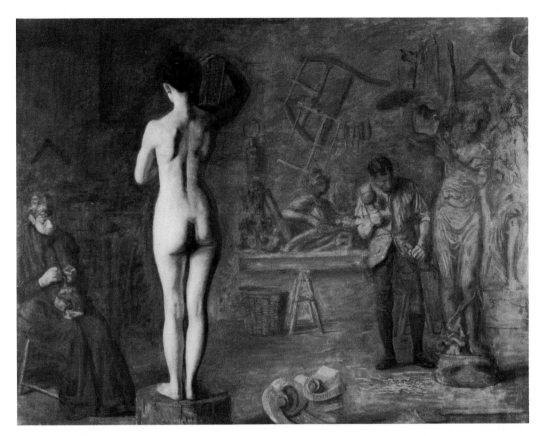

50. William Rush and His Model
Goodrich 451
c. 1908
Oil on canvas
35¼ x 47¼″ (89.5 x 120 cm)
Honolulu Academy of Arts. Gift of Friends of
the Academy, 1947

56

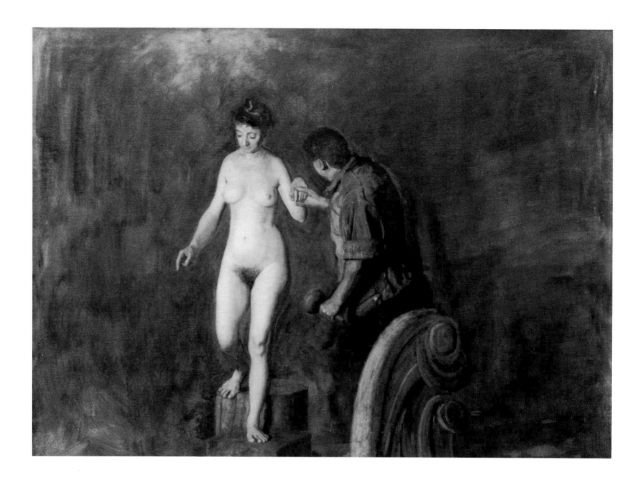

51. Sketch for "William Rush and His Model"
Goodrich 439
c. 1908
Oil on cardboard
14½ x 10½" (36.8 x 26.7 cm)
Philadelphia Museum of Art. Gift of Mrs.
Thomas Eakins and Miss Mary Adeline
Williams

52. Sketch for "William Rush and His Model"
Goodrich 454
c. 1908
Oil on canvas
20⅛ x 14" (51 x 35.4 cm)
Hirshhorn Museum and Sculpture Garden,
Smithsonian Institution, Washington, D.C.

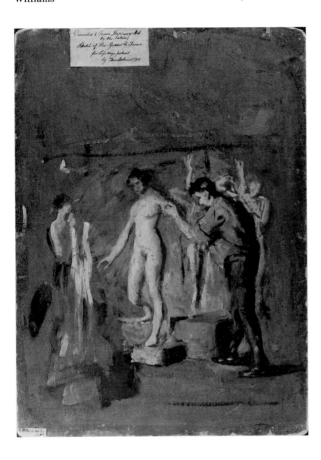

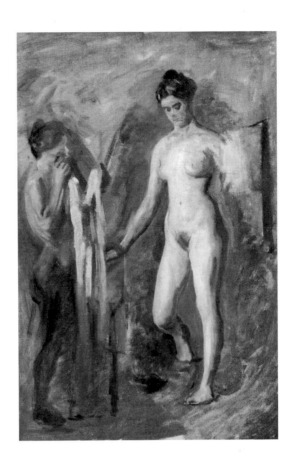

53. The Courtship
Goodrich 119
c. 1878
Oil on canvas
20 x 24″ (50.8 x 60.9 cm)
The Fine Arts Museums of San Francisco.
Gift of M. H. de Young, John McLaughlin,
J. S. Morgan and Sons, Miss Keith Wakeman,
and Mrs. Herbert Fleishhacker

54. Sketch for "The Courtship"
Goodrich 120
c. 1878
Oil on canvas
14 x 17″ (35.6 x 43.2 cm)
Collection of Mrs. John Randolph Garrett, Sr.

In 1876 Eakins made a small painting of an elderly woman in colonial dress working at a spinning wheel, the first of more than a dozen oils, watercolors, and sculptures that he would make during the next six years showing women in old-fashioned dress surrounded by artifacts of colonial times, spinning, knitting, or simply lost in reverie. The old-fashioned paintings are rare examples of Eakins's interest coinciding with public taste. The subjects were noncontroversial, and their period details and air of gentle sentimentality made them appealing; most were sold soon after they were painted.

Interest in America's colonial history and its architecture, painting, and decorative arts was beginning to grow at the time of the Centennial, but it found few manifestations in the exhibition itself. One of these was the New England Log House and Modern Kitchen, in which, it was reported, the "combination of quaint architecture, antiquated furniture, and the epochal costumes of the attendants gives one a pleasing view of life in New England a century ago."[1] Perhaps Eakins was as charmed by demonstrations of colonial life there as was William Dean Howells when he visited:

There are many actual relics of the Pilgrim days, all of which the crowd examined with the keenest interest; there was among other things the writing-desk of John Alden, and at the corner of the deep and wide fire-place sat Priscilla spinning—or some young lady in a quaint, old-fashioned dress, who served the same purpose. I thought nothing could be better than this, till a lovely old Quakeress, who had

stood by, peering critically at the work through her glasses, asked the fair spinster to let her take the wheel. She sat down beside it, caught some strands of tow from the spindle, and with her long-unwonted fingers tried to splice the broken thread; but she got the thread entangled on the iron points of the card, and there was a breathless interval in which we all hung silent about her, fearing for her success. In another moment the thread was set free and spliced, the good old dame bowed herself to the work, and the wheel went round with a soft triumphant burr, while the crowd heaved a sigh of relief. That was altogether the prettiest thing I saw at the Centennial.[2]

For the first painting, called *In Grandmother's Time*,[3] Eakins posed his model in a cap and full-skirted gown similar to the costumes worn by the women in the Centennial's New England Kitchen,[4] furnishing the space in which she sits with only a rag carpet and a child's toy cart and hobbyhorse. For the following work in the series, Eakins apparently drew upon the studies that he made for *William Rush Carving His Allegorical Figure of the Schuylkill*

River (*see* Chapter VI). In 1877, Eakins restudied the chaperone in that painting, making the knitting figure the subject of a watercolor entitled *Seventy Years Ago* [56]. Dressed in a long-sleeved gown otherwise similar in style to that in the Rush painting and seated in the same Chippendale chair, the old woman is turned toward the viewer and the details of the watercolor are concentrated on her intent face and gnarled hands. On one side of her is a spinning wheel and on the other, a tilt-top table, which with the chair and the costumed figure, form the repertory of furnishings that recur in the other works in this series. The tilt-top table appears in a water-color also of 1877, *Young Girl Meditating* [55], in which the table, a small bench, and three pots of geraniums define the space in which the figure stands.

In about 1878, Eakins continued with the spinning theme, this time making studies of Annie Williams, the young woman who had posed for the nude figure in the Rush painting, in preparation for his most explicitly anecdotal work, *The Courtship* [53]. The small sketch for the painting [54] demonstrates that Eakins planned the narrative of the picture in terms of the pos-tures of the two seated figures. The psychological relationship between the lounging figure of the young man and the girl who bends in-tently but self-consciously over her spinning is a subtle and affection-ate interpretation of the theme. The sketch also shows that Eakins planned to develop the background of the space into a more complete setting for the two figures, which for some reason he never followed in the final work. *The Courtship* was painted at a time when Eakins

was making illustrations for stories and poems in *Scribner's Monthly,* but perhaps he found even its restrained narrative too obvious for his taste and so left the painting incomplete.[5]

In 1881 Eakins turned again to the spinning theme with two water-colors of his sister Margaret, seen from different points of view, and with more completely furnished settings than the other old-fash-ioned subjects. In the one entitled *Homespun* [57], the effect of his-torical setting is reinforced by an open cupboard displaying silver and china, while in *Spinning* [60], a closed cupboard creates the same effect. Yet even in these water-colors, Eakins did not aim at the kind of historical accuracy that he sought in his Rush painting, or that other artists would represent in painstaking reconstructions in their colonial genre paintings in the following decades. He simply used the furniture and historical dress to evoke a general sense of past time.

Eakins's focus is upon a woman at work; the activities of spinning and knitting were of as much inter-est to him as the historical details and the general quaintness of the scene. And as much as in the rowing or sailing pictures, expert skill was important to insure correct appear-ance. Eakins recalled another model who had posed for a spinning

55. Young Girl Meditating
Goodrich 116
1877
Watercolor on paper
9 x 5⁹⁄₁₆″ (22.9 x 14.1 cm)
The Metropolitan Museum of Art, New York.
Fletcher Fund, 1925
Philadelphia only

subject: "After I had worked some weeks, the girl in learning to spin well became so much more graceful than when she had learned to spin only passably, that I tore down all my work and recommenced."[6] The difference in conception can be seen by comparing Eakins's pictures of spinning with paintings of women at spinning wheels done by his contemporaries Frank Millet and Thomas Wilmer Dewing.[7] Both of these artists used spinning as an opportunity to paint an antiquarian motif; their beautiful young women sit demurely at their spinning wheels but they are not at work.

In 1882 Eakins was commissioned to design two stone decorative panels as ornaments for the chimneypiece of a house for the Philadelphia businessman James P. Scott. These would be the first sculptures he made as works of art in themselves. The subjects chosen were two versions of the old-fashioned paintings: the figure of a young woman spinning [58], similar to his watercolor *Homespun* [57], and the figure of an old woman knitting [59], which combines the pose of the watercolor *Seventy Years Ago* [56] with the chaperone's costume in *William Rush Carving His Allegorical Figure of the Schuylkill River* [41].

Relief sculpture had been one of the subjects of Eakins's lectures to his students at the Pennsylvania Academy of the Fine Arts, and in a lecture manuscript of about 1884,[8] he considered the special problems of relief sculpture in detail. His models for the study of relief were the casts from the Parthenon frieze which decorated the studios of the Academy. But instead of the delicately modulated surfaces of the Parthenon sculptures, Eakins's panels are modeled in high relief, and accessories such as the spinning wheel and tilt-top table are strongly foreshortened. In a letter later written to his patron when Scott refused to accept the models for these works, Eakins explained his conception of relief sculpture as a problem of perspective in depth:

Relief work too has always been considered the most difficult composition and the one requiring the most learning. The mere geometrical construction of the accessories in a perspective which is not projected on a single plane but in a variable third dimension, is a puzzle beyond the sculptors whom I know.[9]

As part of the settlement of the dispute with Scott, the plaster models for the reliefs were returned to Eakins, who had bronze casts of them made, which he exhibited at the Society of American Artists in New York in the spring of 1887.[10]

56. Seventy Years Ago
Goodrich 114
1877
Watercolor on paper
15⅝ x 11″ (39.7 x 27.9 cm)
The Art Museum, Princeton University. Mather
Collection

62

57. Spinning (Homespun)
Goodrich 146
1881
Watercolor on paper
14 x 10⅞″ (35.6 x 27.6 cm)
The Metropolitan Museum of Art, New York.
Fletcher Fund, 1925
Boston only

58. Spinning
Goodrich 504
1882–83 (cast 1930)
Bronze
Height 18¼″ (46.4 cm)
Philadelphia Museum of Art. Gift of Mrs.
Thomas Eakins and Miss Mary Adeline
Williams

59. Knitting
Goodrich 505
1882–83 (cast 1930)
Bronze
Height 18⅜″ (46.7 cm)
Philadelphia Museum of Art. Gift of Mrs.
Thomas Eakins and Miss Mary Adeline
Williams

60. Spinning
Goodrich 144
1881
Watercolor on paper
11 x 8″ (27.9 x 20.3 cm)
Collection of Mrs. John Randolph Garrett, Sr.

61. The Fairman Rogers Four-in-Hand (A May Morning in the Park)
Goodrich 133
1879–80
Oil on canvas
23¾ x 36″ (60.3 x 91.4 cm)
Philadelphia Museum of Art. Gift of William Alexander Dick

62. Sketch of Fairmount Park
Goodrich 136
1879 or 1880
Oil on wood panel
14⁹⁄₁₆ x 10¼″ (37 x 26 cm)
Philadelphia Museum of Art. Gift of Mrs. Thomas Eakins and Miss Mary Adeline Williams
Philadelphia only

The Fairman Rogers Four-in-Hand [61] is one of Eakins's rare excursions into the world of fashionable subject matter. The painting, originally called *A May Morning in the Park*, shows Fairman Rogers, one of the first Philadelphians to own and drive a four-in-hand coach, with whip in hand, his wife beside him, driving through Fairmount Park. Incongruously crowded together in the row behind Mr. and Mrs. Rogers are Mrs. Rogers's sister Mrs. Franklin A. Dick, and her husband, and Mrs. Rogers's brother George Gilpin, with his wife. The polished red and black body of the coach, painted with great precision, the shining coats of the horses in their monogrammed harnesses, and the carefully studied portraits of the passengers are all satisfying in their material details. But probably what appealed to Rogers, who commissioned this painting for five hundred dollars—the largest sum the artist had yet received for his work—and what must have appealed to Eakins was the satisfaction of knowing that for the first time in history, the movement of horses would be accurately and exactly depicted as the result of both the artist's and patron's interest in recent discoveries about the actual appearance of horses in motion.[1]

Rogers, who was trained as a civil engineer, was chairman of the Committee on Instruction at the Pennsylvania Academy of the Fine Arts when Eakins was invited to return there to teach in 1879. When Eakins was made head of the Academy school, Rogers supported his approach to the teaching of art, and in an article in the *Penn Monthly* in 1881, he explained Eakins's program of study at the Academy and defended its more controversial aspects. In describing the student work in anatomy and dissection, Rogers noted that in addition to human anatomy, anatomy of animals and especially horses was being studied:

The horse enters so largely into the composition of pictures and statuary, especially into works of the higher order, such as historical subjects, and is generally so badly drawn, even by those who profess to have made some study of the animal, that the work seems to be of value. Like the work from the human model, it is intended more to give an accurate fundamental knowledge of the animal, than to teach how to portray him in his varied movements, which are only to be studied out of doors.[2]

Although the actual study of dissection and the living horse began only in 1881, Eakins had made reliefs of horses using Rogers's own prize mare Josephine in 1878 [79], and also a relief sculpture of a horse skeleton [80] for the use of his students at the Academy. That Rogers himself was interested in the exact appearance of moving horses is evident in the fact that he purchased a series of Eadweard Muybridge's photographs of horses in motion soon after they appeared in 1878.[3]

63. Sketch for "The Fairman Rogers Four-in-Hand"
Goodrich 134
1879
Oil on wood panel
10¼ x 14½" (26 x 36.8 cm)
Philadelphia Museum of Art. Gift of Mrs.
Thomas Eakins and Miss Mary Adeline Williams
Philadelphia only

66

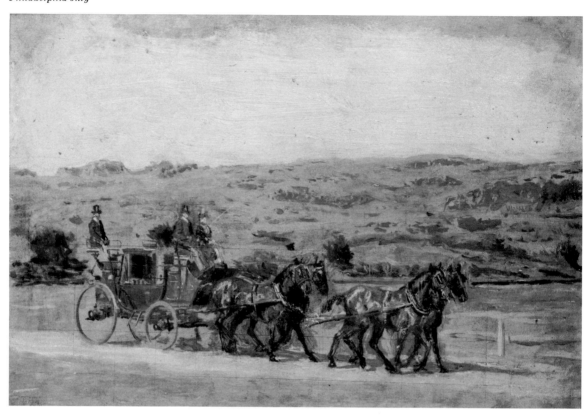

These instantaneous photographs taken in rapid succession showed the exact position of a horse's legs while trotting, which until then had never been accurately recorded. Without a doubt, Rogers showed these photographs to Eakins, for he gave them to the Academy in 1878. Perhaps it was these photographs that sparked the idea of *The Fairman Rogers Four-in-Hand*.

In June and September 1879, in preparation for the painting, Eakins made trips to Rogers's summer cottage in Newport, Rhode Island, to study the horses in motion out of doors. There he made the small sketch showing Mr. and Mrs. Rogers and one groom driving in front of the rocky coastal hills in Newport [63]. This sketch, which is on a small wooden panel of the kind that an artist fits inside his portable paint box, was probably painted out of doors, but the overpainting in green that can be seen around the legs of the horses shows that Eakins adjusted their position to conform to what he had learned from Muybridge's photographs. In showing the legs of each horse in a slightly different position, he represented the series of trotting motion that is shown sequentially in the Muybridge photographs.

At some point Eakins decided to reverse the direction in which the coach and horses were traveling and to show them in a somewhat more foreshortened view. To do this, he utilized models of the horses [69] that he had made in much the same way he had made wax models of William Rush's sculptures in preparing for the painting *William Rush Carving His Allegorical Figure of the Schuylkill River (see* Chapter VI). There can be little doubt that he modeled the horses from the animals themselves but again he corrected the horses' legs to conform to the Muybridge photographs. In preparing the small individual studies of the horses in motion [64–68], which he relied on for painting the final picture, he again apparently used both the models and the actual horses. Eakins may have carried out much of his work in Newport, but he made additional sketches in Philadelphia and then completed the painting in his studio. One of his students, Charles Bregler, remembered later that the coach was painted from an accurate perspective drawing made by its manufacturer. For the background, Eakins made on-the-spot studies of the landscape in Fairmount Park [62].

When *The Fairman Rogers Four-in-Hand* was first exhibited in November 1880 at the second annual exhibition of the Philadelphia Society of Artists, reviewers were critical of the portrayal of motion. Some, such as the critic of the *Philadelphia Daily Times*, thought it "impossible to accept as true, unless it be that Mr. Eakins' perceptions are right and those of everybody else are wrong."[4] A more general criticism, however, was whether or not the scientific representation of motion was an appropriate subject for art, or, as the writer for the *Philadelphia Press* put it:

Mr. Eakins is a builder on the bedrock of sincerity, and an all-sacrificing seeker after the truth, but his search is that of a scientist, not of an artist. . . . He has acquired this knowledge and skill by arduous study, study not confined to outward phenomena, but dealing with constituents, from the skeleton to the skin. . . . But suppose these studies, instead of being held as means, become an end, knowledge being pursued for its own sake? Then such pursuit may develop a good demonstrator of anatomy, but never an artist. . . . As a mechanical experiment it may be a success; on that point we express no judgment, but as to the matter of framing the experiment, hanging it in a picture gallery, and calling it A Spring Morning in the Park, we have to express a judgment decidedly adverse.[5]

64. Study of Right Leader Horse
Goodrich 199 (verso)
1879
Oil on wood panel
14⅝ x 10⅜″ (37 x 26.2 cm)
Hirshhorn Museum and Sculpture Garden,
Smithsonian Institution, Washington, D.C.
Philadelphia only

68

65. Study of Left Leader Horse
Goodrich 182 (verso)
1879
Oil on wood panel
14½ x 10¼″ (36.8 x 26 cm)
Philadelphia Museum of Art. Gift of Mrs.
Thomas Eakins and Miss Mary Adeline Williams
Philadelphia only

68. Study of Left Leader Horse
Goodrich 201 (verso)
1879
Oil on wood panel
10⅜ x 14⅝″ (26.2 x 37.1 cm)
Hirshhorn Museum and Sculpture Garden,
Smithsonian Institution, Washington, D.C.
Philadelphia only

66. Study of Left Wheeler Horse
Goodrich 137
1879
Oil on wood panel
14⅝ x 10¼" (36.9 x 26 cm)
Hirshhorn Museum and Sculpture Garden,
Smithsonian Institution, Washington, D.C.
Philadelphia only

67. Study of Left Wheeler Horse
Goodrich 137 (verso)
1879
Oil on wood panel
10⅜ x 14⅝" (26.1 x 37 cm)
Hirshhorn Museum and Sculpture Garden,
Smithsonian Institution, Washington, D.C.
Philadelphia only

**69. Models of Horses for "The Fairman Rogers
Four-in-Hand"**
1879 (cast 1946)
Bronze
Philadelphia Museum of Art.
Bequest of Mr. and Mrs.
William M. Elkins
Left Leader Horse
Length 12¼" (31.1 cm)
Right Leader Horse
Length 11⅞" (30.2 cm)
Left Wheeler Horse
Length 11¾" (29.8 cm)
Right Wheeler Horse
Length 11¹⁵⁄₁₆" (30.3 cm)

70. Mending the Net
Goodrich 155
1881
Oil on canvas
32⅛ x 45⅛″ (81.6 x 114.6 cm)
Philadelphia Museum of Art. Gift of Mrs.
Thomas Eakins and Miss Mary Adeline
Williams

**71. Geese in Gloucester, New Jersey
(Study for "Mending the Net")**
Hendricks 29
c. 1881
Photograph
3¹⁵⁄₁₆ x 7¼″ (10 x 18.4 cm)
Hirshhorn Museum and Sculpture Garden,
Smithsonian Institution, Washington, D.C.

Around 1880 Eakins purchased a camera and began to use it to make studies for his paintings. Before then he had used photographs taken by others in preparing his paintings, for example, photographs of Dr. Gross in painting *The Gross Clinic* [33] and Muybridge's studies of motion for *The Fairman Rogers Four-in-Hand* [61]. But paintings made immediately after 1880 can be related directly to photographic studies taken specifically for them.

In the early 1880s, Eakins took a series of photographs of the shad-fishing areas of the Delaware River in Gloucester, New Jersey, which he incorporated into paintings of fishermen drawing in shad in their nets. One of these, the watercolor entitled *Drawing the Seine* [72], was taken directly from a photograph [73] and shows that Eakins was interested not merely in the photograph as it recorded the subject but also in the selective focus of the camera lens. He copied the photograph exactly, blurring the foreground and distance and leaving the middle ground, with the workmen and their horse drawing in the net, in the sharpest focus as it is in the photograph. In *Shad Fishing at Gloucester on the Delaware River* [74], painted in 1881, Eakins also used this selective focus, relying on a series of photographs of

fishermen laying out their nets [75].[1] None of these photographs is a direct study for the painting, but Eakins relied on them almost as if he were using drawn studies for a painting. Gordon Hendricks suggested that the group of standing figures watching the fishermen from the shore in *Shad Fishing* is Eakins's own family, and includes his Irish setter Harry.[2] Eakins originally intended this group to be half-hidden behind a sandbank, which would have formed an even more dramatic composition and one much more photographic in its style.[3] The sharply defined figures emerging from the bank would have given the picture something of the arbitrary and momentary view of an Impressionist painting. Careful examination of the canvas shows that the lower halves of the figures are painted in slightly different colors and with slightly less care than their upper halves, and that the dog was part of this later addition. Instead of being interested in carefully observed effects

72

of specific light at different times
of day, such as the glitter of sun-
light on the water in the rowing
pictures (*see* Chapter III), Eakins
created a tonal composition with a
light-filled atmosphere but without
the specifics of reflections or
highlights.

For *Mending the Net* [70],
Eakins probably made a series of
photographic studies. One of them,
a photograph of a group of geese
[71], is similar to the group in the
foreground of the painting; Eakins
used the geese as they appear in the
photograph, incorporating both
their distinctive shapes and their
blurred forms in the canvas. The
group of fishermen mending their
net are shown in great detail in the
middle ground, but as Siegl pointed
out, even within the group there is a
carefully manipulated difference
of detail. The figure at the left is the
most precisely painted, while the
others become progressively
blurred the farther they are to the
right.[4] This work, like *The Meadows,
Gloucester* [76]—the only large
finished landscape Eakins painted—
illustrates the point he made in his
lecture on the focus of the eye that

when looking at an object, the eye
can focus on only one thing at a
time :

*If you hold up your two forefingers
in front of your eye one at arm's
length & the other half a bar, the eye
cannot see them both sharp at the
same time. If you sharpen your eye
on the near one the distant one
blurs, but if you look sharp at the
far one, then the near one blurs.*

*Now if you should attempt to
paint a picture of these two fingers,
you must choose to look at one or the
other finger & give to it only the
sharpness. The attempt to paint
them both sharp would make the far
one look if properly proportioned
like a finger half the size it ought to
be or the near one double the size.*

*The character of depth is incom-
patible with that of sharpness
especially as you go out sideways
from the point of sight, & one or the
other characteristic must be
sacrificed in a picture.*[5]

72. Drawing the Seine
Goodrich 159
1882
Watercolor on paper
11¼ x 16½″ (28.6 x 41.9 cm)
John G. Johnson Collection, Philadelphia

73. Horse and Fishermen in Gloucester, New Jersey (Study for "Drawing the Seine")
Hendricks 31
c. 1882
Photograph
3⁷⁄₁₆ x 4⁵⁄₁₆″ (8.7 x 11 cm)
Collection of John Medveckis

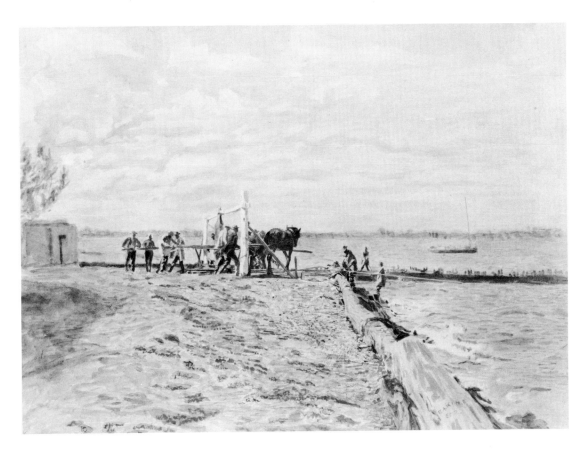

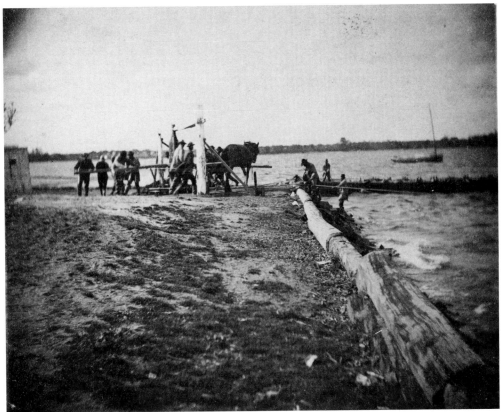

**74. Shad Fishing at Gloucester on the
Delaware River**
Goodrich 152
1881
Oil on canvas
12⅛ x 18⅛″ (30.8 x 46 cm)
Philadelphia Museum of Art. Gift of Mrs.
Thomas Eakins and Miss Mary Adeline
Williams

**75. Fishermen in Gloucester, New
Jersey (Study for "Shad Fishing at
Gloucester on the Delaware River")**
Hendricks 32
c. 1881
Photograph
2⅞ x 3⅞″ (7.3 x 9.8 cm)
Collection of Douglas W. Mellor

74

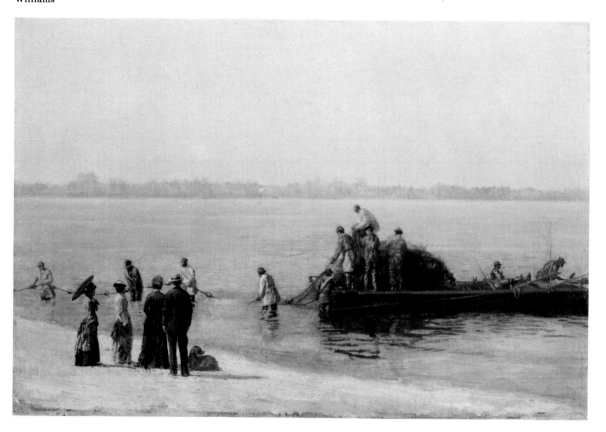

76. The Meadows, Gloucester
Goodrich 161
c. 1882
Oil on canvas
31¹⁵⁄₁₆ x 45⅛″ (81.1 x 114.6 cm)
Philadelphia Museum of Art. Gift of Mrs.
Thomas Eakins and Miss Mary Adeline
Williams

X. Anatomy

77. Back of Male Torso
1880 (cast 1930)
Bronze
Height 30¼″ (76.8 cm)
Philadelphia Museum of Art. Gift of R.
Sturgis Ingersoll

The morality of requiring young art students to study from the nude figure was a controversial issue surrounding Eakins's teaching at the Pennsylvania Academy of the Fine Arts, although life classes in which students drew and painted from the nude figure were the mainstay of academic education in Europe and in the United States. While the emphasis Eakins placed on the study of the nude figure could be questioned, its role in the curriculum of a serious art school was not in doubt. Dissection, however, another of Eakins's innovations based upon his own experience as a student, was unique to the program at the Academy. Dissection raised none of the moral questions that study from the nude figure did, but its place in an art school program did raise philosophical questions, questions that later contributed to Eakins's dismissal from the Academy.

Lectures and anatomical demonstrations were a traditional part of the academic curriculum and had been held in Philadelphia at the Academy before its closing in 1870. When the Academy reopened in 1876, a noted surgeon, Dr. William Williams Keen, inaugurated a series of lectures on artistic anatomy, which he was to continue every year until 1890. In his lectures Keen demonstrated artistic anatomy using living models, statues, skeletons, and dissected cadavers to show the skeletal structure and muscular composition of the body. Eakins's own anatomical study had begun in Philadelphia when he attended lectures in anatomy at Jefferson Medical College. He had continued his anatomical studies in Paris, possibly even doing dissections there, and he resumed these

studies after returning to Philadelphia in 1870. When Eakins began teaching in the evening life-drawing classes at the Academy in 1876, he also assisted Dr. Keen with his anatomy lectures by preparing cadavers, and interested his students in the dissections as well. Keen reported this to the Board of Directors in 1877:

I cannot refrain also from expressing my very deep obligations to Mr. Eakins & some of the students who by their very careful & admirable dissections of the subjects I had, lightened my labors very materially. Mr. Eakins also dissected & has made casts of the muscles of the Cat & the Dog for the collection of the Academy. He expects soon to dissect with Equal care the Horse & the Sheep.[1]

In his article on the art schools of Philadelphia published in *Scribner's Monthly* in 1879, William C. Brownell noted that " what chiefly distinguishes the Philadelphia school . . . is its dissections for advanced pupils."[2] He pointed out that while lectures similar to those of Dr. Keen were common to most art schools, dissection was almost unknown in the United States, although it was encouraged, but not insisted upon or provided for, in Europe. In his description of the courses at the Academy published in the *Penn Monthly* in 1881, Fairman Rogers proudly stated:

The anatomical study is so much more complete than in other art schools, that it requires special notice. Acting upon the principle

78. Right Shoulder, Arm, and Hand
1880 (cast 1930)
Bronze
Length 27½″ (69.9 cm)
Philadelphia Museum of Art.
Gift of R. Sturgis Ingersoll

that everything that can be, should be learned from the original source, the advanced students are encouraged to dissect and to examine for themselves, thus becoming familiar with the mechanism of the body, without which knowledge it is impossible to portray correctly those poses which, from their nature, a model cannot readily assume at will or retain.... These facilities for the study of anatomy are much superior to those possessed by any art school in the world; in the European schools, lectures are given, more or less well illustrated; but the student has to depend for his dissection upon the medical schools or the hospitals.[3]

As an aid to the study of anatomy, Eakins prepared dissections that were cast in plaster and made available to students, as Rogers described:

There are arrangements in the dissecting rooms for making plaster casts, and a set of anatomical casts have been made, duplicates of which are furnished to students, and to art institutions that desire them, at low prices.[4]

Eakins is known to have made at least seventeen casts of the human anatomy, as well as many duplicates of each, although few remain today. The two examples illustrated here[77, 78] come from Eakins's own collection of plasters, which were cast in bronze only after his death.

In addition to the study of human anatomy and the dissection of cadavers, Eakins made a series of studies of animal anatomy, such as the relief of the mare Josephine [79] belonging to Fairman Rogers,

which he sculpted in 1878, and the horse skeleton [80] made the same year. A few years later Eakins and his students went regularly to a bone-boiling establishment to do dissections of horses, and in 1882 made a sculpted figure of a dissected horse [81]—probably also Josephine—to provide a complete set of anatomical models for study. Eakins's skill at animal anatomy was publicly recognized in 1891, when his friend the sculptor William R. O'Donovan asked him to collaborate on the commission he had received for bronze equestrian reliefs of Abraham Lincoln and Ulysses S. Grant for the Soldiers' and Sailors' Memorial Arch in the Grand Army Plaza in Brooklyn. A somewhat later account explained:

There is probably no man in the country, certainly no artist, who has studied the anatomy of the horse so profoundly as Eakins, or who possesses such intimate knowledge of its every joint and muscle.[5]

Eakins modeled Clinker, a horse belonging to Alexander J. Cassatt of Philadelphia[82], as an appropriately noble mount for Grant.

In his commitment to anatomy and dissection as an important part of the art school curriculum, Eakins was supported by Fairman Rogers, who shared his interest in the scientific study of the figure. Brownell, however, raised the question of the need or appropriateness of a rigorous study of anatomy as part of an art curriculum, and used

79. The Mare Josephine
Goodrich 499
1878 (cast 1930)
Bronze
Height 22⅛″ (56.2 cm)
Philadelphia Museum of Art. Gift of Mrs.
Thomas Eakins and Miss Mary Adeline
Williams

80. Horse Skeleton
Goodrich 500
1878 (cast 1930)
Bronze
11 x 14″ (28 x 35.6 cm)
The Butler Institute of American Art,
Youngstown, Ohio

81. The Mare Josephine (Ecorché)
Goodrich 502
1882 (cast 1930)
Bronze
Height 22¼″ (56.5 cm)
Philadelphia Museum of Art. Gift of Mrs.
Thomas Eakins and Miss Mary Adeline
Williams

82. Clinker (Model for Relief for Brooklyn Memorial Arch)
Goodrich 511
1892 (cast 1930)
Bronze
25 x 25½″ (63.5 x 64.8 cm)
Philadelphia Museum of Art. Gift of Mrs.
Thomas Eakins and Miss Mary Adeline
Williams

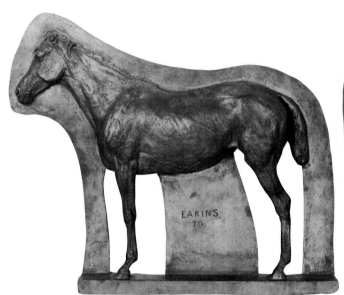

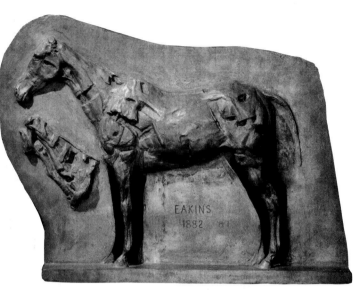

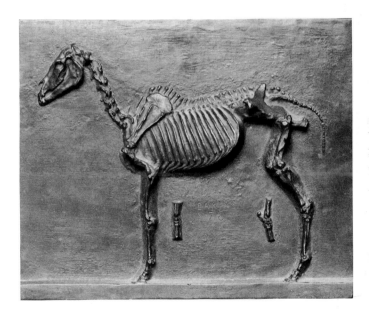

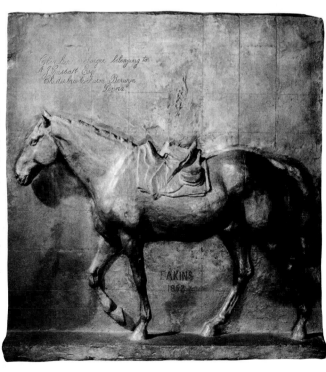

83. Seated Nude Man
Hendricks 193
c. 1890
Photograph
4¹⁵⁄₁₆ x 4″ (12.5 x 10.1 cm)
Philadelphia Museum of Art.
Bequest of Mark Lutz

84. Kneeling Nude Woman
1884
Photograph
3¾ x 3⁵⁄₁₆″ (9.5 x 8.4 cm)
Collection of Seymour Adelman

80 the question of dissection to raise larger questions about Eakins's approach to teaching art, in spite of Eakins's view:

No one dissects to quicken his eye for, or his delight in, beauty. He dissects simply to increase his knowledge of how beautiful objects are put together to the end that he may be able to imitate them.[6]

Brownell emphasized the unpleasantness and unaesthetic aspects of dissection as a study, and feared

the danger arising from constant association with what is ugly and unpoetic, however useful, instead of even occasional association with what is poetic and beautiful, however useless.[7]

And while he admired the thoroughness of education at the Academy, he concluded:

Constant attention to the mechanism of art does little to quicken one's sympathy with the spirit which is the vital element of every work of art, and lacking which, however correct, every work of art becomes lifeless; and that a thirst for knowledge by no means leads to a delight in beauty.[8]

The unaesthetic and occasionally unpleasant aspects of work at the Academy, recognized by Eakins as part of the grinding labor required for an artist's training, were objected to by members of the Academy's Board of Directors and by many of Eakins's students, and

85. **Blanche Hurlbut**
1883
Seven photographs
3⅛ x 8⅛″ (7.9 x 20.6 cm)
Olympia Galleries Limited, Philadelphia

86. **George Reynolds**
1883
Seven photographs
3⅛ x 7⅜″ (7.9 x 18.7 cm)
Olympia Galleries Limited, Philadelphia

87. **Comparative Analysis of Anatomical Photographs**
1883
Ink on tracing paper
Left: 3¾ x 2¼″ (9.5 x 5.7 cm); right: 3¼ x 8¼″ (8.3 x 20.9 cm)
Olympia Galleries Limited, Philadelphia

81

the desire for a broader and less rigorous program of instruction became an additional reason for Eakins's dismissal in 1886.

Another innovative aspect of Eakins's teaching (although not officially taught as a course at the Academy because of resistance by members of the board[9]) was the use of photography both for study and for the creation of a work of art. Photography was important to Eakins's own work at the time. He himself owned a camera by at least 1880, and during the following years he made photographic studies to aid him in composing paintings and sculpture (*see* Chapter IX). Eakins apparently brought his camera to the Academy and made a series of photographs of students posing in classical garb, and he, or some of his students, also made photographs, some humorous, some serious, of classes at the Academy. It has long been known that Eakins used his students and members of his family as models for his photographic studies, but a recently discovered series of photographs further reveals his use of photography to study anatomy [85, 86]. This series of forty-two cardboard strips shows Eakins, his students, and professional models posing in a variety of standardized poses, which allows a detailed comparative study of the figures. On the one hand, these show Eakins's interest in anatomical study and on the other, cast a new light on the outrage and rumor that accompanied his years of teaching. The use of his students, both male and female, for nude photographic studies, which were accessible—albeit in a limited fashion—for study by other students at the Academy, indicates the degree of Eakins's lack of concern

for conventional propriety. Drawings that Eakins made of outlines of some of the figures with notations clearly indicating that he was studying the axis of movement and the distribution of weight through the body [87] show that his interest was almost clinical in nature. However, the fact that all the students who can be identified in this series were among those deeply committed to Eakins's teaching suggests that there was something of an initiation rite for an inner circle of art students in the making of these photographs. In the matter-of-fact systematic poses there is such an obvious interest in the simple study of the nude figure, and a total lack of interest in any sort of artistic surrounding or pretense, that it is easy to see how an observer unfamiliar with the purpose of these studies could have been outraged by them. In their very plainness and lack of aesthetic trappings can be seen the reasons for the public outcry that surrounded Eakins.

Because Eakins used photographs as studies and as a means to an artistic end, he seldom purposely made a photograph that was beautifully composed as an end in itself. Among the exceptions to this are two photographs in which the models seem to be arranged in a way that finds beauty within the figure and the pose itself [83, 84].

Eakins's use of photography for anatomical study extended to the figure in motion. Eakins was keenly interested in the work of Eadweard Muybridge, whose photographs of horses in motion he had used in 1879 in his studies for *The Fairman Rogers Four-in-Hand* (*see* Chapter VIII). When Muybridge proposed to conduct an extensive photographic study of human and animal movement at the University of Pennsylvania in 1884, Eakins was named to the advisory committee appointed to supervise the work. Eakins himself had apparently been experimenting with the apparatus for taking instantaneous photographs some time before, for in 1883 he demonstrated to the Philadelphia Photographic Society an improvement in a procedure that would allow very short exposures. In the spring of 1884, at the same time that Muybridge was beginning his photographs at the University of Pennsylvania, Eakins began to experiment with a technique that paralleled Muybridge's work. Instead of Muybridge's system of using a series of cameras triggered in succession to produce a sequence of individual photographs that recorded the complete cycle of an action, Eakins preferred another system, one invented by the French scientist Etienne-Jules Marey, which used a single camera to produce a series of exposures on one negative. Eakins experimented with both a moving negative plate[10] and a moving shutter [88–90], for which he developed an improved system described in the chapter "The Mechanism of Instantaneous Photography" written by William Dennis Marks and included in *Animal Locomotion:*

The Muybridge Work at the University of Pennsylvania—The Method and the Result.[11] Eakins used his students as models for his photographs, attaching black balls to the shoulders, hips, and knees of one of them, for example, to show the pattern of movement of the figure [88]. The Pennsylvania Academy of the Fine Arts apparently supported Eakins's experiments in photography, and Eakins exhibited the photograph of an unidentified model jumping as the *History of a Jump* at the Academy in 1886. This photograph was described and reproduced as an engraving by Marks:

The reproduction of a boy jumping horizontally . . . which Professor Eakins has photographed on a single plate by means of his adaptation of the Marey wheel, is of exceedingly great interest, because, in this picture, each impression occurred at exact intervals. The velocity of motion can be determined, by measurement of the spaces separating the successive figures, with very great precision, as also the relative motions of the various members of the body.[12]

88. Man Running to the Left
Hendricks 103
1884
Photograph
3¾ x 4¹³⁄₁₆″ (9.5 x 12.2 cm)
Philadelphia Museum of Art.
Gift of Charles Bregler

89. Man Pole-Vaulting to the Right
1884
Photograph
5¹⁄₁₆ x 6¾″ (12.8 x 17.1 cm)
Philadelphia Museum of Art.
Gift of Charles Bregler

90. Boy Jumping Horizontally
Hendricks 113
1884
Photograph
3¹³⁄₁₆ x 4⅞″ (9.7 x 12.4 cm)
Philadelphia Museum of Art.
Gift of Charles Bregler

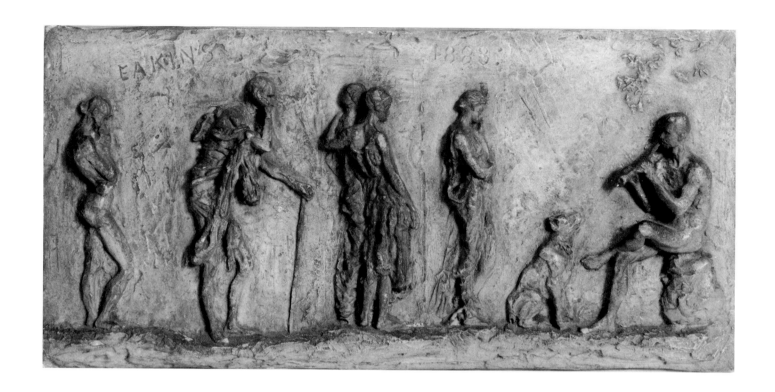

91. Arcadia
Goodrich 506
1883–84
Plaster with transparent brown patina
11¾ x 24″ (29.8 x 61 cm)
Philadelphia Museum of Art. Purchased:
J. Stogdell Stokes Fund
Philadelphia only

92. J. Laurie Wallace (Study for "Arcadia")
Hendricks 47
1883
Photograph
3¼ x 4⅞″ (8.3 x 12.4 cm)
Philadelphia Museum of Art. Bequest of
Mark Lutz

Although Eakins regularly skipped the antique week in Gérôme's studio,[1] his resistance to the study of antique sculpture did not stem from his lack of interest in it, but from the policy of taking the sculpture as an ideal of form to be used in drawing or painting the human figure. Eakins wanted his students to study from nature as the Greeks had, and he encouraged them to begin painting early from the live model. But the example of Greek and Roman art was always before him. The Pennsylvania Academy of the Fine Arts had the largest collection of antique casts in the United States at the time, and antique sculpture was part of his artistic sensibility whether or not he incorporated it into his art.

Among the photographs attributed to Eakins are some that show Academy students dressed in costumes that seem to attempt to copy exactly Greek and Roman dress. The students wear carefully draped robes stenciled in antique patterns, their hair is bound in fillets, and sandals are on their feet. They are shown in the Academy studios in self-consciously "antique" poses along with casts of ancient sculpture, which would suggest either the deliberate archaeology of a costume class, such as those held then in other art schools, or careful preparation for a fancy dress party. In other photographs of female

models, taken in Eakins's studio [94], the draperies are more casually arranged and suggest costumes conceived more generally as "old." The models, too, are posed more casually, as in the photograph of two women with a cast of Eakins's sculpture *Arcadia* [93]. The drapery recalls the treatment of drapery in the relief itself [91], and the pose of the woman at right echoes that of the woman who stands listening to the piper in *Arcadia*.

In approaching the Arcadian theme, Eakins returned to the depiction of the nude figure, which with the exception of his painting of William Rush [41], he had abandoned since he left Paris. In conceiving the two paintings and three sculptures of Arcadian themes made about 1883,[2] Eakins was working within an established tradition. Gérôme had painted carefully researched scenes from Roman history, such as *The Death of Caesar* and *Pollice Verso*,[3] which Eakins had studied in Paris. In England, Sir Lawrence Alma-Tadema and Albert Moore had exhibited more decorative versions of ancient scenes, and Eakins's contemporaries Thomas Wilmer Dewing and Frank Millet had

93. Models in Greek Costumes
Hendricks 62
c. 1883
Photograph
3¾ x 4½" (9.5 x 11.2 cm)
Hirshhorn Museum and Sculpture Garden,
Smithsonian Institution, Washington, D.C.

94. Seated Model in Greek Costume
Hendricks 182
1892?
Photograph
3³⁄₁₆ x 2⁵⁄₁₆" (8.1 x 5.9 cm)
Collection of Mr. and Mrs. Daniel W. Dietrich, II

shown paintings with a similar conception in New York.[4] Unlike their presentation of the theme, Eakins's treatment of the ancient past was not archaeological, decorative, or anecdotal; his choice of a much older time points to an interest in a simplicity of life that is similar in mood to his old-fashioned subjects (*see* Chapter VII). Like these paintings of women in settings of an earlier time, the style of the past is suggested not with a carefully reconstructed setting but with only a few telling details.

In these works Eakins used the narrative device of a standing or reclining figure listening to a man playing a reed flute. As studies for the paintings and sculptures, he made a series of outdoor photographs of his male students in the nude pretending to play the pipes [92, 97]. As a model for the young boy in the painting [95], he photographed his nephew Ben Crowell [96], but for the female figure he may have used a model posed in his studio. He also incorporated elements from the photographs into the landscape of the paintings. Both Arcadian paintings are unfinished, perhaps because Eakins was dissatisfied with the effect of strongly lighted, realistically painted figures as means to convey the mood of a past time. The difficulty of reconciling an ideal subject with a realistic portrayal confronted a number of artists in the late nineteenth century, and perhaps Eakins felt the Arcadian subject was best handled in sculpture, a medium itself associated with ancient art.

At about this time, while Eakins was occupied with the spinning and knitting reliefs [58, 59], he wrote a lecture on the problems of sculpture in relief, in which he stated his admiration for Greek sculpture:

The best examples of relief sculpture are the ancient Greek.... The simple processions of the Greeks viewed in profile or nearly so are exactly suited to reproduction in relief sculpture.... Nine tenths of the people who have seen casts of the frieze of the Parthenon would say the figures are backed by a plane surface so gentle are its numerous curves which are instantly seen on looking endways or putting [it] in a skimming light.[5]

In the sculptured panel *Arcadia* [91], the illusionistic problems of space and light are eliminated, and Eakins created for himself a "simple procession" of figures, which depend upon their rhythmic arrangement on the rectangular panel for their effect. Eakins never exhibited the Arcadian panel during his lifetime, but he included it in the background of the painting of his wife called *Portrait of a Lady with a Setter Dog* [134], and he made plaster replicas that he gave away to his friends.

95. Arcadia
Goodrich 196
c. 1883
Oil on canvas
38⅝ x 45″ (98.1 x 114.3 cm)
The Metropolitan Museum of Art, New York.
Bequest of Miss Adelaide Milton de Groot, 1967

88

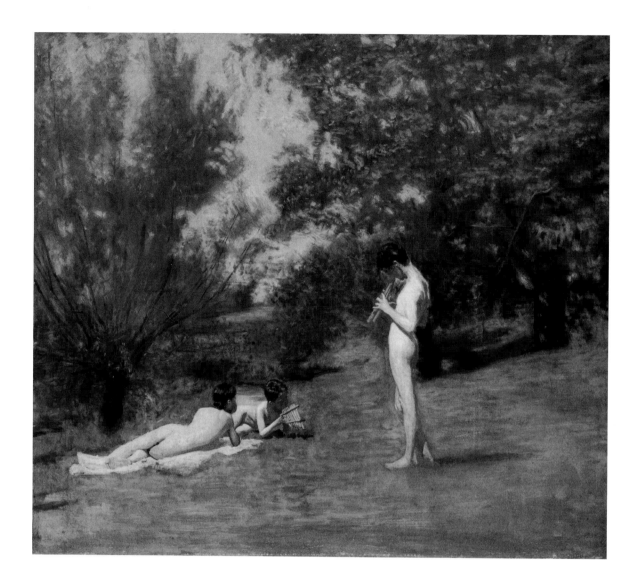

96. Ben Crowell (Study for "Arcadia")
Hendricks 48
1883
Photograph
4¼ x 6″ (10.7 x 14.7 cm)
Hirshhorn Museum and Sculpture Garden,
Smithsonian Institution, Washington, D.C.

97. Standing Piper (Study for "Arcadia")
Hendricks 45
1883
Photograph
3½ x 3⁹⁄₁₆″ (8.5 x 8.7 cm)
Hirshhorn Museum and Sculpture Garden,
Smithsonian Institution, Washington, D.C.

About the same time that Eakins was at work on the Arcadian subjects, he was commissioned to paint *The Swimming Hole* [100]. In it Eakins may have seen the opportunity to reinterpret the archaic in modern terms. Instead of using an ancient theme as an excuse for painting nude figures, he chose a modern subject, but made the nude figures, in their poses, recall antique sculpture. An entry in Eakins's journal for 1883, dated July 31, and headed "Swimming Pictures," lists the artist's expenses for photographic equipment and carfare to Bryn Mawr.[6] The photographs that resulted from this outing [98][7] show Eakins and his students swimming off a rocky ledge in the landscape that appears in the finished painting. The process of making the picture was described by Charles Bregler:

For a picture ... like the "Swimming Hole," a small sketch was made 8 x 10 inches [99], then separate studies of the landscape and figures, to get the true tone and color, etc. The diving figure being the most difficult to paint, was first modelled in wax. This gave him a thorough knowledge of every form.[8]

Eakins may also have employed Muybridge's photograph of tumbling figures in his study of the diving figure,[9] and he may have developed the composition in a second series of photographs which show nude male figures posed out of doors on a large wooden platform.[10]

98. Eakins's Students at the Site of "The Swimming Hole"
Hendricks 42
1883
Photograph
3¼ x 3¾" (8.1 x 9.5 cm)
Hirshhorn Museum and Sculpture Garden,
Smithsonian Institution, Washington, D.C.

99. Sketch for "The Swimming Hole"
Goodrich 191
1883
Oil on fiberboard
8¾ x 10¾" (22.1 x 27 cm)
Hirshhorn Museum and Sculpture Garden,
Smithsonian Institution, Washington, D.C.
Philadelphia only

The spirit of the painting has often been compared to Walt Whitman's imagery of young men bathing in his "Song of Myself,"[11] but a study of the stages in the development of the painting show that Eakins made this scene from his own experience progressively more formal in composition. In the finished painting, the monumentality of the interlocking triangular arrangement of figures and the compression of the space in which they are shown create a sense of balance and order, much as though the figures were occupying the plane surface of an ancient relief sculpture. Indeed, as Phyllis Rosenzweig suggested,[12] the reclining figure in the painting is a quotation in reverse of the Roman sculpture *The Dying Gaul* (*The Dying Gladiator*), of which the Pennsylvania Academy had a cast. The poses of other figures, too, seem to recall figures from the history of art. More informally, however, Eakins included his own self-portrait as the swimming figure in the lower right-hand corner of the painting.

Although Eakins began *The Swimming Hole* in 1883, he was still working on it the following year, and he may have continued to work on it into 1885, when it was lent to the Academy annual by the man who had commissioned it, Edward H. Coates.[13] Coates was apparently dissatisfied with the painting, however, and traded it to Eakins for *The Pathetic Song*.[14] After *The Swimming Hole*, Eakins never again used a nude figure in a landscape as the subject for a painting.

100. The Swimming Hole
Goodrich 190
1883–85
Oil on canvas
27 x 36″ (68.6 x 91.4 cm)
The Fort Worth Art Museum. Purchased by the
Friends of Art, 1925

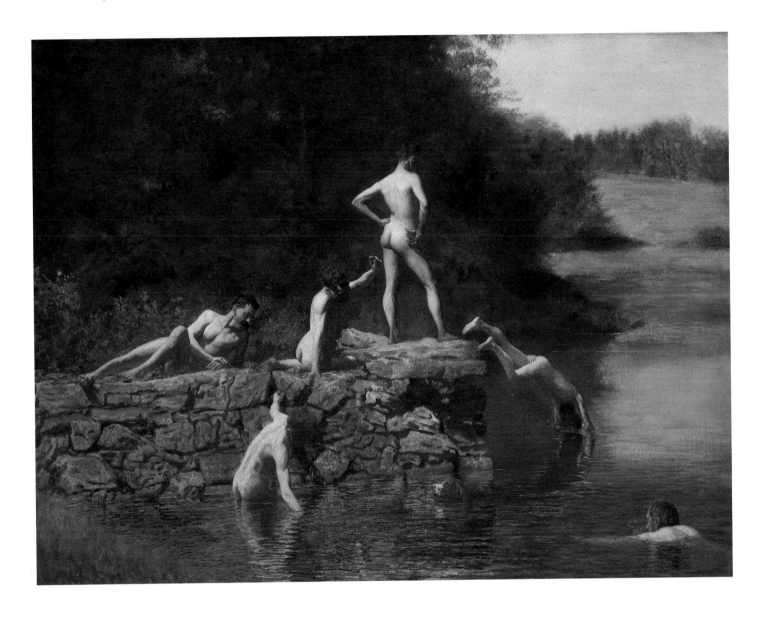

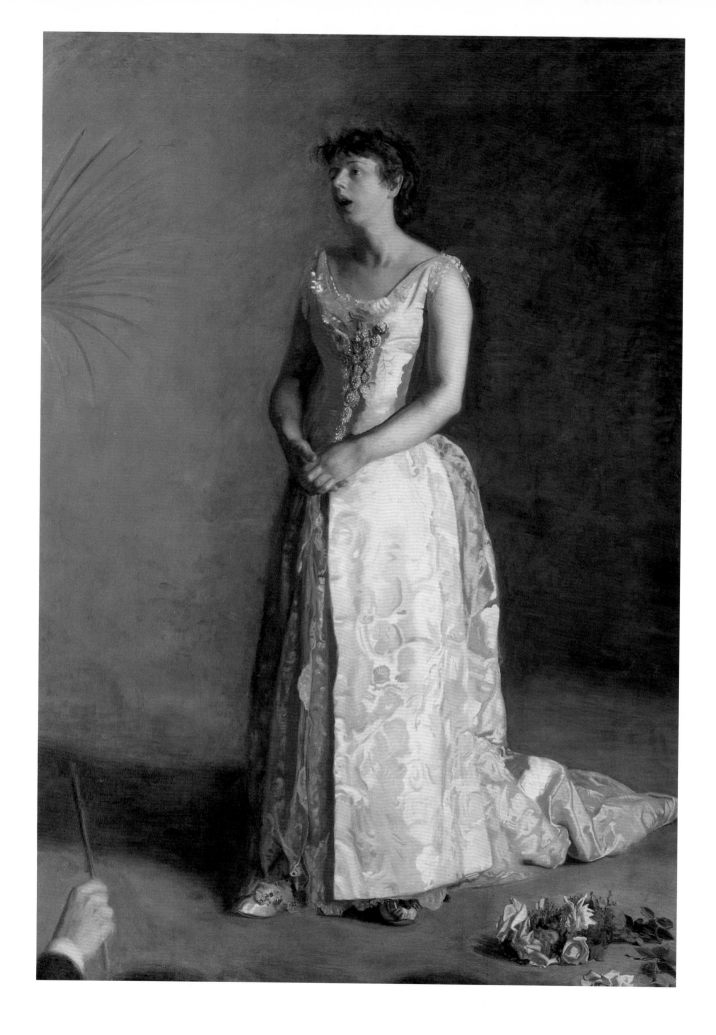

XII. Music

101. The Concert Singer
Goodrich 266
1890–92
Oil on canvas
75⅛ x 54¼″ (190.8 x 137.8 cm)
Philadelphia Museum of Art. Gift of Mrs.
Thomas Eakins and Miss Mary Adeline
Williams

102. Sketch for "The Concert Singer"
Goodrich 267
c. 1890
Oil on canvas
13¾ x 10⅜″ (34.9 x 26.4 cm)
Philadelphia Museum of Art. Gift of Mrs.
Thomas Eakins and Miss Mary Adeline
Williams

Eakins loved music, and all his life he was surrounded by it. His sisters played the piano—as did his wife Susan—and in Paris, for example, he used some of his carefully hoarded allowance to attend performances of the opera. One of the most poignant anecdotes about the artist is the recollection that in his later life he would attend Saturday afternoon musicales and "sit in a corner and sob like a child."[1] In his paintings, from his earliest depictions of his sister Frances at the piano [9] to the portraits of musicians that were among his last works, music was one of his recurring themes.

The list of his portraits confirms that he made friends among musicians as he did among practitioners of the other arts. It seems likely that for Eakins the ability to sing or play a musical instrument was an admirable skill, like rowing or boxing or the knowledge of a scientist or surgeon; in his paintings of musical performances, he was equally concerned for rightness of detail and the approval of professional judgment, as he revealed in a letter describing *The Concert Singer* [101]:

I once painted a concert singer and on the chestnut frame I carved the opening bars of Mendelsohn's "Rest in the Lord." It was ornamental unobtrusive and to musicians I think it emphasized the expression of the face and pose of the figure.[2]

To Eakins the exact appearance of musicians as they performed was indissolubly tied to the music produced.

In 1876 Eakins painted a watercolor showing his friend Max Schmitt, who had posed for him five years earlier [12], playing the zither, and his fellow artist William Sartain listening to the music in a dimly lit interior. Entitled *The Zither Player* [104], the painting is a study in carefully modulated details, emphasizing light falling upon the polished surface of the tilt-top table with its wine bottle and half-filled glasses, and upon Max Schmitt's hands as he plays the zither. The gentle quality of the scene must have appealed to the prominent New York collector and patron of American art Thomas B. Clarke, for in 1883 he commissioned Eakins to paint a slightly different version of it, which is called *Professionals at Rehearsal* [103]. This time Eakins posed his students J. Laurie Wallace and George Reid similarly around the table, adding still-life details of books and sheets of music on the floor and exchanging the meditative mood of the earlier painting for a study of two professional musicians at work. The use of oil instead of watercolor also lends a substance and solidity to the second painting that is lacking in the delicate, flickering watercolor.

103. Professionals at Rehearsal
Goodrich 207
1883
Oil on canvas
16 x 12″ (40.6 x 30.5 cm)
Philadelphia Museum of Art.
The John D. McIlhenny Collection

104. The Zither Player
Goodrich 94
1876
Watercolor on paper
12⅛ x 10½″ (30.8 x 26.7 cm)
The Art Institute of Chicago.
The Olivia Shaler Swan Fund

94

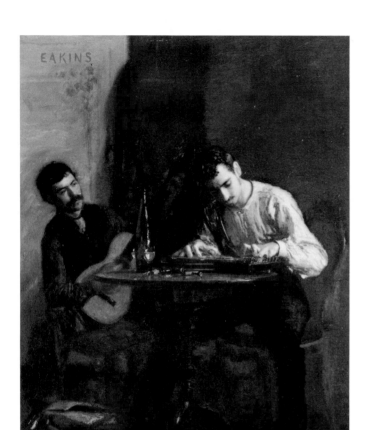

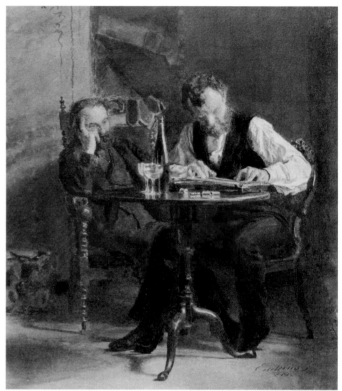

As Siegl pointed out,[3] the later painting represents the change that took place in Eakins's art over the intervening years, reflecting the difference in his approach to focus. Instead of the clear, crisp detail of the front plane of the watercolor, the most detailed focus in *Professionals at Rehearsal* is upon the area of strong interest—the triangular section centering on Wallace's head and his hands on the zither. This section of the painting is rendered in almost *trompe l'oeil* detail, while the rest of the painting is progressively less focused.

In three paintings with a musical theme that Eakins made about 1892, he portrayed Franklin Schenck playing a banjo [105–7]. Schenck was a painter, poet, and talented musician, but as Eakins entitled another portrait of him, painted about 1890, he was above all a Bohemian.[4] Schenck lived at the Philadelphia Art Students' League as its "curator," and he often could be found there singing and playing the guitar. It seems that he was largely supported by Eakins, who paid him for modeling and fed him at his house. In the painting and the watercolor that are each entitled *Cowboy Singing* [105, 106], Schenck is dressed in the cowboy suit and hat that Eakins brought back from his trip to the Bad Lands in the Dakotas in 1887 and shown from two different angles. Although the subject may represent to a degree Eakins's nostalgia

for his experience of the Bad Lands, there is little of this nostalgic mood evoked in the paintings. Schenck wears the costume naturally, and the emphasis is not upon the details of costume or setting, but upon the act of playing and singing. In the version of the painting entitled *Home Ranch* [107], the narrative aspects of the scene are developed with the addition of bits of costume on the floor, an inquisitive yellow-eyed cat, and a second figure, posed by Eakins's student Samuel Murray, who sits at a table clutching a fork and listening to the song. In this painting, Eakins manipulated the focus of the picture, as he had done in his genre paintings of the 1880s, emphasizing Schenck's right hand, which he painted in meticulous detail. In spite of the care given to the execution of these paintings, they exhibit an element of relaxation and good humor that is unusual in Eakins's work. Perhaps

105. Cowboy Singing
Goodrich 249
c. 1892
Watercolor on paper
18 x 14″ (45.7 x 35.6 cm)
The Metropolitan Museum of Art, New York.
Fletcher Fund, 1925
Philadelphia only

106. Cowboy Singing
Goodrich 250
c. 1892
Oil on canvas
24 x 20″ (61 x 50.8 cm)
Philadelphia Museum of Art. Gift of Mrs.
Thomas Eakins and Miss Mary Adeline
Williams

96

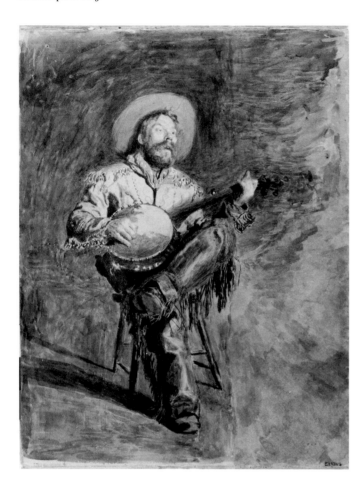

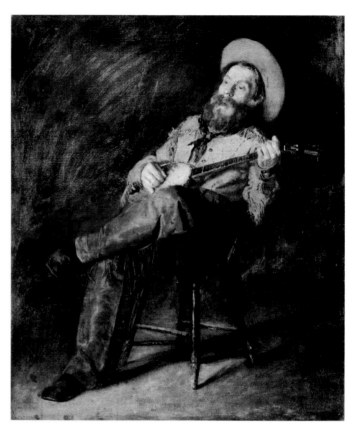

107. Home Ranch
Goodrich 248
1892
Oil on canvas
24 x 20″ (61 x 50.8 cm)
Philadelphia Museum of Art. Gift of Mrs.
Thomas Eakins and Miss Mary Adeline
Williams

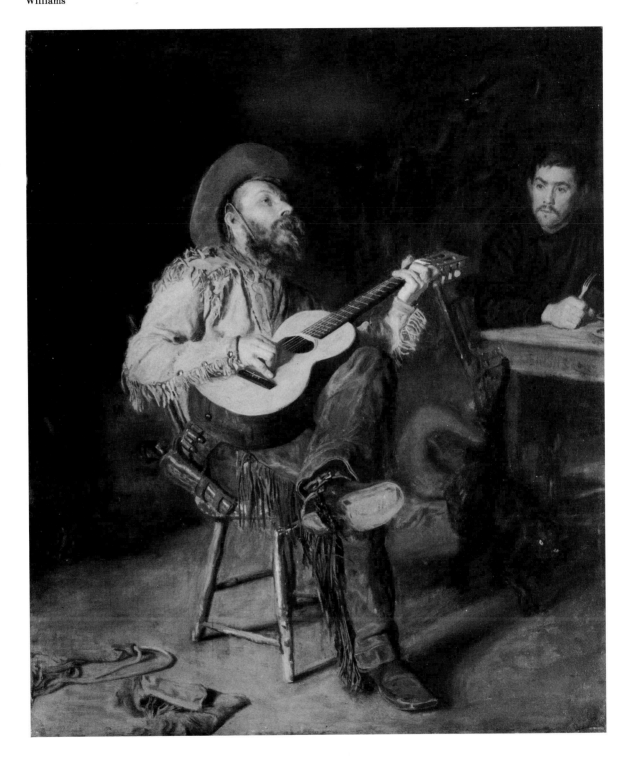

they reflect his own pleasant memories of life on a Dakota ranch and his affection for his student-models at the Art Students' League.

In two large paintings of musicians that Eakins made in the 1890s, *The Concert Singer* [101] and *The Cello Player* [108], he eliminated genre details to concentrate upon the act of making music. The subjects were professional musicians, Weda Cook, a well-known singer, and Rudolph Hennig, a leading Philadelphia cellist. Eakins probably met Weda Cook, a native of Camden and a friend of Walt Whitman who had set his poem "O Captain! My Captain!" to music, when he visited the poet in 1887 and 1888 to paint his portrait [115] and to take photographs of him [116]. Cook and her sisters Catherine and Maud became friends with Eakins, and he and his students made several photographs of the sisters. In addition to the large picture of Weda Cook as *The Concert Singer*, a few years later Eakin's painted portraits of her, her husband Stanley Addicks,[5] and her sister Maud [131].

Weda Cook sang at the third anniversary party of the Art Students' League on February 22, 1889, and it may have been then that Eakins decided to paint a portrait of her singing. Eakins's procedure in making a painting is unusually well documented in the recollections of the subject.[6] She recalled that she posed steadily as Eakins worked on the painting for a year, and less consistently for a second year. Even after she had ceased to pose, Eakins continued to work on the painting, draping the dress over an empty slipper, which he had borrowed from the singer. At the beginning of each session Eakins asked her to sing the same lines from Mendelssohn's oratorio *Elijah* in order to watch the action of her mouth and throat. From these observations he apparently decided to paint the singer as she sang a particular phrase, the opening bars of "O Rest in the Lord." Eakins established the basic elements of the composition, the stance of the singer, and the relation between the figure and the hand of the conductor in a small sketch [102]. The placement of the full-length figure in evening clothes isolated in a large space, her train trailing out of the picture to one side, is similar to Bonnat's approach to female portraiture.[7] But within this format, certain ambiguities of space, such

as the point of view and the conductor's hand—from the earliest sketch placed without room to accommodate an orchestra—add an emotional effect to the painting.[8] In *The Concert Singer*, as in his other large portraits, Eakins used the costume and the few other elements in the otherwise empty space to affect the narrative. The conductor's hand, the bouquet of roses, even the fronds of a palm, suggest the importance of this formal concert. But typically, Eakins did not combine these elements in order to emphasize the glamour of the event or to give a generalized impression of it. Instead, he sought to convey the beauty that he himself saw—the visual artist studying the singer as she sings—as though the intensity of his vision would reveal the secret of her voice. The beauty of sound—and of the woman—sharpens the ability to see.

Similar characteristics can be seen in the painting *The Cello Player*. Although it has none of the narrative details of *The Concert Singer*, it concentrates on the act of making music in the same way. In its concern for the exact appearance of the cellist as he plays, in its admiration for the delicacy of his hands, and in the concentration of his face as the performer listens to the sound he is making, observation evokes music.

Among Eakins's paintings of musicians and of writers, critics, and others linked with the musical world is the large portrait of an avid collector of old musical instruments, Mrs. William D. Frishmuth, painted in 1900 [109]. Mrs. Frishmuth did not sing or play music, but her passion for collecting antique instruments was such that by 1897 she had given some five hundred of them to the Free Museum of Science and Art at the University of Pennsylvania (now the University Museum), and by the time Eakins painted her portrait, she had given about eleven hundred items. From 1902 to 1926 she was honorary curator of the department of musical instruments at the Pennsylvania Museum (now the Philadelphia Museum of Art). Both the woman and her collections must have interested Eakins, for he asked her to pose for him, and chose one of his largest canvases, next in size only to *The Gross Clinic* [33] and *The Agnew Clinic* [40]. Instead of painting an architectural setting for Mrs. Frishmuth, Eakins created a large space around her by his arrangement of the instruments, which he worked out in preliminary perspective drawings.[9] The varied shapes, the exotic colors, and the delicacy of the instruments provide a powerful contrast to the monumental, sober figure. The original title of the painting, *Antiquated Music*, however, suggests another aspect of the painting. With one hand, Mrs. Frishmuth sounds a note as if to tune the viola d'amore that she holds in her lap. Unlike so many of Eakins's other paintings in which the sitter concentrates upon the action portrayed, here Mrs. Frishmuth stares into space as if the single note had provoked not action but reflection and thought. The variety of instruments from all parts of the world implies an equally unusual variety of sound. The potential for all kinds of music in these instruments, as well as their exotic appearance, is a comment on the imagination and enthusiasm otherwise unapparent in the formidable, self-contained figure.

108. The Cello Player
Goodrich 291
1896
Oil on canvas
64⅛ x 48¼″ (162.9 x 122.6 cm)
The Pennsylvania Academy of the Fine Arts,
Philadelphia. Temple Fund Purchase

100

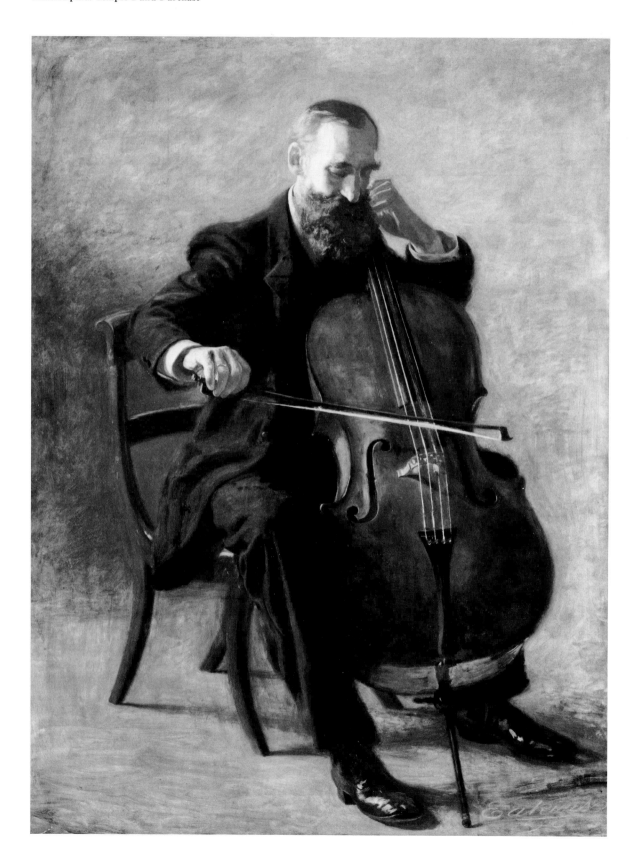

109. Portrait of Mrs. William D. Frishmuth
(Antiquated Music)
Goodrich 338
1900
Oil on canvas
97 x 72″ (246.4 x 182.9 cm)
Philadelphia Museum of Art. Gift of Mrs.
Thomas Eakins and Miss Mary Adeline
Williams

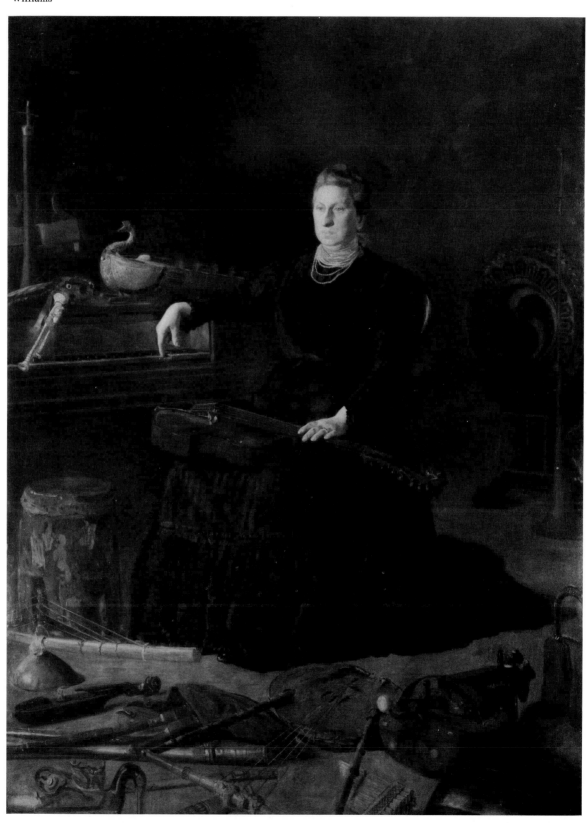

110. Portrait of Prof. Henry A. Rowland
Goodrich 264
1891
Oil on canvas
82½ x 53¾" (209.6 x 136.5 cm)
Addison Gallery of American Art, Phillips
Academy, Andover, Massachusetts. Gift of
Stephen C. Clark

**111. Sketch for "Portrait of Prof. Henry A.
Rowland"**
Goodrich 265
1891
Oil on canvas
12 x 9" (30.5 x 22.9 cm)
Addison Gallery of American Art, Phillips
Academy, Andover, Massachusetts

Like most academically trained artists, Eakins considered the painting of subjects that allowed him to show his skill in composing figures in a scene with some narrative content as the proper occupation of a serious artist. Most of the work that he made and exhibited in the 1870s and through the mid-1880s was of this kind. Yet, like many artists, Eakins also considered painting portraits as a good source of income, as he wrote to his father from Paris:

One terrible anxiety is off my mind. I will never have to give up painting, for even now I could paint heads good enough to make a living anywhere in America.[1]

When he first exhibited his work in 1871, he showed both an ambitious genre scene—*Max Schmitt in a Single Scull* [12]—and a portrait. One motivation for painting *The Gross Clinic* [33] in 1875 may have been Eakins's desire to win portrait commissions from Jefferson Medical College. About the same time he painted three other large-scale canvases—portraits of Prof. Benjamin Howard Rand, in 1874,[2] Dr. John H. Brinton, in 1876,[3] and Archbishop James Frederick Wood, in 1877.[4] Although these portraits lack the heroic dimension of *The Gross Clinic*, they resemble it in that they not only show the features of the sitters but also characterize them through settings that indicate their occupations. In his desire to attract a portrait clientele, however, it seems that Eakins limited the field in which he wanted to work to those that would dignify the sitter, the institution for which they were intended, and the artist.

He apparently made no effort to obtain commissions for portraits of social figures.

In 1877 Eakins gained a prestigious commission from the Union League of Philadelphia for a portrait of President Rutherford B. Hayes, but the circumstances surrounding this commission presaged the troubles Eakins would later encounter with commissions. In a letter to the committee that commissioned the portrait,[5] he redefined the commission in his own terms and insisted that the president give him as many sittings as he required. Hayes was an impatient sitter, and one suspects that Eakins did nothing to ingratiate himself to his subject; as he said later, he had to study the president as he would a "small animal."[6] The finished portrait—an unidealized portrayal of a man at work flushed with the summer's heat[7]—apparently symbolized nothing of the dignity and power of his office to the Union League committee. They refused the painting at first, but eventually it was hung at the League, soon, however, to disappear from the walls and vanish altogether.

104

Eakins began to concentrate on portraits only after his dismissal from the Academy in 1886, perhaps because he felt that his firing signified a more general public rejection of his work. Surely it is significant that when for the first time after leaving that institution he showed his paintings at the Academy's annual exhibition in 1891, he chose to exhibit only portraits. And it has been suggested that by showing a large number of portraits in a variety of formats at his only one-man exhibition, at the Earles' Galleries in Philadelphia in 1896, Eakins attempted to attract new portrait commissions.[8] A sympathetic critic of the time pointed out, however, that if Eakins wanted commissions he would have to change his style:

It is the fashion to say that Eakins is "brutally frank," that he has too high a regard for Art to idealize or etherealize his subjects.

All of which translated into plain every day English means that he paints his subjects as he finds them, imperfections, blemishes and all.

This is all very well from 'an Art for Art's sake' standpoint, but in the progressive work-a-day world of the present time, the portrait painter, the same as everyone else, must trim his craft to the trade winds....

The people demand idealization, and if they don't get it at one shop they will bend their footsteps to another.[9]

Eakins received only occasional commissions for portraits, but apparently his interest in the portrait as a form of artistic expression grew, for in the years between 1891 and about 1906, he painted many portraits, which are recognized today as among his greatest works. The subjects were the artist's family and friends, and people he knew and admired—scientists, physicians, fellow artists, musicians, clerics. He developed the large-scale portrait as a subject for exhibition, and the new public recognition that his work gained in the late 1890s and the first decade of the twentieth century was largely due to his portraits. Not subject paintings, but portraits of individuals such as Archbishop William Henry Elder [127] and Leslie W. Miller [125] won prizes and awards for Eakins. His achievement as a portrait painter was recognized both by his contemporaries, who had earlier ignored his genre scenes, and by the new generation of artists, who found in them a strength of technique and a directness of observation akin to their interests in their own work.

Eakins's approach to portraiture, which remained fundamentally unchanged throughout his career, was formed in Paris, not by Gérôme (who had little interest in portraits), but by Léon Bonnat, in whose studio Eakins studied for a brief time. From Bonnat, Eakins learned both the technique and the presentation of the figure that he would use in his own portrait painting.[10] The large-scale portraits that Eakins made in the 1870s—and others that he made later on—showing the sitters in surroundings that define their profession are of a type that were popular in Europe and

known as the *portrait d'apparat*.[11] *The Gross Clinic* is unique in Eakins's work in raising this type to the heroic level, but among the other examples, his portrait of Prof. Henry A. Rowland [110] is perhaps the greatest. Rowland, a brilliant physicist and professor of physics at Johns Hopkins University in Baltimore, sits in his laboratory holding a diffraction grating showing the colors of the spectrum, which he used in his work on spectrum analysis. In the background is the ruling machine that Rowland had invented, which made his work, and that of other scientists in his field, possible. Also shown is Rowland's instrument maker, Theodore Schneider, who made and cared for the precision instruments. Eakins extended the concept of characterization to the frame of the painting itself, which he made and carved with scientific symbols and formulas chosen by Rowland to relate to his work.[12]

Perhaps Gérôme's insistence on the careful preparation of every detail of a painting can be seen in the pains to which Eakins went to make this portrait—traveling to Maine to paint Rowland, and to Baltimore to study the machine and paint his assistant—but in the dramatically lit figure set against a dark background and in the technique, it resembles the paintings of Bonnat. Eakins's typical full-length portraits are even closer to Bonnat's. The portrait of Harrison S. Morris [120] is the most similar to Bonnat's work in the strongly lit figure brought close up to the picture plane and shown against a plain background. The realism of Eakins's paintings, like that of Bonnat's work, extends to the clothing of his figures, which he gave the rumpled appearance of everyday dress. Unlike Bonnat, however, Eakins used the elements of his portraits as expressive devices rather than as evidence of objective observation. He took the interest in clothing as characterization beyond the everyday, and often asked his sitters to wear clothes in which they would not ordinarily have appeared. Leslie Miller recalled:

He not only wanted me to wear some old clothes but insisted that I go and don a little old sack coat—hardly more than a blouse—that he remembered seeing me in in my bicycle days, and which I certainly never would have worn facing an audience, which the portrait represented me as doing. He did much the same thing with Dean Holland [123]. He made the poor Dean go and put on a pair of old shoes that he kept to go fishing in, and painted him shod in this way when he faced a distinguished audience on a very impressive occasion.[13]

Eakins also manipulated the appearance of his sitters in several other ways. By moving the figure back into the space of the painting, he intensified the effect of psychological isolation, as in *The Dean's Roll Call* [123], while in the painting of Archbishop Elder [127] the placement of the figure combined with Eakins's focus upon such anatomical details as the gnarled hands suggest not objective observation but an exploration of the psychology of the sitter. This conception is perhaps closer to a painting such as Velázquez's portrait of Innocent X[14] than to any example by Bonnat.

Another characteristic of Eakins's portraiture, and the fundamental difference from that of Bonnat, is that the sitter does not usually look out of the painting but gazes away into the distance. Unlike the objectivism of Bonnat's paintings, in which the viewer's direct confrontation with the eyes of the subject is an important part of the self-confidence and command given the sitter, Eakins's objective observation was of the person without the intervention of their conception of their own personality. When all of these devices were applied to a sitter whom Eakins apparently found unsympathetic, the result could become devastating. A. W. Lee commissioned and paid for his portrait [128], but refused to accept it. In the few instances where Eakins's sitters do look out at the viewer, the effect is compelling. In Eakins's self-portrait [126], painted as his "diploma" piece upon election to the National Academy of Design in 1902, it is not self-confidence and success that are seen in the artist's face, but a look of accusation and bitterness that echoes his words in a letter of 1894:

My honors are misunderstanding, persecution & neglect, enhanced because unsought.[15]

105

Beginning with the portrait of his sister Margaret [8], Eakins painted a series of small bust-size portraits throughout his life, many of them of sitters well known to the artist—his family [122], friends, and students [121]. As a continuous series, these small paintings show the changes in technique that occurred over the years. His portrait of J. Harry Lewis, painted in 1876 [112], reduced the approach to form that Eakins used in *The Gross Clinic* to a domestic scale. The modeling of the face, built up in successive layers, and the dramatic contrast of light and dark recall that painting, as does the portrait of Mrs. John H. Brinton painted a few years later [133]. In contrast, the portrait of Douglass Morgan Hall [113], thinly and economically painted, is similar to the technique used in *The Agnew Clinic* [40], which was painted about the same time. In the later paintings, those done after 1900, such as his self-portrait, Eakins's treatment of form is much freer, using strokes of paint exactly placed but not blended, which resolve into the appearance of form, and shaped strokes, which define volumes. Within the general evolution of his painting style, Eakins also apparently experimented with other techniques, as can be seen in his portrait of Frank B. A. Linton [129], which in its cool tonalities and suave brushwork seems to echo the work of John Singer Sargent.[16] In the portraits of his father-in-law, William H. Macdowell, the widest range of Eakins's technical experiments can be seen. As a photograph of Macdowell shows [117], he must have been an interesting model, with a handsome face and strong bone structure, unselfconscious before

the artist and willing to sit for the long hours that his paintings required. Eakins seldom painted more than one portrait of a sitter, but he painted Macdowell seven times. He made the rich impasto portrait of about 1891 [118] in preparation for a watercolor,[17] while one of the most extreme examples of his late technique [119] shows the figure very thinly painted, with every line and smudge of age relentlessly studied and drawn on the face of the dauntless old man. In his portrait of Walt Whitman, manipulation of the physical fact of appearance can be seen in the contrast between the small oil sketch [114], which shows a dozing figure with pinched face and lank hair, and the ruddy, energetic, and good-natured figure of the finished painting [115]. The photograph [116], made about four years later, is a beautiful study of old age, but the melancholy of Whitman's vacant gaze is far from the alert spirit of the painting. Whitman was unusual among Eakins's sitters in that his admiration of his portrait is recorded, in words that perhaps Eakins would have agreed with:

Look at Eakins' picture. How few like it. It is likely to be only the unusual person who can enjoy such a picture—only here and there one who can weigh and measure it according to its own philosophy. Eakins would not be appreciated by the artists, so-called—the professional elects: the people who like Eakins best are the people who have no art prejudices to interpose.[18]

112. Portrait of J. Harry Lewis
Goodrich 95
1876
Oil on canvas
23⅜ x 19¾″ (60 x 50.2 cm)
Philadelphia Museum of Art. Gift of Mrs.
Thomas Eakins and Miss Mary Adeline
Williams

113. Portrait of Douglass Morgan Hall
Goodrich 233
c. 1889
Oil on canvas
24 x 20″ (61 x 50.8 cm)
Philadelphia Museum of Art. Gift of Mrs.
William E. Studdiford

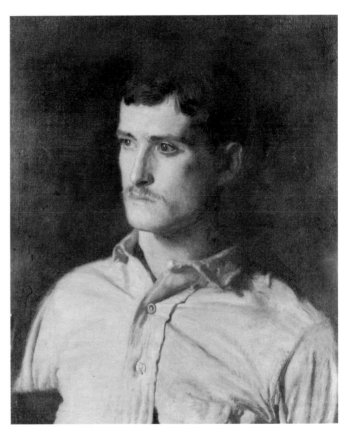

114. Sketch for "Portrait of Walt Whitman"
Goodrich 221
c. 1887
Oil on panel
5¼ x 5¼" (13.3 x 13.3 cm)
Museum of Fine Arts, Boston. Helen and Alice
Colburn Fund
Boston only

115. Portrait of Walt Whitman
Goodrich 220
1887–88
Oil on canvas
30 x 24" (76.2 x 61 cm)
The Pennsylvania Academy of the Fine Arts,
Philadelphia. General Fund Purchase

108

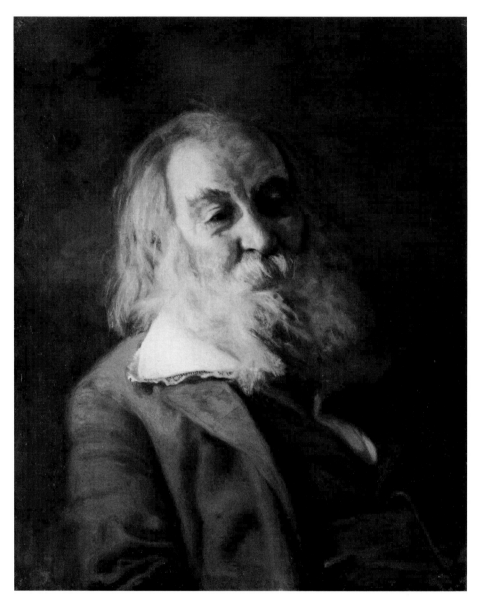

116. Walt Whitman
Hendricks 152
c. 1891
Photograph
3¹⁵⁄₁₆ x 4¹⁵⁄₁₆″ (10 x 12.5 cm)
Philadelphia Museum of Art. Bequest of
Mark Lutz

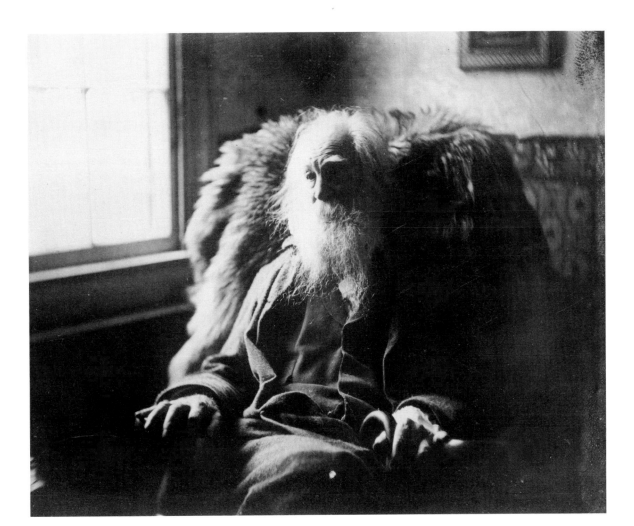

117. William H. Macdowell
Hendricks 74
c. 1891?
Photograph
3⅞ x 3¹⁄₁₆″ (9.8 x 7.8 cm)
Collection of Mr. and Mrs. Daniel W. Dietrich II

118. Portrait of William H. Macdowell
Goodrich 261
c. 1891
Oil on canvas
28 x 22″ (71.1 x 55.9 cm)
Randolph-Macon Woman's College Art Gallery,
Lynchburg, Virginia

119. Portrait of William H. Macdowell
Goodrich 416
c. 1904
Oil on canvas
24 x 20″ (61 x 50.8 cm)
Memorial Art Gallery of the University of
Rochester. Marion Stratton Gould Fund

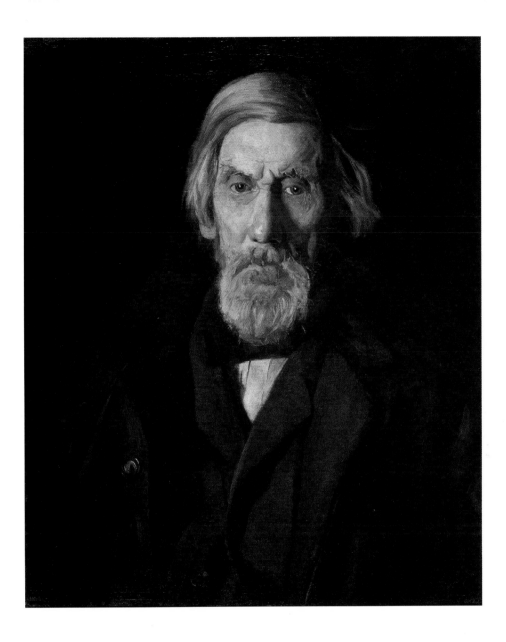

120. Portrait of Harrison S. Morris
Goodrich 294
1896
Oil on canvas
54 x 36″ (137.2 x 91.4 cm)
Collection of Mr. and Mrs. Harrison M. Wright

121. Portrait of Henry O. Tanner
Goodrich 345
1900
Oil on canvas
24⅛ x 20¼″ (61.3 x 51.4 cm)
The Hyde Collection, Glens Falls, New York

122. Portrait of Benjamin Eakins
Goodrich 324
c. 1894
Oil on canvas
24⅛ x 20″ (61.3 x 50.8 cm)
Philadelphia Museum of Art. Gift of Mrs.
Thomas Eakins and Miss Mary Adeline
Williams

123. The Dean's Roll Call
(Portrait of James W. Holland)
Goodrich 327
1899
Oil on canvas
84 x 42″ (213.4 x 106.7 cm)
Museum of Fine Arts, Boston.
Abraham Shuman Fund

114

123. The Dean's Roll Call
(Portrait of James W. Holland)

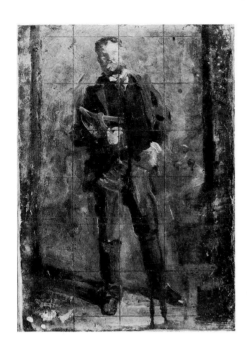

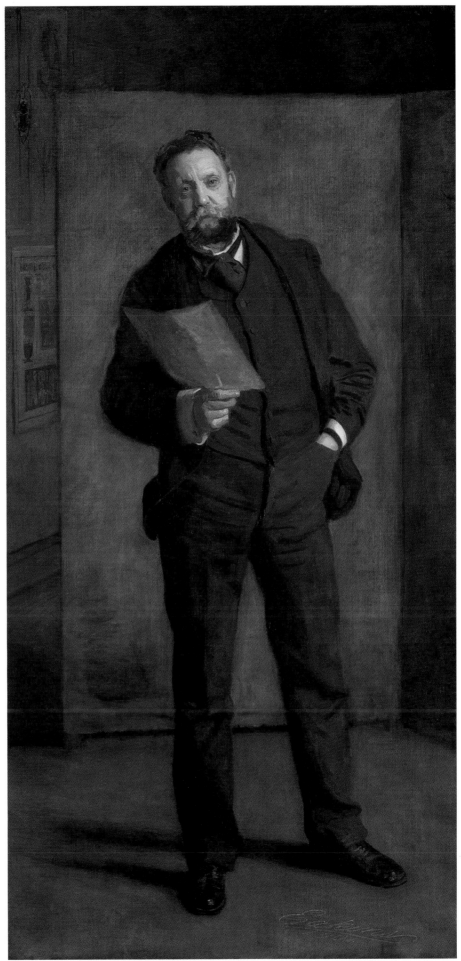

124. Sketch for "Portrait of Leslie W. Miller"
Goodrich 349
1901
Oil on cardboard
13⅜ x 9⅝" (34 x 24.4 cm)
Philadelphia Museum of Art.
Gift of Percy Chase Miller

125. Portrait of Leslie W. Miller
Goodrich 348
1901
Oil on burlap canvas
88 x 44" (223.5 x 111.8 cm)
Philadelphia Museum of Art. Gift in
memory of Edgar Viguers Seeler by Martha
Page Laughlin Seeler

126. Self-Portrait
Goodrich 358
1902
Oil on canvas
30 x 25″ (76.2 x 63.5 cm)
National Academy of Design, New York

116

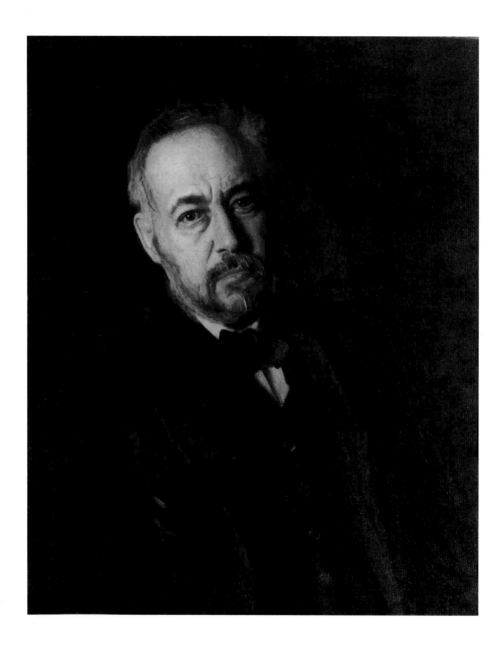

**127. Portrait of Archbishop
William Henry Elder**
Goodrich 374
1903
Oil on canvas
66½ x 41⅛″ (168.9 x 104.5 cm)

Cincinnati Art Museum. Louis Belmont family
in memory of William F. Halstrick,
Bequest of Farny R. Wurlitzer, Edward Foote
Hinkle Collection, and Bequest of
Frieda Hauck, by exchange

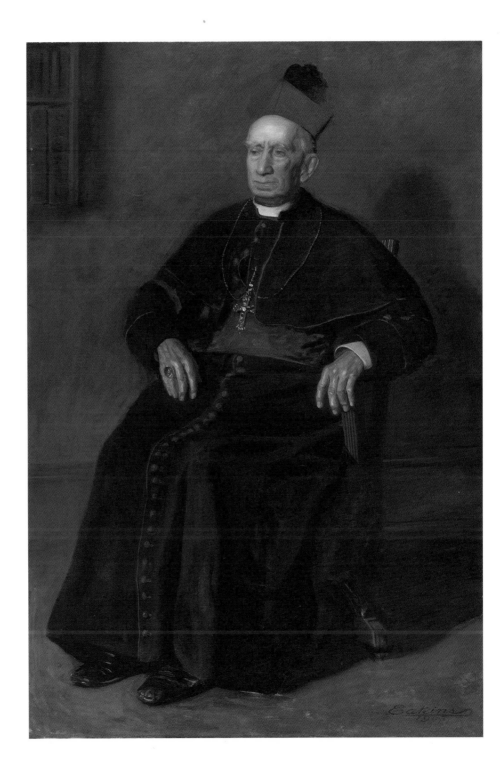

128. Portrait of A. W. Lee
Goodrich 427
1905
Oil on canvas
40 x 32″ (101.6 x 81.3 cm)
Reynolda House, Inc., Winston-Salem,
North Carolina

129. Portrait of Frank B. A. Linton
Goodrich 406
1904
Oil on canvas
24 x 20¼″ (61 x 51.2 cm)
Hirshhorn Museum and Sculpture Garden,
Smithsonian Institution, Washington, D.C.

118

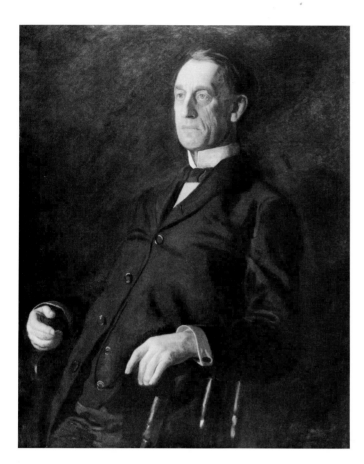

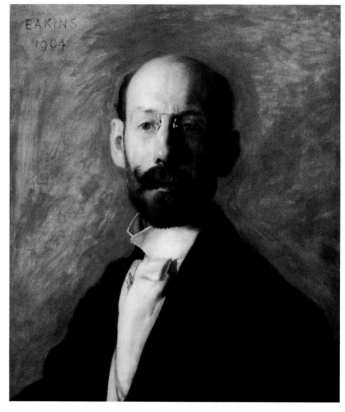

130. Portrait of Monsignor James P. Turner
Goodrich 438
c. 1906
Oil on canvas
88 x 42″ (223.5 x 106.7 cm)
Misericordia Hospital, Philadelphia

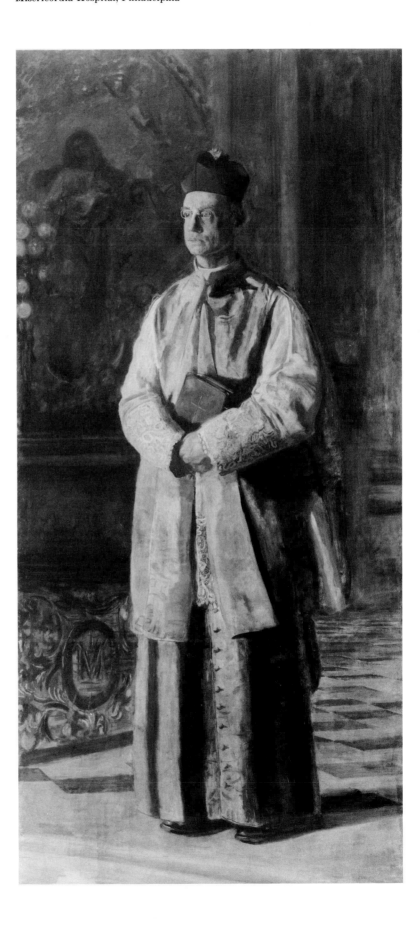

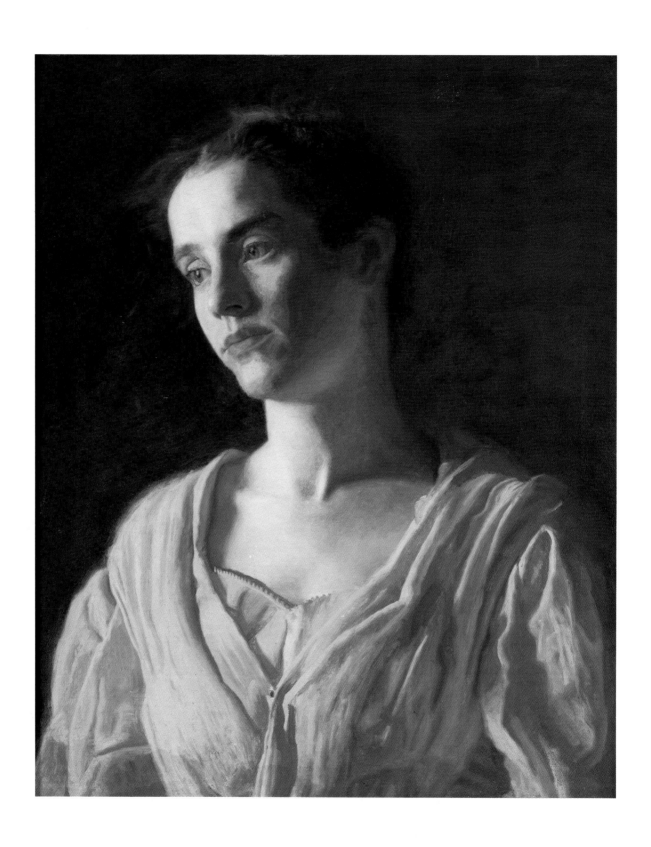

131. Portrait of Maud Cook
Goodrich 279
1895
Oil on canvas
24 x 20″ (61 x 50.8 cm)
Yale University Art Gallery, New Haven.
Bequest of Stephen Carlton Clark, B.A. 1903
Philadelphia only

Eakins's early paintings of his sisters and those of William Crowell (*see* Chapter II), remarkable for their unconventional portrayals of women according to the standards of the time, set the pattern of his later female portraits. In one of them, *Portrait of a Lady with a Setter Dog* [134], the connection with the early paintings seems most direct. Like *Elizabeth Crowell with a Dog* [6], which reinterpreted the conventions of sentimental genre, this painting is a reworking in Eakins's own terms of another popular subject of the day, the studio interior as it was being painted by William Merritt Chase and others.[1] Begun soon after the newlywed couple moved to Eakins's studio at 1330 Chestnut Street, it shows Susan Macdowell Eakins surrounded by examples of Eakins's work—the sculptural relief of *Arcadia* [91] is at the right—and reflects fashionable artistic taste in the model's unconventional dress and in the book of Japanese prints that she holds. But the effect is far from the fashionable artistic life as Chase portrayed it in his studios full of picturesque bric-a-brac occupied by prettily dressed women. Nor is there anything of the exquisite compositional talents of the new aesthetic represented by Whistler's portrait of his mother, which had been shown at the Pennsylvania Academy of the Fine Arts in 1881.[2] In fact, Eakins seems to have reworked the painting to emphasize the volume of the figure and the space around it.[3] In Susan Eakins's careworn face, in the directness of her gaze as she looks out of the picture, and in her beautifully painted hands resting on the book of prints, the realism and physicality are so pronounced that they seem an embodiment of an artistic belief directly opposed to Whistler's painting, which both Eakins and his wife would have upheld.

In general, Eakins's paintings of women differ from the male portraits in their mood. In his representations of men, the capacity for emotion is masked by the appearance of objective observation—the sensitive face of Henry O. Tanner [121] is about as expressive as Eakins allowed most of his men to be. Only in his self-portrait [126] did Eakins equal a depth of emotion that he depicted in the faces of Edith Mahon [141] or his own wife [136]. If portraits of women, such as that of Letitia Wilson Jordan [132] or Suzanne Santje [140], are compared to male portraits similar in format, such as that of Harrison S. Morris [120] or one of the large-scale *portraits d'apparat*, the difference in emotional content can be seen. Eakins's study of his female models reflects nothing of the conventional ideas of beauty and has little in common with the idea of the beautiful effect achieved through fashion. His portrait of Maud Cook [131] is a rare example of Eakins's studying the physical beauty of a young woman; in the firm structure and pallor of her face, seen in strong light, she resembles a classical sculpture more than a pretty, contemporary woman. Letitia

132. Portrait of Letitia Wilson Jordan
Goodrich 222
1888
Oil on canvas
60 x 40″ (152.4 x 101.6 cm)
The Brooklyn Museum, New York. Dick S.
Ramsay Fund

122

Wilson Jordan's festive dress is played against her vacant expression and the droop of her shoulders, and her abstraction contradicts her stylishness and her effort to appear fashionable. In his portraits of women, Eakins's manipulation of the elements of the painting—costumes, space, and light—is even more striking than in his portraits of men. In the rare example of two studies existing for a portrait, the transformation of the face of Helen Parker, the wearer of the old-fashioned dress, is apparent [142–44]. Perhaps the most famous example of Eakins's transforming a sitter dramatically while maintaining the effect of severe realism is the contrast between the two paintings that he made of the family friend Mary Adeline Williams, who was known as Addie. In the first painting, made in 1899 [137], a strong side light emphasizes Addie's wrinkled brow and the tight folds around her mouth. Her black and white dress equals the severity of her expression. In a second portrait, painted about a year later [138], Addie faces the light and seems an entirely different person. She appears younger, sadder, and more emotionally vulnerable, and her frivolous costume implies not youth, but age.

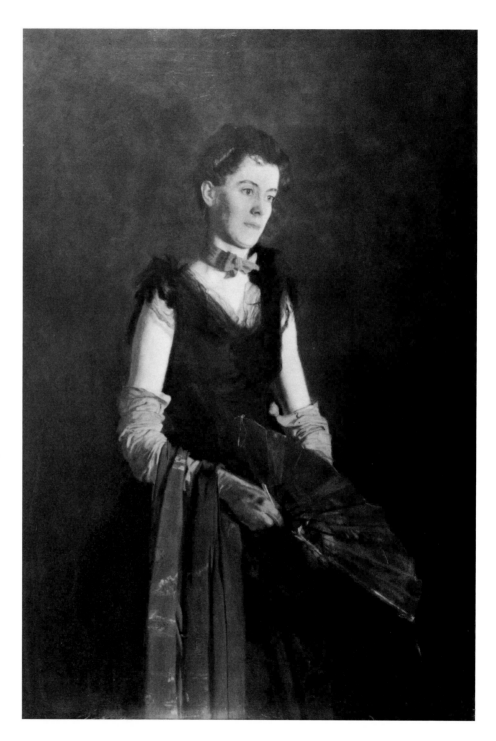

133. Portrait of Mrs. John H. Brinton
Goodrich 126
1878
Oil on canvas
24½ x 20⅛" (62.2 x 51.1 cm)
Collection of Mrs. Rodolphe Meyer de
Schauensee
Philadelphia only

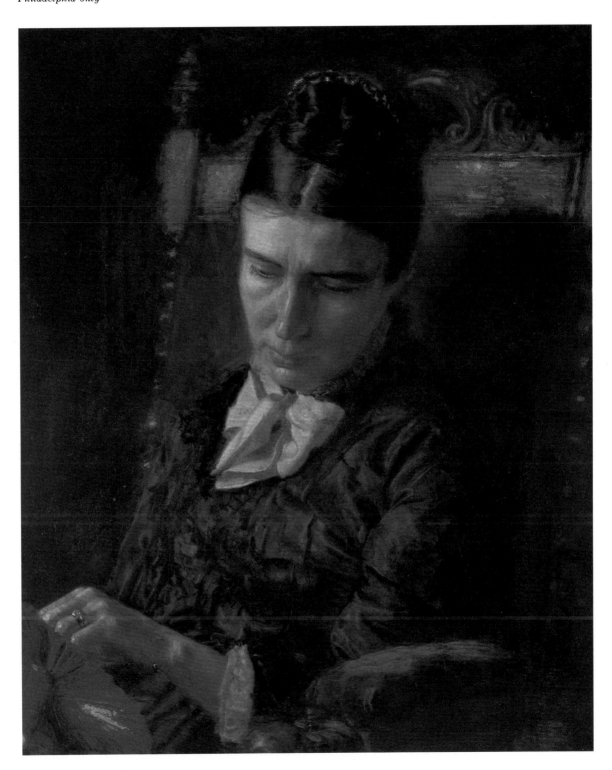

134. Portrait of a Lady with a Setter Dog
Goodrich 213
c. 1885
Oil on canvas
30 x 23″ (76.2 x 58.4 cm)
The Metropolitan Museum of Art, New York.
Fletcher Fund, 1923

124

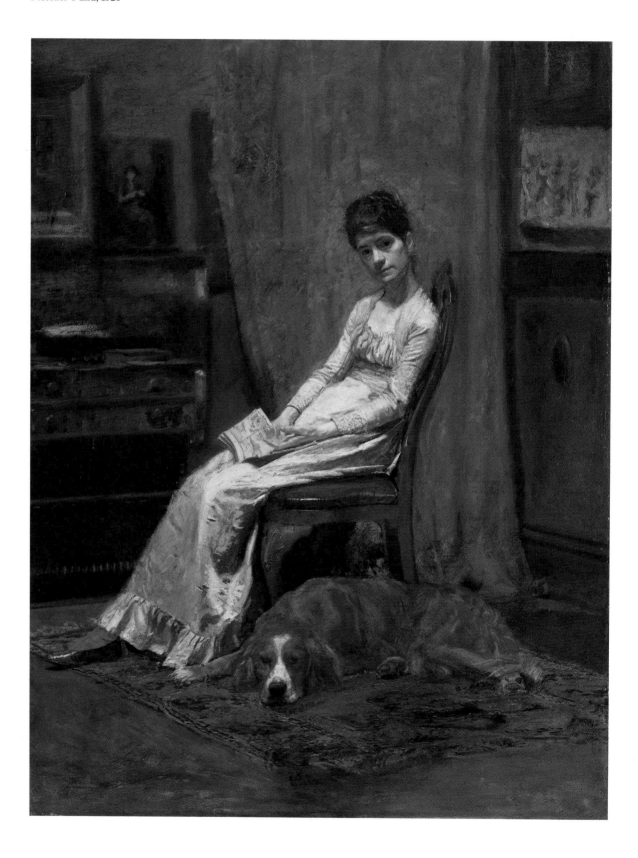

135. Mrs. Thomas Eakins
Hendricks 239
c. 1899
Photograph
6¼ x 4½" (15.9 x 11.4 cm)
Collection of Peggy Macdowell Thomas

136. Portrait of Mrs. Thomas Eakins
Goodrich 325
c. 1899
Oil on canvas
20⅛ x 16⅛" (51 x 40.8 cm)
Hirshhorn Museum and Sculpture Garden,
Smithsonian Institution, Washington, D.C.

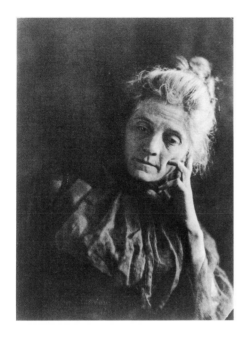

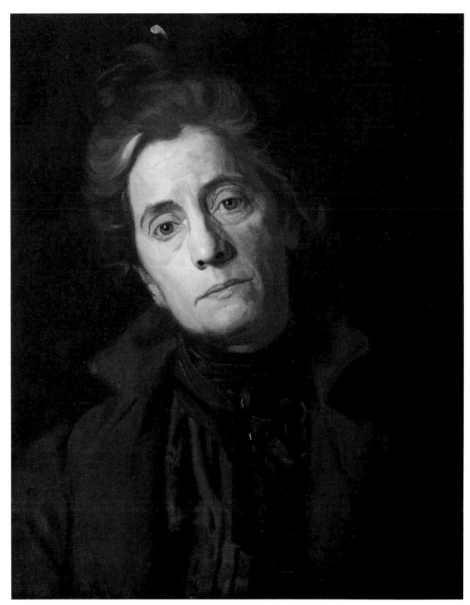

**137. Portrait of Mary Adeline Williams
(Addie, Woman in Black)**
Goodrich 323
1899
Oil on canvas
24 x 20⅟₁₆″ (61 x 50.1 cm)
The Art Institute of Chicago. Gift of the
Friends of American Art

126

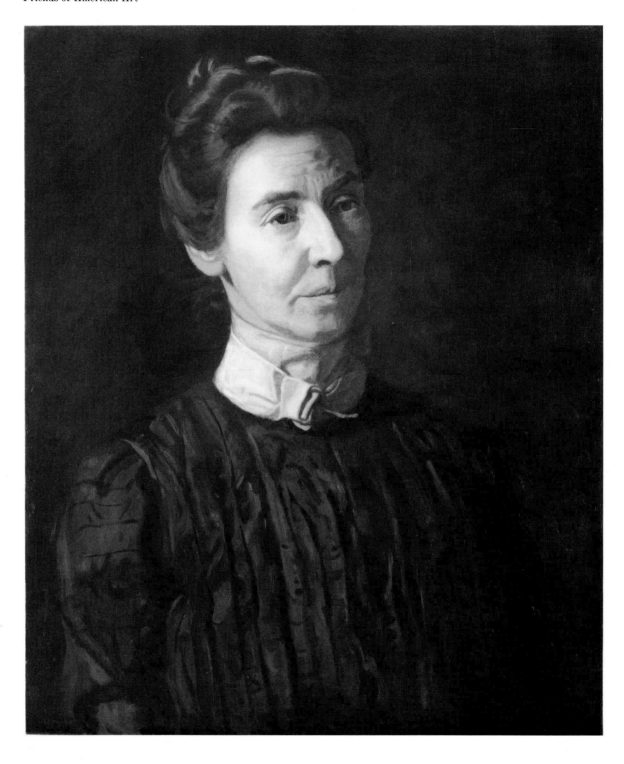

138. Portrait of Mary Adeline Williams (Addie)
Goodrich 333
c. 1900
Oil on canvas
24⅛ x 18⅛" (61.3 x 46 cm)
Philadelphia Museum of Art. Gift of Mrs.
Thomas Eakins and Miss Mary Adeline
Williams

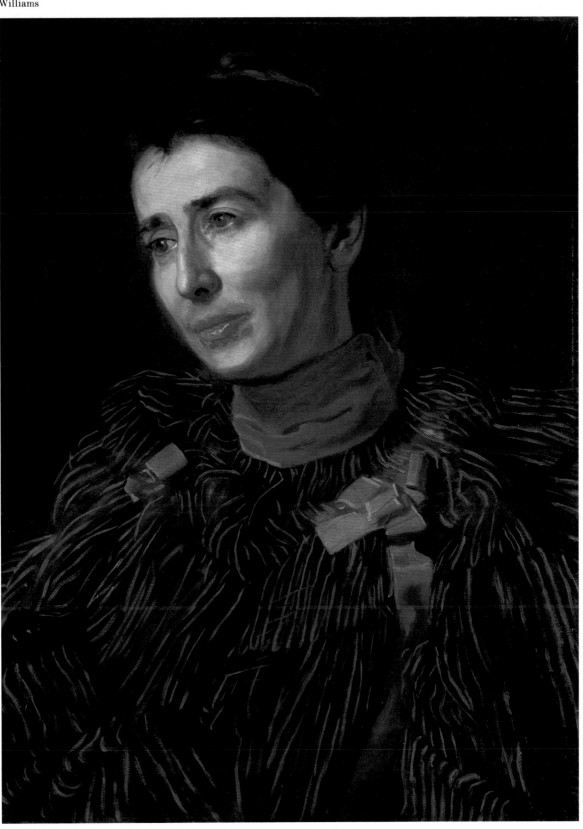

139. Sketch for "An Actress"
Goodrich 385
c. 1901
Oil on canvas
13⅞ x 10½″ (35.1 x 26.5 cm)
Hirshhorn Museum and Sculpture Garden,
Smithsonian Institution, Washington, D.C.
Philadelphia only

140. An Actress (Portrait of Suzanne Santje)
Goodrich 384
1903
Oil on canvas
79¾ x 59⅞″ (202.6 x 152.1 cm)
Philadelphia Museum of Art. Gift of Mrs.
Thomas Eakins and Miss Mary Adeline
Williams

128

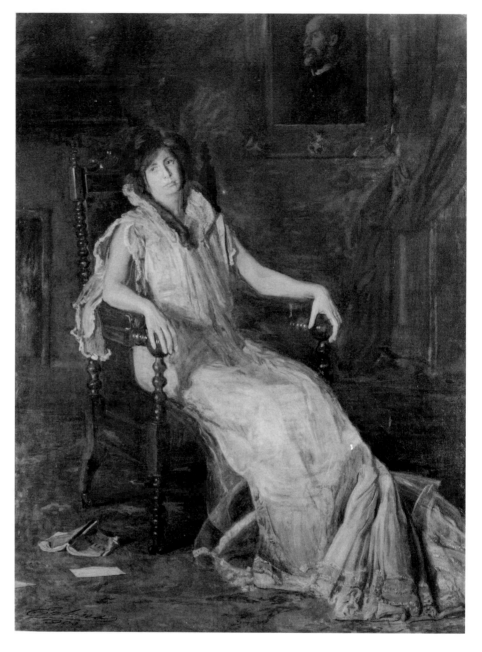

141. Portrait of Mrs. Edith Mahon
Goodrich 407
1904
Oil on canvas
20 x 16″ (50.8 x 40.6 cm)
Smith College Museum of Art, Northampton,
Massachusetts. Purchased, 1931

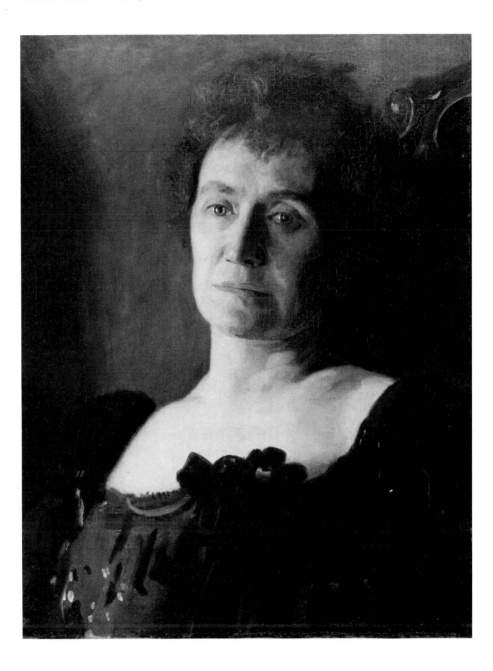

**142. The Old-Fashioned Dress (Portrait of
Helen Parker)**
Goodrich 457
c. 1908
Oil on canvas
60⅛ x 40³⁄₁₆″ (152.7 x 102.1 cm)
Philadelphia Museum of Art. Gift of Mrs.
Thomas Eakins and Miss Mary Adeline
Williams

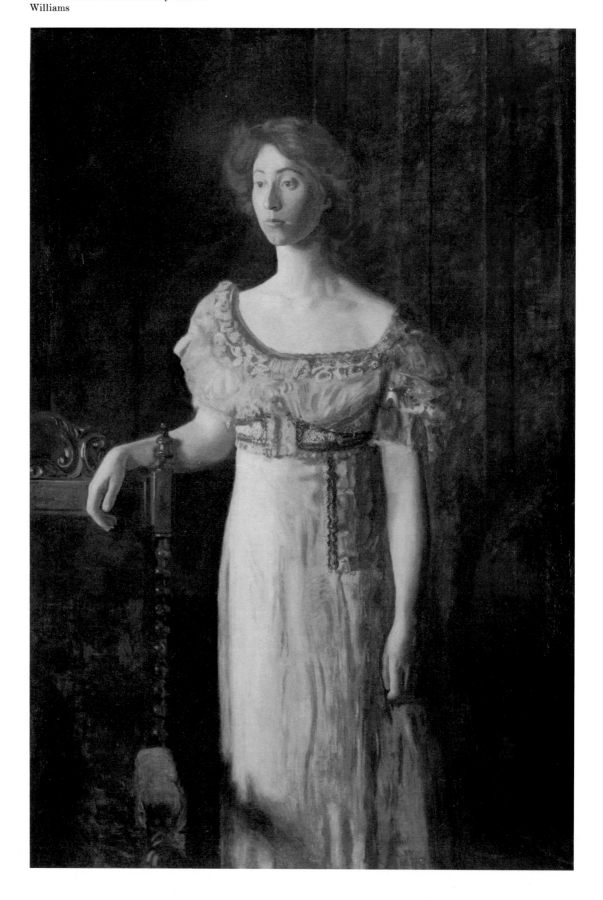

143. Sketch for "The Old-Fashioned Dress"
Goodrich 458
c. 1908
Oil on cardboard
11⅛ x 7″ (28.3 x 17.8 cm)
Collection of Mr. and Mrs. Daniel W.
Dietrich II

144. Study for "The Old-Fashioned Dress"
Goodrich 459
c. 1908
Oil on canvas
36 x 22″ (91.4 x 55.9 cm)
Collection of Mr. and Mrs. Daniel W.
Dietrich II

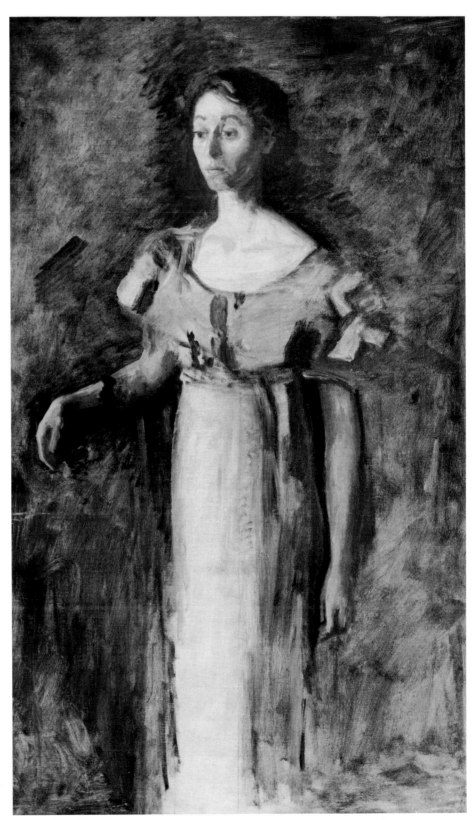

ACKERMAN
Gerald M. Ackerman. "Thomas Eakins and His Parisian Masters Gérôme and Bonnat." *Gazette des Beaux-Arts*, 111th year, vol. 73 (April 1969), pp. 235–56.

BREGLER
Charles Bregler. "Thomas Eakins as a Teacher." *The Arts*, vol. 17, no. 6 (March 1931), pp. 378–86; vol. 18, no. 1 (October 1931), pp. 28–42.

BROWNELL
William C. Brownell. "The Art Schools of Philadelphia." *Scribner's Monthly*, vol. 18, no. 5 (September 1879), pp. 737–50.

GOODRICH
Lloyd Goodrich. *Thomas Eakins: His Life and Work*. New York, 1933.

HENDRICKS
Gordon Hendricks. *The Photographs of Thomas Eakins*. New York, 1972.

HENDRICKS, *Life*
Gordon Hendricks. *The Life and Work of Thomas Eakins*. New York, 1974.

HOOPES
Donelson F. Hoopes. *Eakins Watercolors*. New York, 1971.

MCHENRY
Margaret McHenry. *Thomas Eakins, Who Painted*. 1946.

PAFA, *In This Academy*
Philadelphia, PAFA. *In This Academy: The Pennsylvania Academy of the Fine Arts, 1805–1976*. 1976.

PARRY, *"Gross Clinic"*
Ellwood C. Parry III. *"The Gross Clinic* as Anatomy Lesson and Memorial Portrait." *The Art Quarterly*, vol. 32, no. 4 (Winter 1969), pp. 373–90.

PMA, *Three Centuries*
Philadelphia, PMA. *Philadelphia: Three Centuries of American Art*. April 11–October 10, 1976.

ROGERS
Fairman Rogers. "The Schools of the Pennsylvania Academy of the Fine Arts." *The Penn Monthly*, vol. 12 (June 1881), pp. 453–62.

ROSENZWEIG
Phyllis D. Rosenzweig. *The Thomas Eakins Collection of the Hirshhorn Museum and Sculpture Garden*. Washington, D.C., 1977.

SELLIN
David Sellin. "The First Pose: Howard Roberts, Thomas Eakins, and a Century of Philadelphia Nudes." *Philadelphia Museum of Art Bulletin*, vol. 70, nos. 311–12 (Spring 1975).

SIEGL
Theodor Siegl. *The Thomas Eakins Collection*. Philadelphia, 1978.

Institutions

PAFA
The Pennsylvania Academy of the Fine Arts, Philadelphia

PMA
Philadelphia Museum of Art

HIRSHHORN MUSEUM
Hirshhorn Museum and Sculpture Garden, Washington, D.C.

Notes

Preface

1. Quoted in Siegl, p. 95, no. 42.

2. Quoted in Evan H. Turner, "Preface," in Siegl, p. 7.

3. Quoted in Siegl, p. 150, no. 98.

Thomas Eakins: Artist of Philadelphia

1. Nicholas B. Wainwright, "Education of an Artist: The Diary of Joseph Boggs Beale, 1856–1862," *The Pennsylvania Magazine of History and Biography*, vol. 97, no. 4 (October 1973), pp. 485–510.

2. Quoted in Hendricks, *Life*, p. 49.

3. Quoted in *ibid.*, p. 54.

4. Quoted in Goodrich, pp. 48–49.

5. 1870, private collection (Hendricks, *Life*, pl. 6). The letters are quoted in Goodrich, pp. 32–33.

6. Earl Shinn [Sigma], "A Philadelphia Art School," *The Art Amateur*, vol. 10, no. 2 (January 1884), p. 33.

7. *Ibid.*, pp. 32–34.

8. Rogers, p. 458.

9. Quoted in Hendricks, *Life*, pp. 137–38.

10. Earl Shinn, "The Pennsylvania Academy Exhibition," *The Art Amateur*, vol. 4, no. 6 (May 1881), p. 115.

11. Quoted in PMA, *Three Centuries*, p. 381.

I. Student Work

1. *Map of Switzerland*, 1856–57, Hirshhorn Museum (Hendricks, *Life*, p. 7, fig. 10); *Map of Southern Europe*, 1856–57?, private collection (*ibid.*, p. 7, fig. 11).

2. Quoted in Elizabeth Johns, "Drawing Instruction at Central High School and Its Impact on Thomas Eakins," *Winterthur Portfolio*, vol. 15, no. 2 (Summer 1980), p. 140. *See also* Peter C. Marzio, *The Art Crusade: An Analysis of American Drawing Manuals, 1820–1860* (Washington, D.C., 1976).

3. *See* Goodrich 1.

4. *See* Ronald Onorato, "The Context of the Pennsylvania Academy: Thomas Eakins' Assistantship to Christian Schuessele," *Arts Magazine*, vol. 53, no. 9 (May 1979), pp. 121–29.

5. *See* Hendricks, *Life*, p. 28.

6. Siegl, pp. 60–62, nos. 15–19.

7. Quoted in Goodrich, pp. 26–27.

8. Quoted in *ibid.*, p. 27.

9. Quoted in *ibid.*, p. 32.

10. Quoted in *ibid.*

11. 1870, private collection (Hendricks, *Life*, pl. 6).

12. Quoted in Goodrich 32.

13. Quoted in *ibid.*, p. 33.

II. Early Portraits at Home

1. *See* McHenry, p. 54.

III. Rowing

1. Quoted in Goodrich, p. 18.

2. Elizabeth Johns, however, has shown the importance of feeling as inspiration for Eakins's work in "Thomas Eakins: A Case for Reassessment," *Arts Magazine*, vol. 53, no. 9 (May 1979), p. 133.

3. Quoted in Goodrich, pp. 17–18.

4. Barbara Novak has discussed "combination" in Eakins's work in *American Painting of the Nineteenth Century* (New York, 1969), pp. 191–210.

5. Quoted in Sellin, p. 19.

6. Quoted in Bregler, p. 384.

7. Quoted in Hendricks, *Life*, pp. 70–71.

8. *See* PMA, *Three Centuries*, pp. 391–93, nos. 336a,b.

9. Quoted in Goodrich, p. 47.

10. Quoted in Hendricks, *Life*, pp. 74–75.

11. Quoted in Goodrich 60.

12. Quoted in Hendricks, *Life*, p. 82.

13. Quoted in *ibid.*

IV. Sporting Scenes

1. Quoted in Goodrich, p. 49.

2. Quoted in Hendricks, *Life*, p. 81.

3. Quoted in Ellwood C. Parry, III, "Thomas Eakins and the Everpresence of Photography," *Arts Magazine*, vol. 51, no. 10 (June 1977), p. 113.

4. Quoted in Siegl, p. 58, no. 12.

5. Quoted in Goodrich, p. 42.

6. Quoted in Siegl, pp. 58–59, no. 13.

7. 1875, private collection (Hoopes, p. 35, pl. 7).

8. *The Nation*, February 18, 1875, p. 120.

9. 1898, Yale University Art Gallery, New Haven (Goodrich 303, pl. 48).

10. 1899, PMA (Siegl, pp. 149–50, no. 98).

11. Quoted in Goodrich, p. 13.

12. *See* Ackerman, p. 244.

13. *Ave! Caesar*, 1859, Yale University Art Gallery, New Haven (Dayton, The Dayton Art Institute, *Jean-Léon Gérôme [1824–1904]* [November 10—December 30, 1972], pp. 44–45, no. 9); and *Pollice Verso*, 1874, Phoenix Art Museum (*ibid.*, pp. 68–69, no. 24).

V. The Gross Clinic and The Agnew Clinic

1. *See* Ellwood C. Parry III and Maria Chamberlin-Hellman, "Thomas Eakins as an Illustrator, 1878–1881," *The American Art Journal*, vol. 5, no. 1 (May 1973), p. 23.

2. Quoted in Parry, "*Gross Clinic*," p. 374.

3. 1874, Jefferson Medical College, Thomas Jefferson University, Philadelphia (Hendricks, *Life*, p. 89, fig. 72).

4. *See* Parry, "*Gross Clinic*," pp. 376–80, fig. 7.

5. *Ibid.*, p. 381. *See also* William H. Gerdts, *The Art of Healing: Medicine and Science in American Art* (Birmingham, Ala., 1981), p. 64.

6. *See* Michael Quick, "Achieving the Nation's Imperial Destiny: 1870–1920," in Los Angeles, Los Angeles County Museum of Art, *American Portraiture in the Grand Manner: 1720–1920* (November 17, 1981—January 31, 1982), p. 64.

7. Quoted in Siegl, p. 64, no. 21.

8. *See* McHenry, p. 70.

9. *See* Siegl, p. 64, no. 21, p. 173, ill. 4.

10. *See* Parry, "*Gross Clinic*," p. 381.

11. *Ibid.*, p. 375.

12. Quoted in *ibid*.

13. Quoted in Hendricks, *Life*, p. 92.

14. Quoted in *ibid.*, pp. 93–94.

15. Quoted in *ibid.*, p. 96.

16. *See* Sellin, p. 36, fig. 30.

17. Quoted in Hendricks, *Life*, p. 98.

18. *See* Parry, "*Gross Clinic*," p. 384.

19. Gerdts makes a careful comparison of these paintings and discusses Eakins's other medical portraits in *The Art of Healing*, cited above, pp. 59–79.

20. Quoted in Goodrich, p. 127.

VI. William Rush Carving His Allegorical Figure of the Schuylkill River

1. 1876, Metropolitan Museum of Art, New York (Hendricks, *Life*, p. 333, CL-180, pls. 21–23).

2. 1874, Jefferson Medical College, Thomas Jefferson University, Philadelphia (Hendricks, *Life*, p. 349, CL-325, pl. 19).

3. *Whistling for Plover*, 1874, The Brooklyn Museum, New York (Hendricks, *Life*, p. 76, fig. 63).

4. *See* Ackerman, p. 244.

5. *Ibid. Rembrandt Etching* is reproduced in Earl Shinn [Edward Strahan], ed., *Gérôme: A Collection of the Works of J. L. Gérôme in One Hundred Photogravures* (New York, 1881), vol. 1, pl. XI.

6. Quoted in Goodrich 109.

7. Quoted in Sellin, p. 44.

8. Quoted in *ibid*.

9. 1814 (Henri Marceau, *William Rush, 1756–1833: The First Native American Sculptor* [Philadelphia, 1937], pp. 42–46, no. 29). The letter is in the Cadbury Collection, Friends Historical Library, Swarthmore College, Swarthmore, Pennsylvania.

10. PAFA, *In This Academy*, p. 24, no. 24.

11. *Self-Portrait*, c. 1822 (Marceau, cited above, pp. 53–55, no. 42). The portrait by Peale is in *ibid.*, frontispiece (cited as Charles Willson Peale).

12. Quoted in Siegl, p. 72, no. 28.

13. Quoted in Hendricks, *Life*, p. 115.

14. Goodrich 448–50.

15. *See* Dayton, cited above, p. 95, no. 42.

16. *See* Van Deren Coke, *The Painter and the Photograph* (Albuquerque, 1964), pp. 162–63, nos. 359–60.

VII. Old-Fashioned Subjects

1. Quoted in Rodris Roth, "American Art: The Colonial Revival and 'Centennial Furniture,'" *The Art Quarterly*, vol. 27 (1964), p. 60.

2. William Dean Howells, "A Sennight at the Centennial," *The Atlantic Monthly*, vol. 38, no. 225 (July 1876), pp. 100–101. This article was brought to my attention by Constance Kimmerle.

3. 1876, Smith College Museum of Art, Northampton, Massachusetts. (Hendricks, *Life*, p. 329, CL-139).

4. *See* Roth, cited above, p. 65, fig. 5.

5. *See* Parry and Chamberlin-Hellman, cited above, pp. 27–30.

6. Quoted in Goodrich, p. 64.

7. *See* H. Barbara Weinberg, "The Career of Francis Davis Millet," *Archives of American Art Journal*, vol. 17, no. 1 (1977), p. 5, fig. 5; and Susan Hobbs, "Thomas Wilmer Dewing: The Early Years, 1851–1885," *The American Art Journal*, vol. 13, no. 2 (Spring 1981), p. 25, fig. 24.

8. Siegl, p. 109, no. 56G.

9. Quoted in Goodrich, p. 64.

10. The bronzes in this exhibition were cast in 1930 from plasters owned by Mrs. Eakins and inscribed with the incorrect date 1881; *see* Siegl, pp. 100–101, no. 47.

VIII. The Fairman Rogers Four-in-Hand

1. *See* Siegl, p. 76, no. 31. For a detailed consideration of Eakins's interest in motion and photography, *see* William I. Homer and John Talbot, "Eakins, Muybridge and the Motion Picture Process," *The Art Quarterly*, vol. 26, no. 2 (Summer 1963), pp. 194–216.

2. Rogers, pp. 459–60.

3. Siegl, p. 76, no. 31.

4. Quoted in Hendricks, *Life*, p. 118.

5. Quoted in *ibid.*, pp. 119–20.

IX. Figures in the Landscape

1. Hendricks, p. 31, figs. 31–32.

2. *See* Hendricks, *Life*, pp. 148–49, figs. 118–20.

3. *See* Siegl, p. 94, no. 41.

4. *See ibid.*, p. 93, no. 40.

5. Quoted from Eakins's lecture manuscript and notes in PMA (*see* Siegl, p. 109, no. 56).

X. Anatomy

1. Quoted in Siegl, p. 87, no. 36.

2. Brownell, p. 742.

3. Rogers, pp. 460–61.

4. *Ibid.*, p. 461.

5. Quoted in Siegl, p. 134, no. 84.

6. Quoted in Brownell, p. 745.

7. *Ibid.*, p. 749.

8. *Ibid.*, p. 750.

9. *See* Louise Lippincott, "Thomas Eakins and the Academy," in PAFA, *In This Academy*, p. 173.

10. *See* Hendricks, figs. 127–28.

11. Philadelphia, 1888, pp. 10–15.

12. *Ibid.*, pp. 14–15, fig. 3.

XI. Arcadia and The Swimming Hole

1. *See* Goodrich, p. 16.

2. *Arcadia* [95]; *An Arcadian*, oil, c. 1883, private collection (Hendricks, *Life*, p. 154, fig. 131); *Arcadia* [91]; *Youth Playing Pipes*, relief, c. 1883, PMA (plaster) (Siegl, p. 108, no. 55); *An Arcadian*, relief, private collection (Goodrich 507).

3. *The Death of Caesar*, 1867, The Walters Art Gallery, Baltimore (Dayton, cited above, p. 62, no. 20); *Pollice Verso*, 1874, Phoenix Art Museum (*ibid.*, pp. 68–69, no. 24). *Pollice Verso* now is usually dated 1874, but in a letter to Shinn, Eakins wrote of having seen it in Paris. *See* Ackerman, pp. 241–42.

4. *See* Hobbs, cited above, figs. 28–32; and Weinberg, cited above, figs. 7–9.

5. Quoted in Siegl, p. 107, no. 54.

6. *See* Rosenzweig, p. 101, no. 45.

7. Two others are also in the Hirshhorn Museum; *see ibid.*, pp. 102–3, nos. 46a–c.

8. Bregler, pp. 38–40.

9. *See* Lippincott, in PAFA, *In This Academy*, pp. 174–76, nos. 226, 242.

10. Garnett McCoy, "Some Recently Discovered Thomas Eakins Photographs," *Archives of American Art Journal*, vol. 12, no. 4 (1972), p. 15, repro. p. 17.

11. *See*, for example, Evan H. Turner, "Introduction," in Siegl, pp. 25–26.

12. *See* Rosenzweig, p. 101, no. 45.

13. *See ibid.;* and Hendricks, *Life*, pp. 160, 349, no. 322.

14. 1881, Corcoran Gallery of Art, Washington, D.C. (Hendricks, *Life*, p. 160, pl. 30).

XII. Music

1. Quoted in McHenry, p. 121.

2. Quoted in Siegl, p. 128, no. 78.

3. *See ibid.*, p. 105, no. 52.

4. *The Bohemian (Portrait of Franklin Louis Schenck)*, c. 1890, PMA (Siegl, p. 124, no. 74).

5. *Maud Cook* [131]; *Weda Cook*, c. 1895, Columbus Gallery of Fine Arts, Ohio (Hendricks, *Life*, pp. 192–93, fig. 193); and *Stanley Addicks*, c. 1895, Indianapolis Museum of Art (*ibid.*, p. 326, CL-121).

6. *See* Goodrich, p. 144.

7. *See* Quick, cited above, p. 67.

8. *See* Johns, "Case for Reassessment," cited above, p. 132.

9. *See* Siegl, p. 152, no. 100.

XIII. Male Portraits

1. Quoted in Goodrich, p. 22.

2. Jefferson Medical College, Thomas Jefferson University, Philadelphia (Hendricks, *Life*, pl. 19).

3. Armed Forces Institute of Technology, on loan to the National Gallery of Art, Washington, D.C. (Hendricks, *Life*, p. 109, fig. 80).

4. Seminary of Saint Charles Borromeo, Philadelphia (Hendricks, *Life*, p. 109, fig. 86).

5. Quoted in Goodrich, pp. 55–56.

6. Quoted in Hendricks, *Life*, p. 116.

7. *See* Goodrich, p. 56.

8. *See* Evan H. Turner, "Thomas Eakins: The Earles' Galleries Exhibition of 1896," *Arts Magazine*, vol. 53, no. 9 (May 1979), p. 102.

9. Quoted in *ibid.*, p. 105.

10. *See* Quick, cited above, p. 64; and Ackerman, pp. 247–48.

11. *See* Quick, cited above, p. 65.

12. For an explanation of Rowland's ruling machine and the symbols and formulas on the frame, *see* A. D. Moore, "Henry A. Rowland," *Scientific American*, vol. 246, no. 2 (February 1982), pp. 150–61.

13. Quoted in Goodrich, p. 115.

14. *See* William H. Gerdts, "Thomas Eakins and the Episcopal Portrait: Archbishop William Henry Elder," *Arts Magazine*, vol. 53, no. 9 (May 1979), p. 156, repro.

15. Quoted in PMA, *Three Centuries*, p. 381.

16. *See* Turner, "Introduction," in Siegl, p. 35.

17. *Portrait of William H. Macdowell*, c. 1891, Baltimore Museum of Art (Hoopes, pp. 84–85, pl. 32).

18. Quoted in Goodrich, p. 123.

XIV. Female Portraits

1. *See*, for example, Chase's *Tenth Street Studio* (1880, St. Louis Art Museum), reproduced in Santa Barbara, University of California, *The First West Coast Retrospective Exhibition of Paintings by William Merritt Chase (1849–1916)* (1964–65), no. 4.

2. *See* Ellwood C. Parry, III, "The Thomas Eakins Portrait of Sue and Harry; Or, When Did the Artist Change His Mind?," *Arts Magazine*, vol. 53, no. 9 (May 1979), pp. 148–49.

3. *Ibid.*, p. 149.